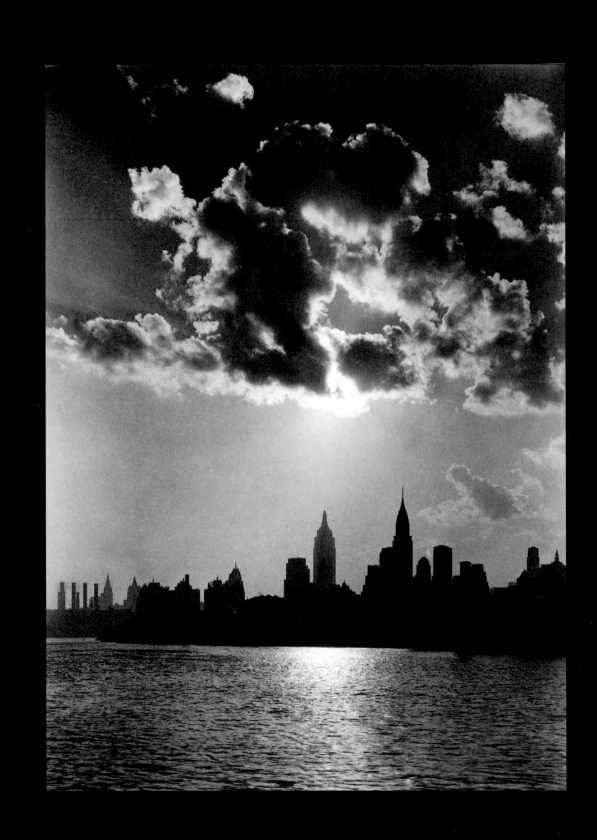

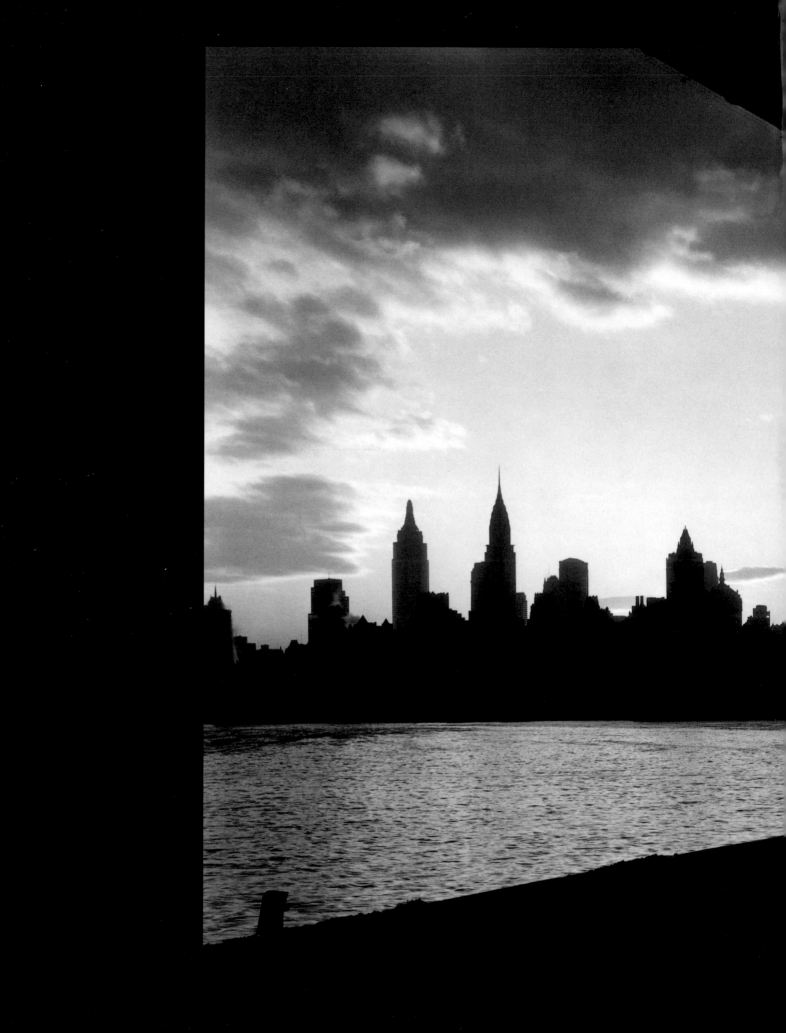

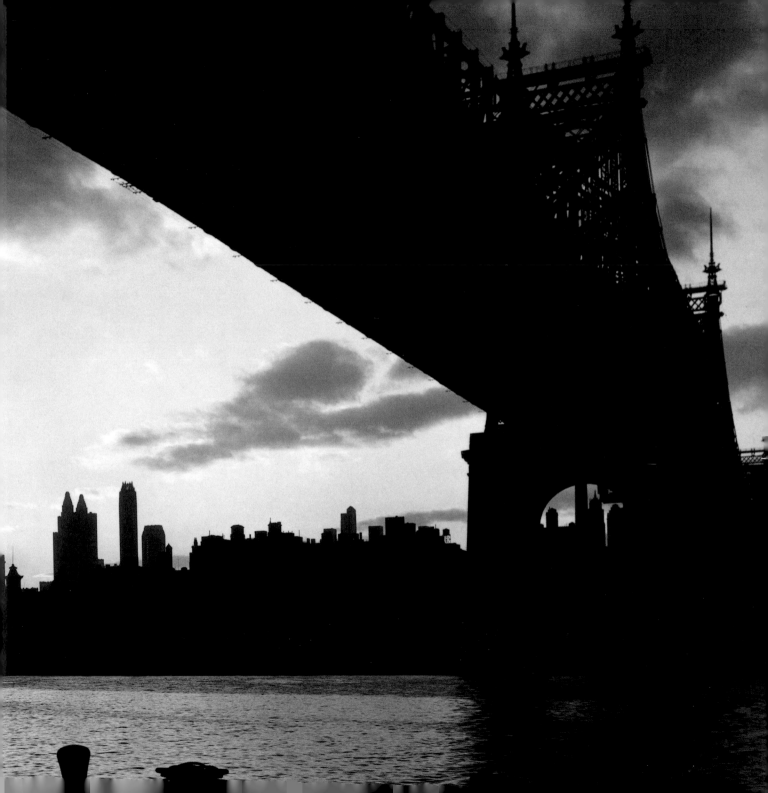

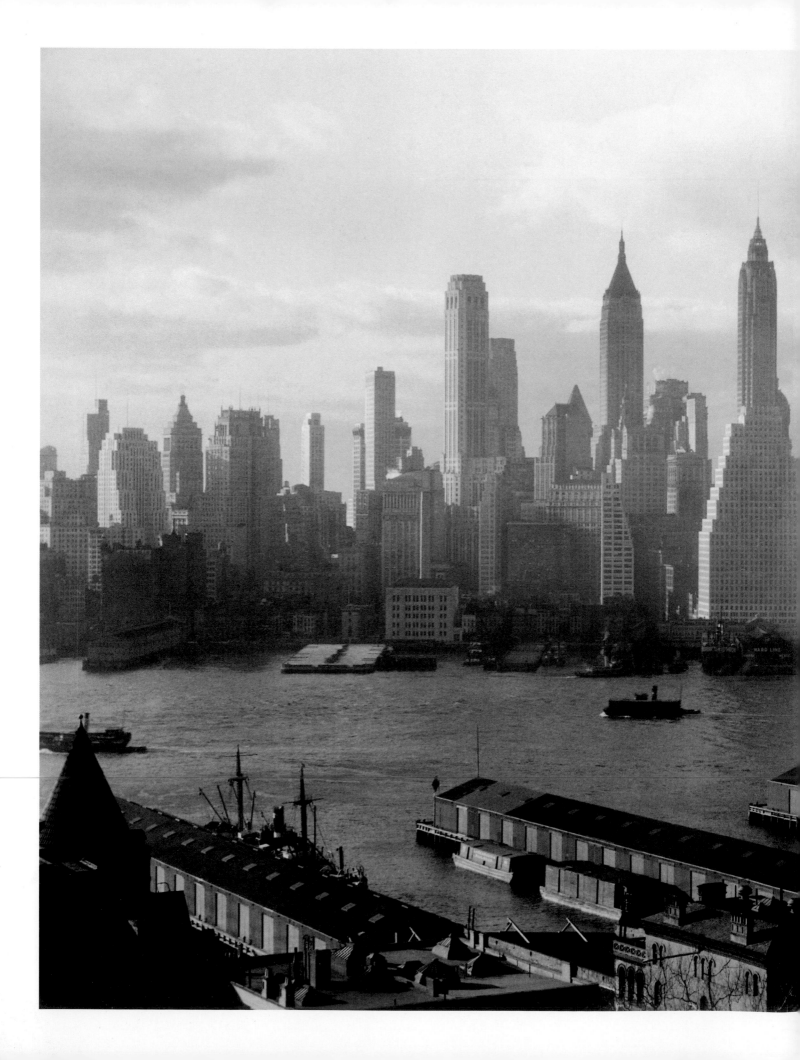

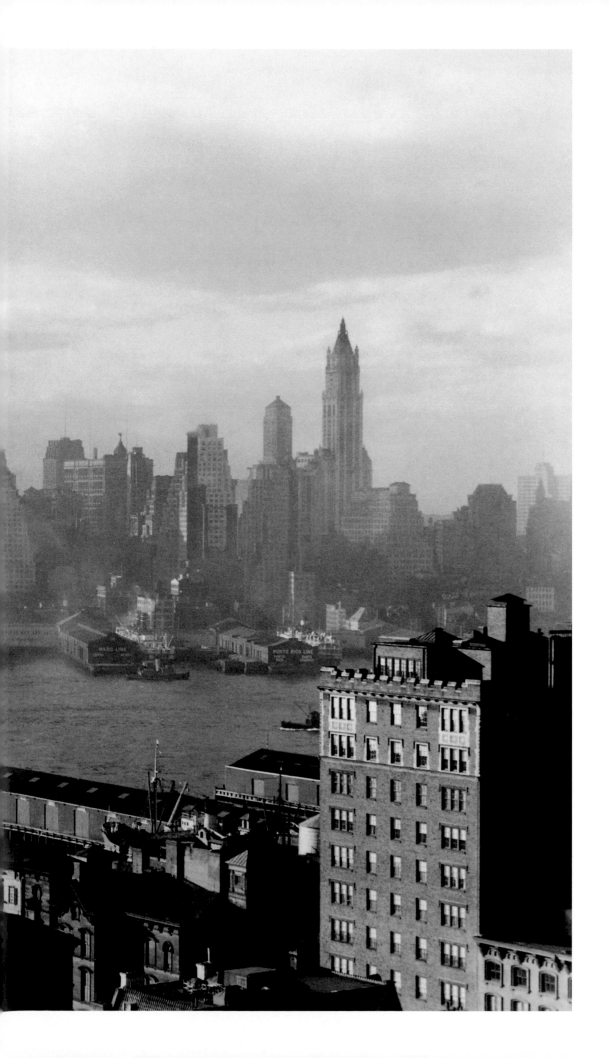

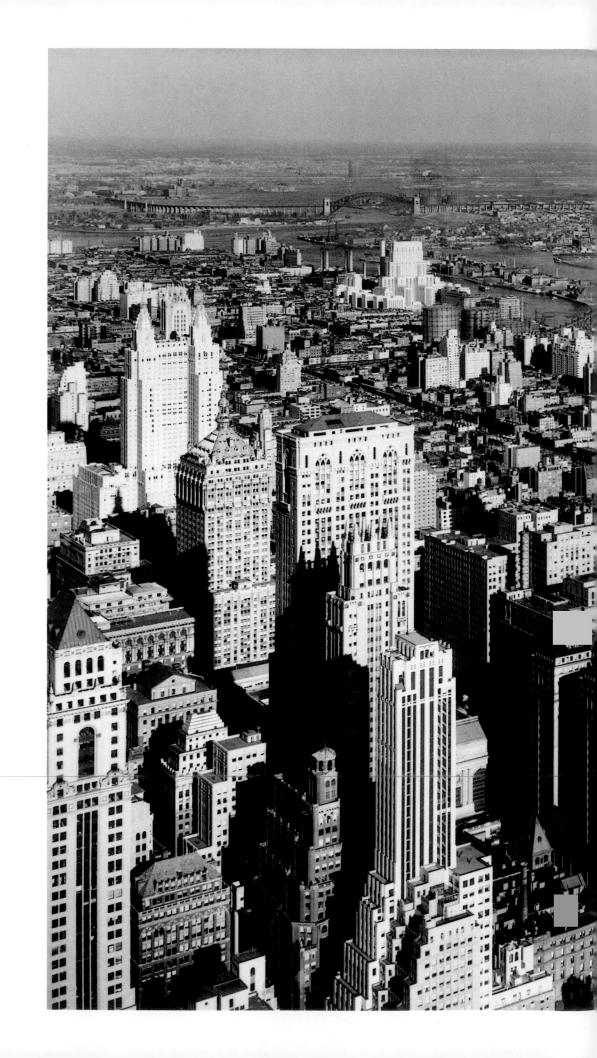

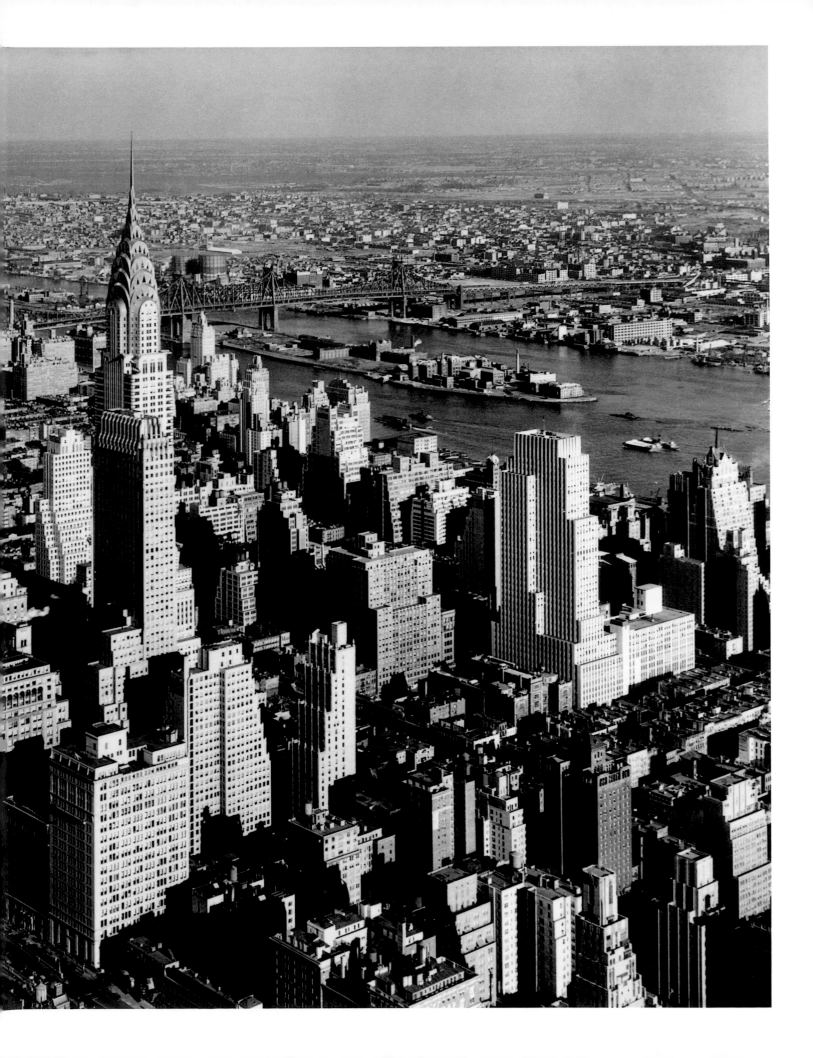

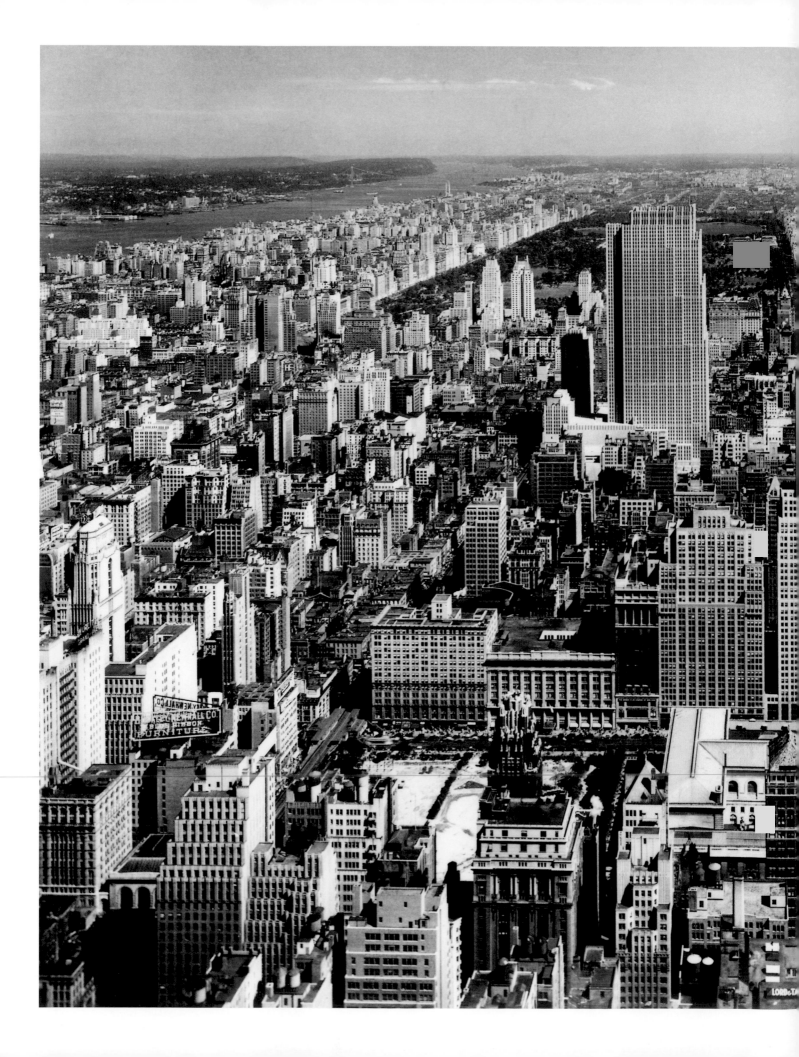

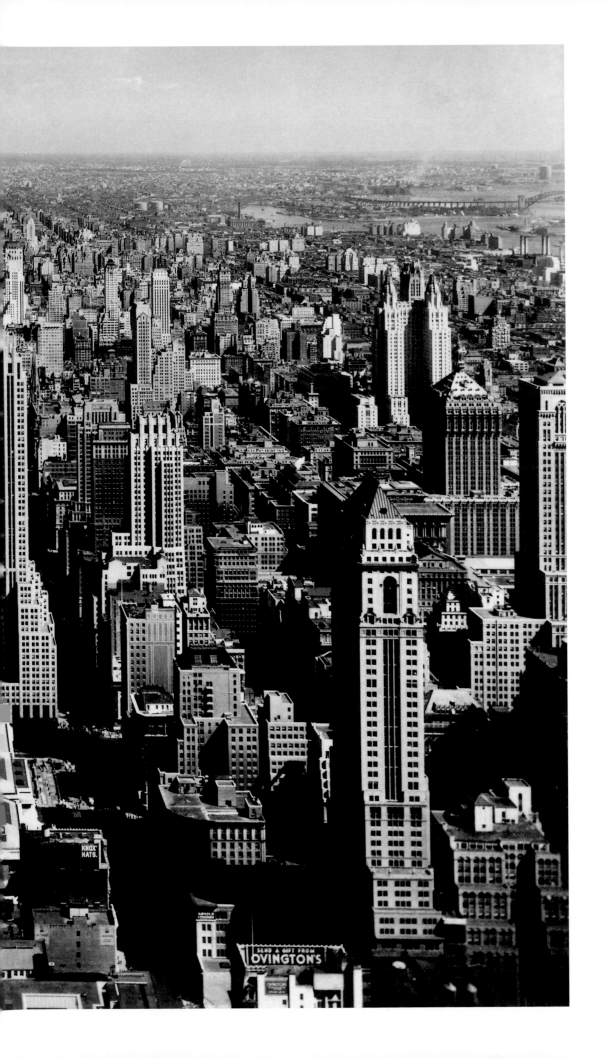

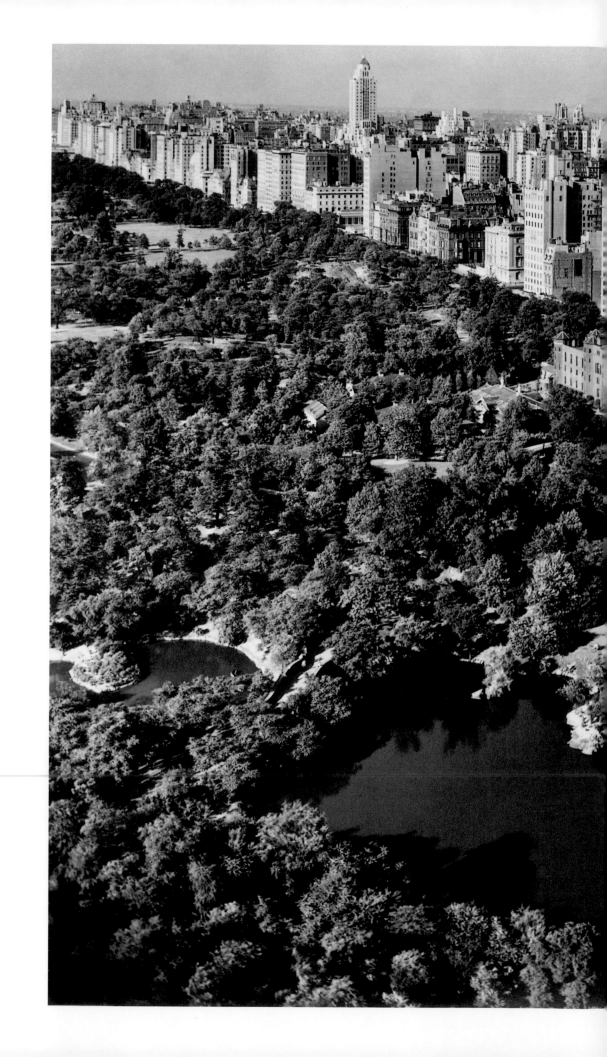

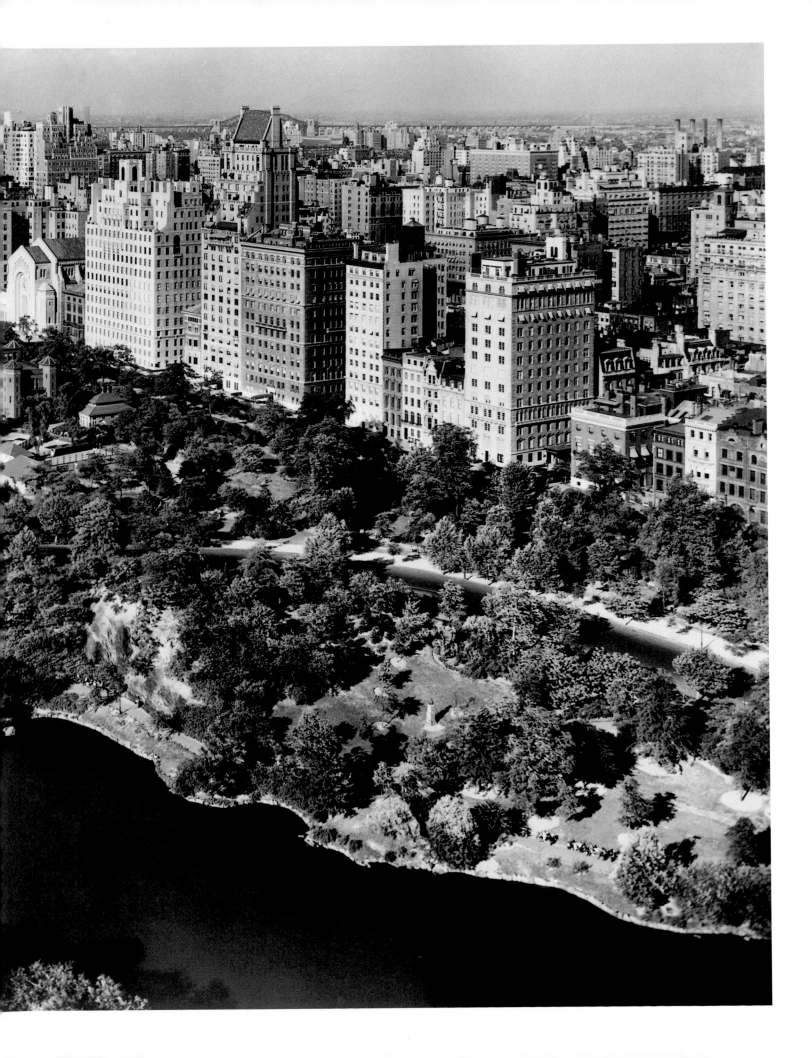

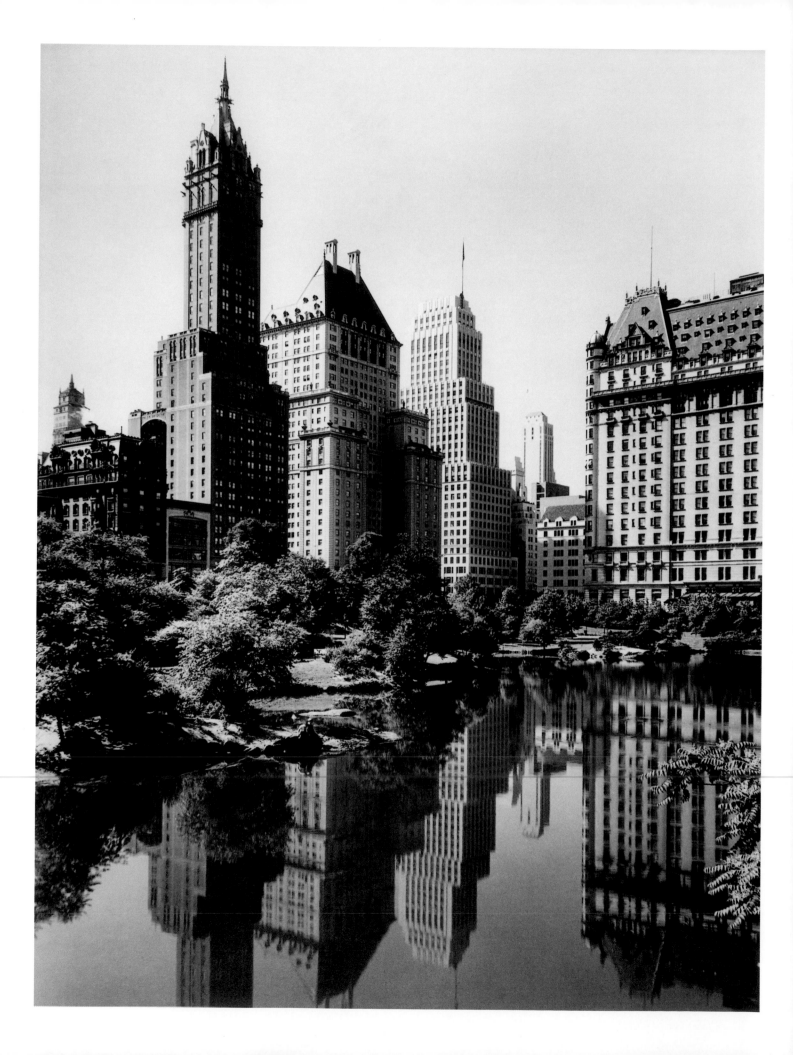

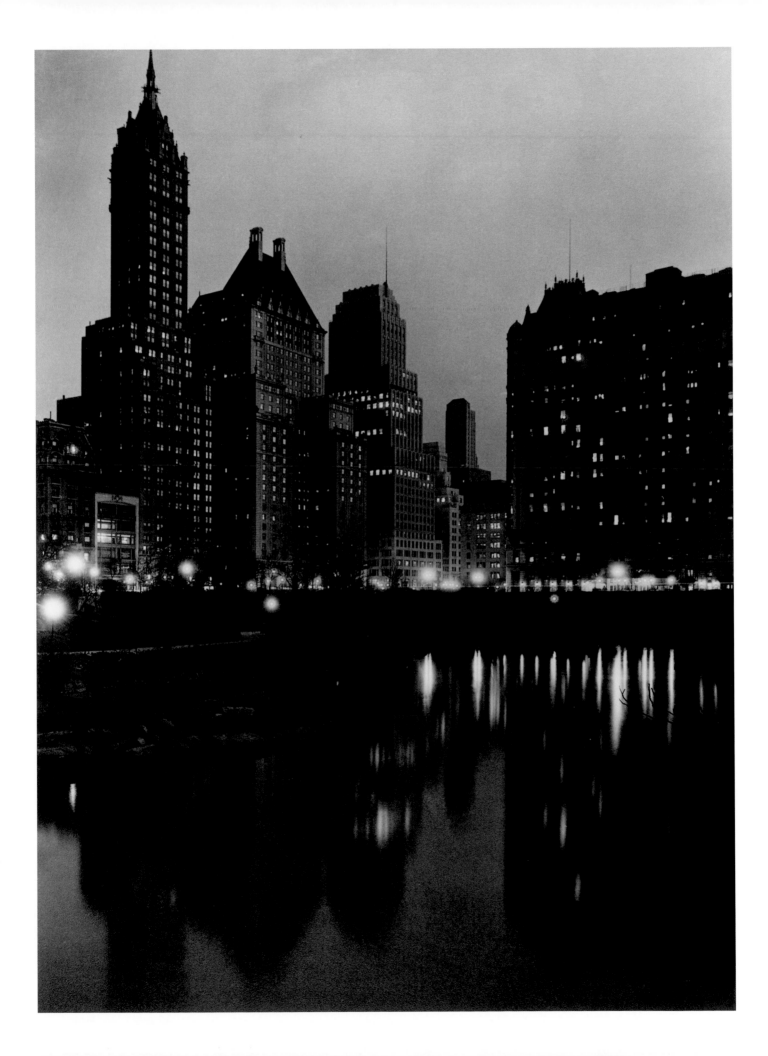

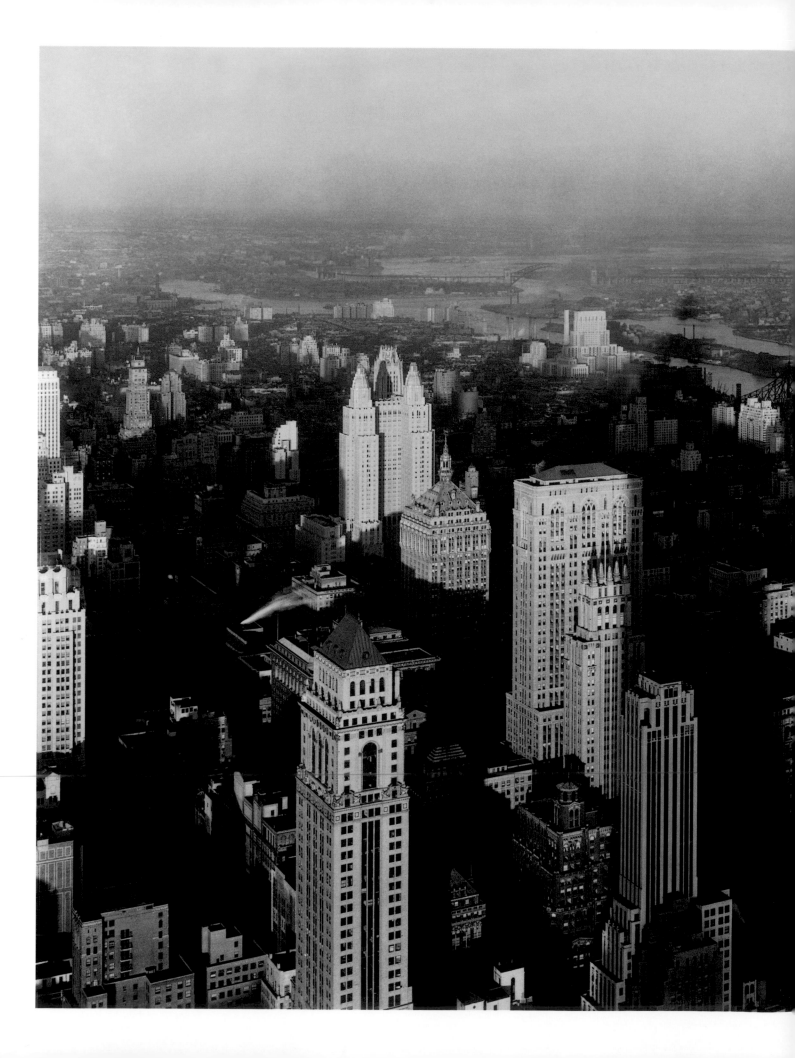

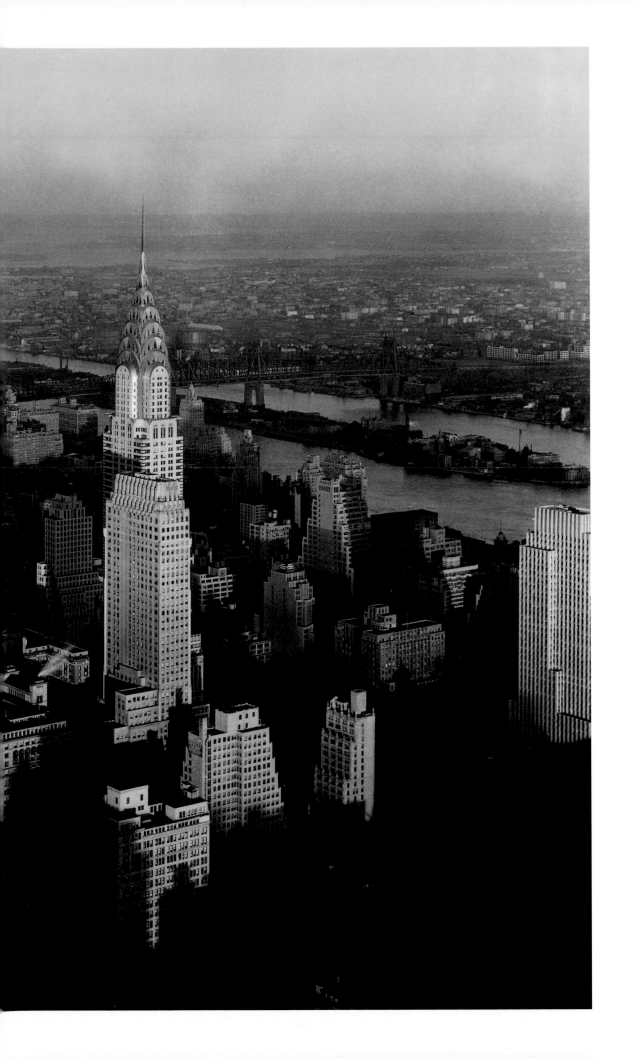

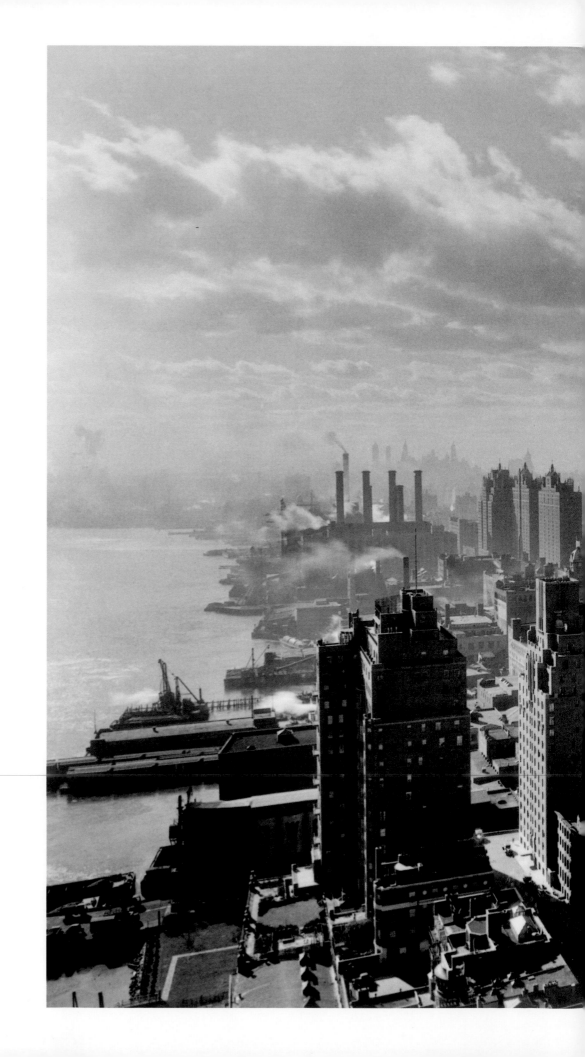

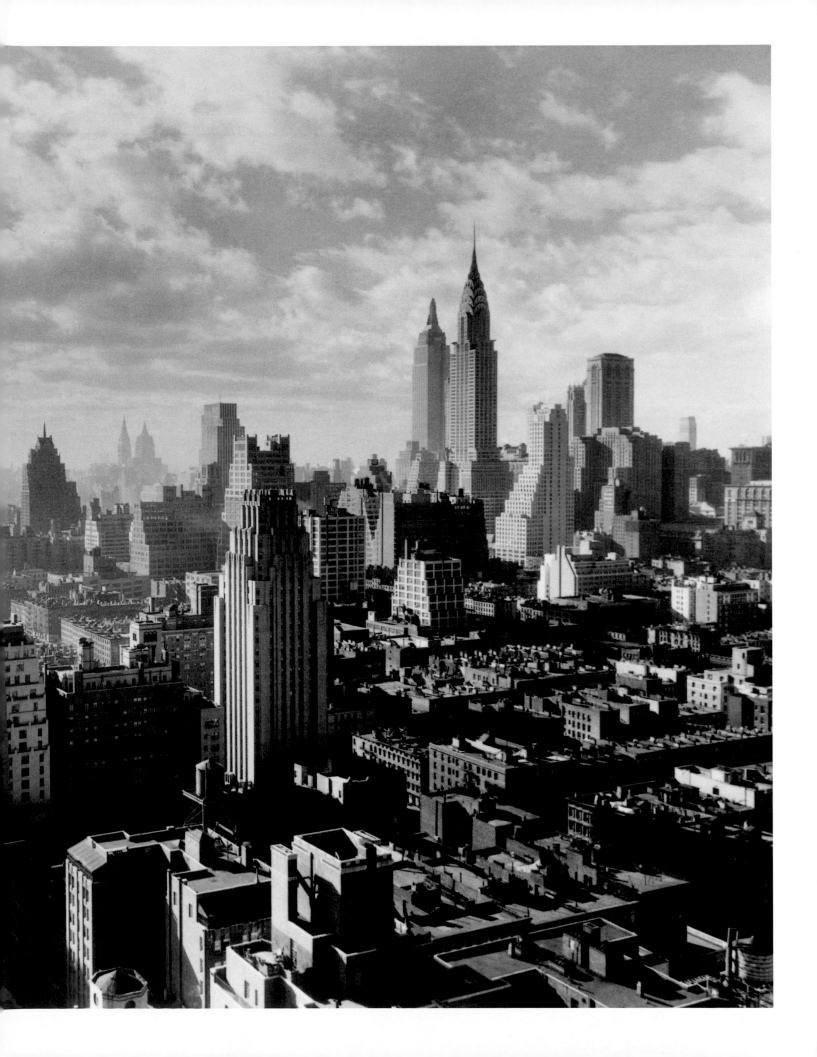

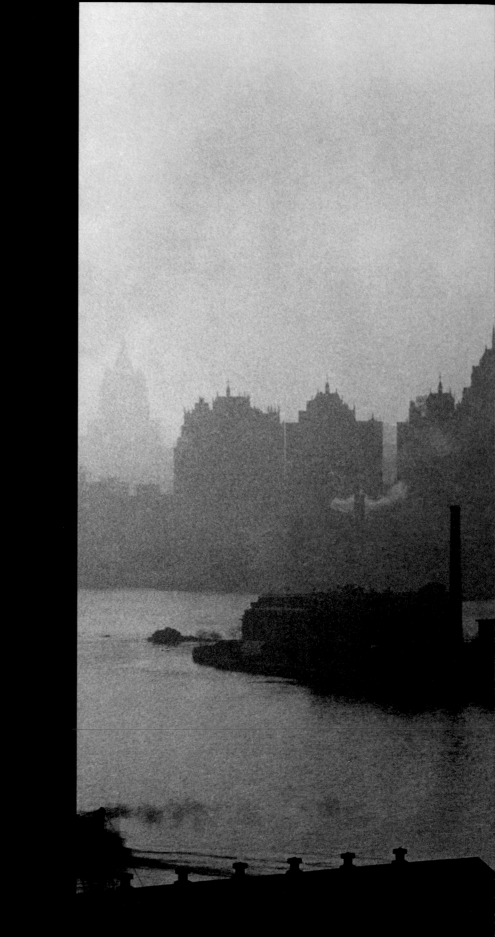

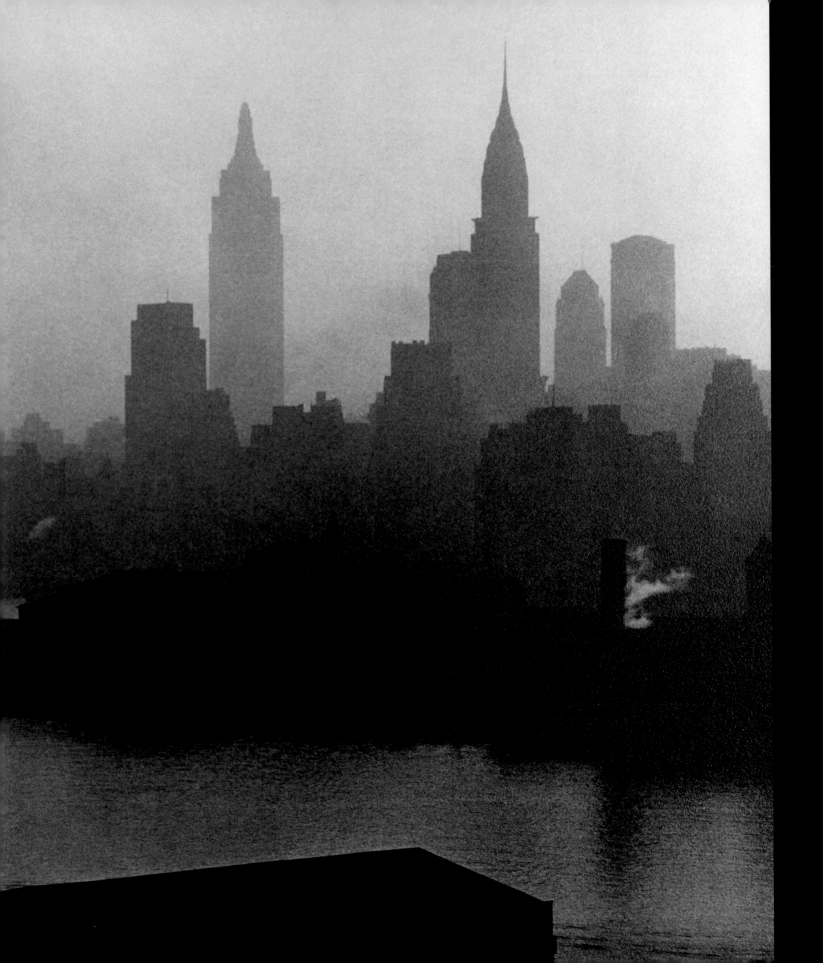

THE MYTHIC CITY

PHOTOGRAPHS OF NEW YORK

BY SAMUEL H. GOTTSCHO, 1925–1940

DONALD ALBRECHT

MUSEUM OF THE CITY OF NEW YORK

AND

PRINCETON ARCHITECTURAL PRESS

Published by
Princeton Architectural Press
37 East Seventh Street
New York, New York 10003

For a free catalog of books, call 1.800.722.6657.
Visit our web site at www.papress.com.

Editing: Linda Lee
Design: Pure+Applied (www.pureandapplied.com)

Special thanks to: Nettie Aljian, Dorothy Ball, Nicola Bednarek, Janet Behning, Megan Carey, Penny (Yuen Pik) Chu, Russell Fernandez, Jan Haux, Clare Jacobson, John King, Mark Lamster, Nancy Eklund Later, Katharine Myers, Lauren Nelson, Molly Rouzie, Jane Sheinman, Scott Tennent, Jennifer Thompson, Joseph Weston, and Deb Wood of Princeton Architectural Press
—Kevin C. Lippert, publisher

Library of Congress Cataloging-in-Publication Data

Albrecht, Donald.
 The mythic city : photographs of New York by Samuel H. Gottscho, 1925–1940 / Donald Albrecht.
 p. cm.
Includes bibliographical references.
ISBN 1-56898-562-2 (pbk. : alk. paper)
1. Architectural photography—New York (State)—New York—Exhibitions. 2. New York (N.Y.)—Pictorial works—Exhibitions. 3. Gottscho, Samuel H. (Samuel Herman), 1875–1971—Exhibitions. 4. Museum of the City of New York—Photograph collections— Exhibitions. 5. Photograph collections—New York (State)—New York—Exhibitions. I. Gottscho, Samuel H. (Samuel Herman), 1875-1971. II. Title.
 TR659.A48 2005
 779'.4747'1—dc22
 2005005015

All photographs are from the Gottscho-Schleisner Collection of the Museum of the City of New York and are located in the borough of Manhattan, New York, unless otherwise noted. Dates indicate when photographs were taken.

As Gottscho was primarily a commercial photographer, he usually identified his images by their building name or address and would only title images when they were exhibited or published. For this reason, this book does not treat subject identifications as titles.

PAGE 1: Manhattan skyline from Long Island City, Queens, New York, 1933

PAGES 2–3: Manhattan skyline framed by the Queensboro Bridge, 1932

PAGES 4–5: Financial District from the Hotel Bossert, Brooklyn, 1933

PAGES 6–7: Aerial view from Empire State Building looking northeast toward the Chrysler Building, 1932

PAGES 8–9: Aerial view of midtown Manhattan looking north, most likely from the Empire State Building, 1933

PAGES 10–11: Fifth Avenue and Central Park from the St. Moritz Hotel, 1932

PAGE 12: Daytime view of Fifth Avenue and Fifty-ninth Street seen from Central Park, showing the Sherry-Netherland Hotel (left), Savoy-Plaza Hotel (middle with peaked roof), and Plaza Hotel (right), 1932

PAGE 13: Nighttime view of Fifth Avenue and Fifty-ninth Street seen from Central Park, 1933

PAGES 14–15: Midtown Manhattan looking northeast from the Empire State Building, 1932

PAGES 16–17: Aerial view of midtown Manhattan looking south, 1931

PAGES 18–19: Midtown from the Queensboro Bridge, 1932

CONTENTS

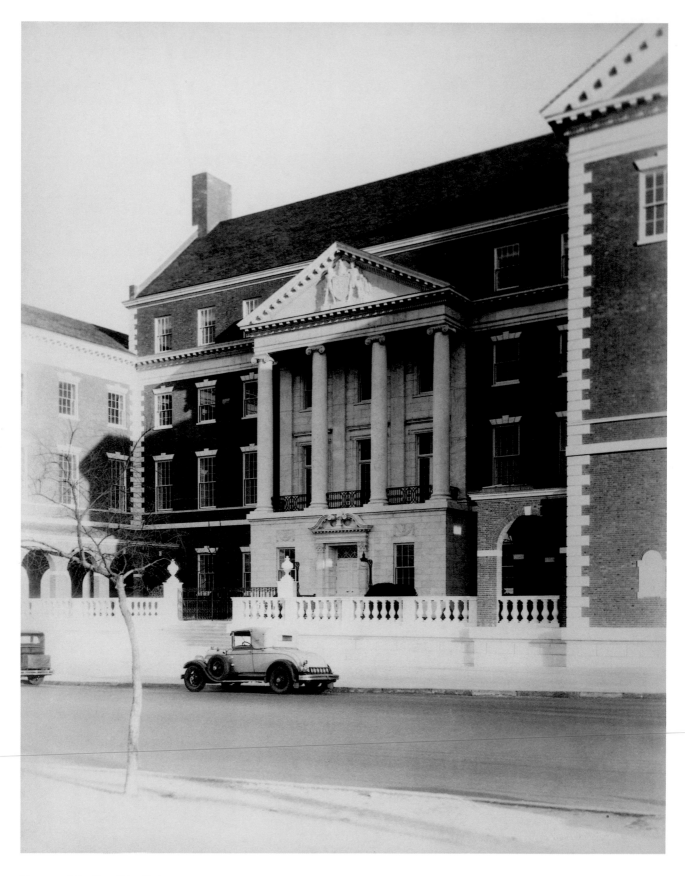

Museum of the City of New York,
1220 Fifth Avenue, ca. 1932
Joseph H. Freedlander, Architect

PREFACE

The Museum of the City of New York is proud
to possess many collections of photographs that not only document the city in depth, but also
capture the style and flair of this great metropolis. Preeminent among these holdings is the
outstanding Gottscho-Schleisner Collection. Samuel H. Gottscho started his professional
photographic studio in New York in 1925, after working for many years as an amateur photo-
grapher and traveling salesman. (In 1935 he joined forces with William H. Schleisner, who
soon became his son-in-law, and formed the firm Gottscho-Schleisner.) While Gottscho
received commissions throughout the United States, he produced an especially dazzling portrait
of New York City from the mid-1920s through the late 1930s, which projected an aura of New
York City sophistication across the country.

The Mythic City: Photographs of New York by Samuel H. Gottscho, 1925–1940 is the
first exhibition at the Museum to focus on this collection in almost fifty years, and this accompa-
nying catalog is the first publication ever devoted to the work of this remarkable photographer.
The Museum's association with Gottscho dates back to the early years of the institution.
His first one-man show, New York Night Scenes, was held here in 1934, two years after the
Museum opened in its new Fifth Avenue building. To honor the twentieth anniversary of the
Gottscho-Schleisner firm, the Museum mounted the exhibition Twenty Years of Photography
by Gottscho-Schleisner in 1956. Over the years, Samuel Gottscho graciously donated many
of his prints and negatives to the Museum and today the collection comprises approximately
six thousand images. We are especially proud to be one of only three institutions with major
Gottscho-Schleisner archives, alongside the Library of Congress in Washington, DC, and the
Avery Architectural and Fine Arts Library at Columbia University in New York City.

The current exhibition and book greatly benefit from conservation efforts funded by the
Surdna Foundation in the late 1980s and an earlier grant from the New York State Library
Conservation/Preservation Discretionary Grant Program. This exhibition and catalog were
made possible through the generosity of Museum of the City of New York trustee James G.
Dinan and his wife, Elizabeth R. Miller. I also want to acknowledge the efforts of curator
Donald Albrecht, editors Mark Lamster and Linda Lee of Princeton Architectural Press, and
designers Paul Carlos and Urshula Barbour of Pure+Applied, who designed both the catalog
and the exhibition. Through their efforts, we are honored to showcase the work of Samuel H.
Gottscho, mythic image maker of New York City.

Susan Henshaw Jones
PRESIDENT AND DIRECTOR
MUSEUM OF THE CITY OF NEW YORK

INTRODUCTION

DONALD ALBRECHT

During the late 1920s and '30s, architectural photographer Samuel H. Gottscho created a now-classic portrait of New York as the quintessential modern metropolis. Gottscho focused on the bold interplay of sun and shadow, dramatizing the chiseled forms of Manhattan's new skyscrapers and silhouetting the city's signature skyline and bridges. Rigorously editing out the city's Depression-weary seamy side—its tenement slums, breadlines, and shantytowns—Gottscho presented a dreamlike city of towers. His New York literally and figuratively glowed with a glamorous

Samuel H. Gottscho's business card, 1930s
Courtesy Library of Congress, Prints &
Photographs Division, Gottscho-Schleisner
Collection (LC-USZC2-4538 DLC)

sheen, as he cast his gimlet eye on the city's various scales—from the vast metropolis captured in aerial views, to individual buildings and interiors, and even to products sold within its stores. Through his lens, skyscrapers became embodiments of forward-looking urbanism. The sparkling plate-glass windows of the city's fashionable businesses framed and reflected streetscapes of streamlined cars and stylish pedestrians. Rooms were bathed in natural light, which passed through glass block facades and shimmered off walls of mirror and metal. Contemporary furniture and household objects were elevated into shining objects of modern desires. And in Gottscho's New York, arguably the first round-the-clock city, night was as charismatic as day. His nocturnal portraits were dazzling, turning Times Square theaters and World's Fair pavilions into artificially illuminated fairylands of popular culture.

Gottscho's brilliance as a photographer was rooted in his capacity to synthesize the documentary and the artistic. His photographs conveyed volumes of information about the way the city looked at a pivotal moment in its development, and they are now invaluable tools for understanding New York's ever-evolving built environment. Gottscho meticulously surveyed a city that had been largely rebuilt in only a few short decades, transformed by rising immigration, expansive corporate business practices, and radical advances in transportation, communication, and building technologies. Yet the wealth of information provided by Gottscho's images was always animated by a profoundly aesthetic sensibility that rendered his portrayal of the city proud, heroic, and defiantly optimistic. Composed of both photographs commissioned by the city's leading architects, designers, and builders and noncommissioned images, or "views" as he often labeled them, Gottscho's body of work exuded a consistently powerful promotional zeal, as it simultaneously revealed and celebrated the multiple layers of modern New York.

Gottscho's portfolio of late-1920s and '30s New York comprised the first chapter in his professional career, which spanned from 1925 until his death in 1971.[1] Born in Brooklyn in 1875 to a German father and a mother of French ancestry, Samuel Herman Gottscho took his first amateur photographs of ships and of Brooklyn's Prospect Park after purchasing a large-format box camera at age twenty-one. Gottscho's images of Coney Island's amusement parks as nighttime dreamscapes taken around 1905 presaged his later ability to render a fantastical Manhattan. However, married in 1910 and soon a father, Gottscho was unable to support his family as a professional photographer. He followed in the mercantile path of his father, who had worked in wholesale notions and fancy goods. While making his living as a traveling salesman of laces, embroideries, and fabrics, Gottscho continued to take photographs in his spare time and educated himself by reading photography magazines. Around 1915 Gottscho began selling his amateur photographs, some featuring his daughter, to a calendar company. His pictures of gardens then led to a commission by a landscape contractor to photograph suburban houses and gardens in Queens, for which he was paid three dollars apiece.

By 1925, this work allowed fifty-year-old Gottscho to quit his job as a traveling salesman and begin a new career as a professional photographer. He soon opened a studio in Queens where he specialized in photographing grand country estates, new suburban houses, and commercial city buildings. A series of photography exhibitions in Manhattan, especially those at the fashionable Architectural League of New York, convinced him he could "do work as good as what was on the wall."

Working fourteen hours a day, seven days a week, Gottscho compiled an impressive roster of commissions within a few years. His pictures highlighted the world of the wealthy, who had the financial resources to commission architects and hire photographers like Gottscho to document their buildings. His employers were frequently architects, such as New Yorkers Dwight James Baum and John Russell Pope, for whom he photographed both urban and suburban projects. He also worked for some of the city's top builders and developers and claimed that he successfully weathered the Depression by taking annual trips to Palm Beach, Florida, photographing the mansions of the wealthy. Early on Gottscho learned to meet his clients' marketing needs, helping them to attract tenants to their office and apartment buildings, as well as to feed the expanding appetite for images of glamorous lifestyles presented in illustrated books and magazines. His work regularly appeared in such magazines as *Town and Country* and *House and Garden*, and he claimed that for several years in the 1930s he was practically the staff photographer for *American Architect* magazine. Using a five-by-seven professional view camera, which

Samuel H. Gottscho, ca. 1956

1 The biographical information in this essay is drawn from two unpublished manuscripts housed in the Prints & Photographs Division of the Library of Congress in Washington, DC. One is an illustrated, four-volume autobiography written by Gottscho between the mid-1950s and early 1960s. The second is a shorter autobiography that Gottscho wrote in the late-1960s in order to attract a publisher for the longer work. All quotations by Gottscho in this essay are from these manuscripts, unless otherwise noted.

was standard equipment for an architectural photographer of his generation, Gottscho provided clients with two kinds of images: photographs printed on high-quality creamy paper with a rich range of gray tones suitable for display and photographs printed in high-contrast black and white that were best for publication. "Suppress your ego," he advised his colleagues, "follow the client's lead. Think how best to serve him."

By focusing on architectural photography, Samuel Gottscho was one of a growing cadre of commercial photographers who successfully served the needs of architects, builders, and publishers in the early decades of the twentieth century. Although architecture had been a subject

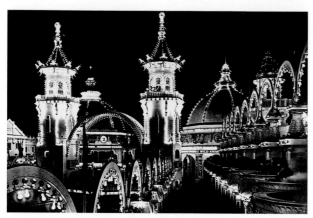

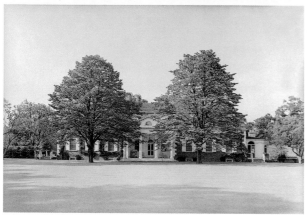

Luna Park at Coney Island, Brooklyn, 1906
Frederic Thompson, Architect

Estate of Mrs. Evelyn Marshall Field, Syosset, Long Island, 1936
Courtesy Library of Congress, Prints & Photographs Division, Gottscho-Schleisner Collection (LC-G612-T01-27380 DLC)

for photographers since the invention of the medium in the late 1830s, it became increasingly clear by the end of the nineteenth century that photographs, rather than drawings, would be the primary means of visual communication for the architectural profession. By the 1890s, every city had at least one professional architectural photographer. In 1895, for example, Norman and Lionel Wurts established in New York the architectural photography studio Wurts Brothers Company, whose images of residences, offices, and factories would be reproduced in magazines, advertisements, brochures, and even postcards.[2] They and other photographers, such as Clarence Fuermann, who photographed Frank Lloyd Wright's 1906 Larkin Administration Building in Buffalo, New York, and Europeans like Hugo Schmölz, who photographed German buildings by Bauhaus founder Walter Gropius in the 1910s, demonstrated that photographs had the ability to do more than capture the documentary facts of modern architecture. They could also project the architect's aesthetic intentions. As a result, architectural photography grew as a profession, and the architectural photographer became a major player in the promotion (and sometimes the creation) of new architectural ideas.

The 1920s—when film and photography took firm hold of popular visual culture—proved an especially heady decade for architectural imagery. In addition to Gottscho's own firm, started in 1925, other premier architectural photo studios included Hedrich-Blessing (Chicago), Nyhold and Lincoln (New York), and Dell and Wainwright (London). At the same time, art photographers, defined as those whose photographs represented their own agendas more than those of clients, began to see commercial culture as the very essence of modern American life and accepted commissions from magazines eager to present their readers with new visual styles. Margaret Bourke-White, the star photographer of Luce Publications' *Fortune* and *LIFE* in the 1930s, began her career as an architectural photographer for *House and Garden* in 1928. Edward Steichen was lead photographer for Condé Nast Publications' *Vogue* and *Vanity Fair*, and in 1929 Berenice Abbott, New York's premier modernist photographer of the 1930s, turned her extraordinary visual acumen to the city's architecture. "These photographers and others," architecture curator Joseph Rosa has noted, "helped to dissolve the boundaries of architectural photography" in that they created artistic compositions along with more straightforward images.[3]

Gottscho's career manifested this newly blurred boundary between artistic and commercial photography. Throughout his half-century career making a living as a commercial photographer, he never lost what he described as "the inquiring and enthusiastic spirit of the amateur." In the spring of 1928, for example, Gottscho began his famous series of noncommissioned vistas

2 The Museum of the City of New York houses a great collection of Wurts Brothers photographs, as does Washington's National Building Museum, which presented an exhibition of their collection, Building the Ballyhoo: Architectural Photographs by the Wurts Brothers Company, in 1996.
3 Joseph Rosa, "Constructed Perceptions: Architectural Photography in the United States," http://www.nbm.org/blueprints/90s/winter96/page2/page2.htm.

and street scenes of the city at large, beginning with the Sherry-Netherland and Savoy-Plaza hotels viewed from Central Park and Midtown from the Queensboro Bridge. Sometimes, a job to photograph a skyscraper afforded access to spectacular vistas that he captured at the same time, such as his images of Midtown taken while photographing a new office building on Fortieth Street off Fifth Avenue in 1930. During 1932 and 1933, when the Depression caused a downturn in his business and gave him more spare time, Gottscho calculated that he and his driver traveled over six thousand miles in the city, "looking for compositions and locations, and where feasible, to get contrasts of old and new," as he wrote.

Gottscho's portraits of New York captured the city in a variety of moods. He usually created crisp, objective photographs—whether of individual buildings, aerial views of midtown Manhattan at midday, or dramatic nighttime shots in which the skyscrapers' abstract geometric

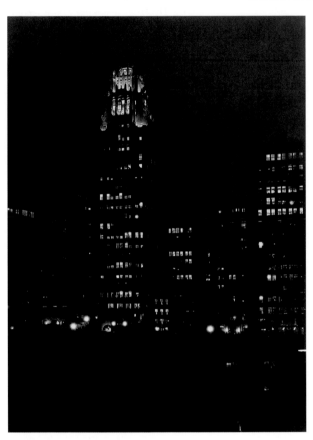

American Radiator Building, 1926
Raymond Hood, Architect
Courtesy Library of Congress, Prints &
Photographs Division, Gottscho-Schleisner
Collection (LC-G612-T01-05710 DLC)

patterns of lights obscured all human activity. His fascination with the abstract shapes of the modern city can also be seen in his noncommissioned 1932–33 aerial photograph entitled *Ants and Beetles* in which Broadway's deep canyon appears as a diagonal strip across the image. Such abstract, cubist representations of the city were characteristic of photographers like Berenice Abbott, but only rarely appeared in Gottscho's work. A notable exception in his commissioned work occurred in the early 1930s when the advertising agents for the art deco Radio City Music Hall in Rockefeller Center hired him to take images for the theater's premiere. Gottscho noted that at their insistence on "ultra dramatic pictures," he abandoned his typically straightforward approach and positioned his camera near the floor to create abstract, low-angle viewpoints of the theater's lobby and auditorium. However, Gottscho's flirtations with truly modernist aesthetics were rare. His sensibility was representational, fitting for a photographer of his generation and suiting his clients' needs. Gottscho's pragmatism was at odds with the utopianism of many "new vision" photographers who believed that the camera could change vision and thus change society. For Gottscho, modern society was essentially fine just as it was.

While Gottscho focused on commissioned architectural photography, he occasionally created noncommissioned images that looked back to the more artistic pictorialist tradition of the century's first decades. At that time, art photographers such as New Yorker Alfred Stieglitz and Bostonian Alvin Langdon Coburn had sought to elevate photography into an art form by reproducing impressionistic painters' effects in the medium. Although the romantic style went out of favor after World War I, it continued to influence Gottscho, who was old enough to have encountered pictorialist imagery first hand. His 1931 image of Manhattan towers and smokestacks along the East River shrouded in clouds and smoke expressed the pictorialist fascination with mood and atmosphere; so too did Gottscho's dusky image of the Manhattan skyline, which he poetically dubbed *Mist and Mystery* (1932–33)[4].

Gottscho's infatuation with photographing nocturnal Manhattan was inaugurated in the mid-1920s as he became "much fascinated by the beauty of buildings at night, with a myriad of windows, sparkling like jewels." It was the American Radiator Building, whose mountainlike black-and-gold form had caused an architectural sensation in 1924 that offered Gottscho his first major opportunity to experiment with photographing skyscrapers at night. (Georgia O'Keeffe also portrayed the building in her 1927 painting *Radiator Building, Night-New*

4 Gottscho usually identified his images by their building name or address and would only title images, such as *Mist and Mystery*, when they were exhibited or published.

York.) Gottscho was inspired to develop what became his trademark technique of photographing buildings at night using two separate exposures that were combined into one composite image. The first exposure was made at dusk to register the building's ziggurat silhouette against the darkening sky; the second, from the exact same spot but with a longer exposure time, was made later to capture the building's windows blazing with artificial illumination. The resulting images painted a luminous city in a surreal moment, poised between night and day.

Gottscho's mid-1920s nocturnal photographs of the American Radiator Building were pivotal in his career, both commercially and artistically. They launched a series of images of nighttime New York as "the city that never sleeps" and became a staple of his work in the 1920s and '30s. By 1934, nine years after he had first photographed the American Radiator Building, Gottscho's nocturnal images helped market the film version of Fanny Hurst's novel *Symphony of Six Million* and were published in *Architectural Record* magazine. And, establishing Gottscho's credentials as an art photographer, his work appeared in the 1932 inaugural exhibition in New York at the influential Julien Levy Gallery, entitled Photographs of New York by New York Photographers, an eclectic display that put Gottscho in the company of such luminaries as Margaret Bourke-White, Walker Evans, and Berenice Abbott. Gottscho was one of the most avidly sponsored photographers of the newly opened Museum of the City of New York. (Abbott was the other.) He documented its new building on Fifth Avenue after it opened in 1932 and had an exhibition devoted to him in 1934: New York Night Scenes featured twenty-two images Gottscho had produced since the mid-1920s.[5] Some of Gottscho's night scenes were also among the sixty New York images featured in a privately published volume (1933) that garnered him high respect from New York's photography elite. "The pictures are so beautiful that they impart that delicious sense of sadness that beauty always does," wrote Christopher Morley of *The Saturday Review* in a letter to Mitchell Kennerley, whose Manhattan bookstore had been a meeting place for pictorialist photographers and who unsuccessfully tried to secure a publisher for Gottscho's New York views. "He rinses our eyes…and we look again and with new eyes at our daily undeserved astonishment."[6]

While these accolades poured in, Gottscho assured his commercial success by solidifying his relationship with Raymond Hood, the celebrated architect of the American Radiator building who had purchased Gottscho's nocturnal images of his famous structure. Hood went on to commission some of Gottscho's most celebrated images, including great ones of Rockefeller Center, one of the few major commercial projects to be built in New York during the Depression. Through his connections to Hood, who designed the multibuilding complex with a team of other architects, Gottscho became the center's quasi-official photographer, beginning in the spring of 1932 when it was under construction and continuing throughout the decade until its completion in the late 1930s.

Rockefeller Center was a twenty-four-hour city within the city, conceived as a *gesamptkunstwerk,* or "total work of art," of contemporary city planning, architecture, art, and furnishings. More than any other commission, it offered Gottscho the ideal arena to photographically explore his fascination with the modern metropolis' various scales. Over the course of the decade, Gottscho lovingly photographed the center's art deco theaters; the chiseled body of its main tower, gleaming in the sun and bathed in artificial light at night; the submerged gardens and golden statue of Prometheus at the tower's base; and the elegant Rainbow Room, which sparked the imaginations of Hollywood art directors for a decade, at the tower's pinnacle. The center's extensive retail spaces, including a branch of the Chase National Bank and offices and

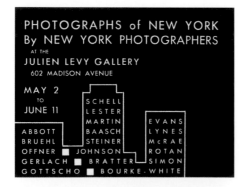

Announcement for photography exhibition at the Julien Levy Gallery, 1932
© Berenice Abbott/
Commerce Graphics Ltd., Inc.

5 In 1956, the Museum presented another exhibition, Twenty Years of Photography by Gottscho-Schleisner, on the firm's work.

6 The letter is dated June 28, 1932 and is quoted in a press release, located in the files of the Museum of the City of New York, for the exhibition Samuel Gottscho: New York: Night and Day, presented in New York at the Alan Klotz Photocollect Gallery, now the Klotz/Sirmon Gallery.

showrooms for the National Cash Register Company, were the subject of widely published, glamorous images by Gottscho that, in his words, successfully "glorified" the late-1930s architectural vocabulary of swooping streamlined forms, shimmering reflective materials, and indirect lighting effects. Ultimately, Gottscho's photographs imbued Rockefeller Center with a sense of greatness, elevating it to a metaphor of capitalist enterprise and a symbol of New York City's resilience in the face of the Depression's economic adversities.

Rockefeller Center attracted the attention of many commercial and art photographers besides Samuel Gottscho during the 1930s. Gottscho's view of New York, in contrast to many of his professional peers, was distinctively optimistic. Preeminent among the artists attracted to the center was Alfred Stieglitz. Whereas Stieglitz's turn-of-the-century night shots of skyscrapers such as the Flatiron Building were misty and romantic in the pictorialist style, his Depression-era images of Rockefeller Center, dubbed "skyscraper noir" by historian Mary Woods, were dark and brooding, suggesting an economically depressed city whose inhabitants were literally and metaphorically crushed under the lengthening shadow of businessmen like John D. Rockefeller, Jr.[7] Berenice Abbott created yet another view of Rockefeller Center—as symbol of the city in the throes of radical, and often jarring, change.

While Gottscho's oeuvre of the 1930s is threaded with images of Rockefeller Center, he also photographed virtually every other built form of the modern city. For Gottscho, the city's architecture, engineering, and advertising—not its residents—were the major protagonists of New York. People appeared as little more than props: anonymous pedestrians scurried along Fifth Avenue giving scale to the street's stylish store fronts, while lone individuals in front of store windows directed the viewer's gaze toward merchandise inside the windows. Gottscho's most consistent use of the city's inhabitants occurred in his photographs of new housing projects, such as the Harlem River Houses, where unanimated children posed to suggest the projects' social beneficence.

The real stars of the city's drama for Gottscho were its skyscrapers, which he captured in a series of New York views he described as "sharp, clear, well-composed architectural studies in straight-line perspective." Revolutionary advances in building construction and technology had made possible enormous skyscrapers in Midtown and the downtown financial district. These stone-and-glass behemoths soon became the most dramatic physical manifestations of the contemporary metropolis, attracting the attention of avant-garde photographers, painters, and filmmakers. For artists like Alfred Stieglitz, Georgia O'Keeffe, and Fritz Lang, Manhattan was a potent subject for modern art, its physical geography enhancing its inherent photogenic qualities. The city's skyscrapers, located on a dense street grid, created vertiginous slices of space and offered dramatic perches for aerial views, while Manhattan's wide swaths of parks and its island setting, encircled by broad rivers, allowed panoramic vistas of its famous skyline from the parks and rivers.

Gottscho chose to photograph these skyscrapers as tall and vertical—a decision that had both technical and aesthetic implications. New York skyscrapers of his time were high, thin, and wedged between other buildings, so it was often hard to stand back the requisite distance to capture them in traditional perspective with parallel verticals.[8] Like other architectural photographers working in the city, Gottscho solved this problem by photographing buildings from a great distance, such as his images of the American Radiator Building from Bryant Park and of the great apartment buildings that surround Central Park. In these images, Gottscho used the park's lakes to mirror these buildings and extend their man-made presence into the park's

7 Mary Woods develops this idea in her essay "Photography of the Night: Skyscraper Nocturne and Skyscraper Noir," in *Architecture of the Night: The Illuminated Building*, ed., Dietrich Neumann (Munich, London, New York: Prestel, 2002).

8 Cervin Robinson and Joel Hershman, *Architecture Transformed: A History of the Photography of Buildings from 1839 to the Present* (New York and Cambridge: The Architectural League of New York and the MIT Press, 1988), 115.

natural features. When photographing skyscrapers close up, he used a professional view camera, which allowed him to adjust his camera position and minimize distortion.

In addition to photographing New York's skyscrapers, Gottscho documented every other aspect of the city's new architectural scene, especially the increasing adoption of modernism for office buildings, shops, and even traditional institutions such as banks. For many businesses during the Depression, streamlined forms, new industrial materials, and innovative lighting schemes were ways to attract the attention of customers and to combat falling sales. Materials such as shining porcelain panels, multicolored terrazzo pavement, and gleaming stainless steel also appealed to the public as symbols of a bright, new future beyond the travails of the economic downturn. Glass, in particular, had undergone remarkable scientific and aesthetic transformations since the mid-nineteenth century. From Joseph Paxton's glass-and-iron Crystal Palace at London's Great Exhibition of 1851 to the glass skyscrapers proposed by German architect Ludwig Mies van der Rohe in the 1920s and the glass-walled "House of Tomorrow" at the 1933–34 Century of Progress Exposition in Chicago, the translucence and transparency of glass buildings came to symbolize a new and liberating society.

Gottscho photographed some of the most spectacular uses of these new materials and designs, including a Stetson shoe shop, where two rows of glass portholes framed the shop's glass entrance doors, which were recessed in expanses of curving glass show windows. Another company to go modern was Steuben, the upstate New York glass manufacturer. In the early 1930s, Steuben introduced a new line of pure crystal objects for the home and office and, in 1937, moved into the new Corning-Steuben Building, notable for its exterior walls of thirty-eight hundred Corning Pyrex glass blocks set within panels of smooth Indiana limestone, on Fifth Avenue. Gottscho's photographs of the new building fused architecture, product design, and marketing strategy by highlighting the new material's brilliant reflectivity and translucence—the same qualities projected by the company's new glass objects.

Preeminent among the new buildings Gottscho photographed was another important Raymond Hood commission: a setback skyscraper he designed for the McGraw-Hill publishing company that was completed in 1931. The building's design posed considerable photographic challenges. First, although its exterior was composed of two different materials—glass strip windows set flush with spandrels of blue-green and machine-made terra-cotta tiles—the architects' intention was to render the building's facades as a single, taut plane of machined purity. Gottscho struggled to render this effect, eventually achieving it in two dramatic images. Standing close to the building's corner and pointing his camera up, Gottscho captured McGraw-Hill's silhouette profile by contrasting its sunlit setback facade on Forty-second Street with its side facade cast in shadow. Another image, photographed by locating his camera a few blocks away from the building, was taken at the very moment the rising sun hit the side facade, which gleamed like a stretched wrapper of cellophane. Equally challenging was capturing the building's many different parts simultaneously. Like many skyscrapers of the early twentieth century, McGraw-Hill was meant to be experienced from different vantage points, from its stylish facade and lobby from street level, to its large rooftop sign that advertised the company as an important figure on the Manhattan skyline from a distance. As it was impossible to visually encompass all these elements in a single image, Gottscho adopted a cinematic approach, creating a photographic portfolio of the building in long and medium shots as well as dramatic close-ups.[9]

While celebrating office buildings and stores as emblems of the capitalist city, Gottscho's images chronicled the importance of other forces that were shaping the modern metropolis.

9 The problem of capturing the many scales of skyscrapers is discussed in
Architecture Transformed, 107.

Using light and shadow to powerful effect, he dramatized the monumentality of the New York State Office Building in Lower Manhattan, elevating the building, in 1931, to a symbol of solidity during the tumultuous Depression. Similarly, striking images of the white setback forms of the New York Hospital-Cornell Medical Center depicted it as a complex in command of the latest advances in modern science and medicine.

Not only individual buildings, but also the infrastructure that linked them to the greater urban fabric fascinated Gottscho. A metropolis largely comprised of islands, New York required bridges, tunnels, and roadways to connect the expanding boroughs. While serving the functional needs of transporting people and vehicles, these modern infrastructures also symbolized the dynamism of the contemporary city that was in a constant state of movement and flux. Gottscho photographed new road systems such as the West Side Highway, which served an increasingly automobile-centered region surrounding the city. He was especially fascinated by structures like

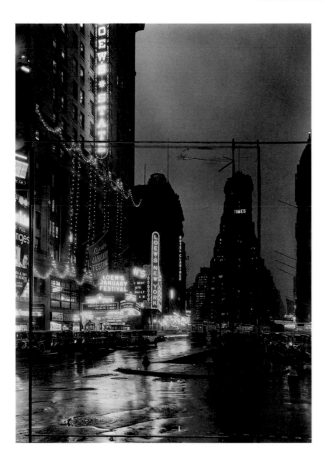

Proof print of Times Square showing crop marks, 1932

Gottscho created 5 x 7 proof prints of virtually every photograph he took. When a photo's composition did not meet his visual standards, the proof was marked to indicate where it should be cropped for publication.

the bridges that spanned the city's rivers and the elevated railroad lines that crisscrossed Manhattan. In his photographs, these metal behemoths were sculptural objects that shone in the sun, cast dappled shadows onto the ground, and twinkled with artificial illumination at night. They had special visual appeal for photographers like Gottscho who used their massive horizontal spans to dramatically frame the city's vertical towers. In the early 1930s, Gottscho created iconic images of Lower Manhattan from the Brooklyn Bridge and Midtown from the Queensboro Bridge. Its decorative silhouette was the subject of several Gottscho images, most memorably those that captured the bridge as a phantom presence in the distance behind Sutton Place's elegant masonry townhouses. Gottscho's eye was also drawn to newer, more functional forms of bridge design. The George Washington Bridge, which opened in the fall of 1931, immediately became, in Gottscho's words, "New York City's No. 1 camera subject." Also photographed by Edward Steichen for *Vanity Fair*, the bridge was praised by modernists for the utilitarian beauty of its naked steel structure, which, ironically, was not a deliberate aesthetic decision but a result of the financially strapped economy of the Depression.

Gottscho's urban photographs, especially those taken at night, evidenced the escalating commercialism of the city and the resulting increase in the presence of signage on the city's skyline. His images of New York were filled with glowing signs towering over the city, proclaiming the names of automobile manufacturers (General Motors, Fisk Tires), banks (Chase National Bank), and publishing companies (McGraw-Hill). His pictures of Times Square celebrated the bright advertising promises of toothpaste companies and soft drink manufacturers, as well as the glamorous celebrity of popular movie stars like Jean Harlow, George Burns, and Gracie Allen. Their illuminated names on marquees cast their glow onto wet streets and curvaceous automobiles, indelibly fusing them with images of the city. The Times Square pictures, like so many of his New York images of the 1930s, espoused an "only in New York" localism—their "classic" status established by fixing in one's memory a particular time, the Depression, and a particular urban place, Times Square.

While Gottscho was fascinated with Times Square and other urban settings, no neighborhood as consistently captured his attention as the Upper East Side of Manhattan, with its new fashionable apartment buildings, hotels, and social clubs. The well-heeled residents of this enclave were enthralled with new decorating styles, and Gottscho was especially masterful at

photographing interiors created by leading decorators and designers such as Elsie Cobb Wilson and Aymar Embury II. As wealthy New Yorkers moved into apartments and residential hotels, architects and designers conceived ingenious design strategies—from mirrored walls to indirect lighting—to make small spaces appear larger and more complex. These new buildings were usually financed as cooperatives, in which shareholders were more likely than renters to continue to make costly renovations to reflect the latest styles. This gave photographers like Gottscho many opportunities for commissions.[10]

Gottscho created interior photographs that were primarily experiential. He welcomed the viewer into spaces by placing his camera near eye-level and by bringing walls and domestic objects close to the picture plane, thereby bridging the real world and the world of the photograph. Since contemporary magazines shied away from inhabited photographs, furniture and decorative objects were often used as surrogates for residents or club members. In his photographs of the new Cosmopolitan Club from the early 1930s, Gottscho pulled a dining chair out from the table, suggesting that it was ready to receive the viewer, and even cropped its legs out of the frame, a device he would often use with furniture so it appeared to be as much in the viewer's world as in the image's. Similarly, Gottscho's slightly raised camera would afford unobstructed views of tables, set with elegant accoutrements that reinforced his clients' high style.

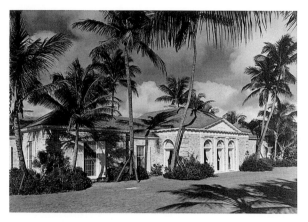

Residence at 1860 South Ocean Boulevard, Palm Beach, Florida, 1930s
Courtesy Library of Congress, Prints & Photographs Division, Gottscho-Schleisner Collection (LC-USZC2-4475 DLC)

Of all the devices interior designers used to dramatize and enlarge new interiors, none was as prevalent or effective as mirrors, which were lavishly promoted by such style leaders as Dorothy Draper and prominently featured in magazines like *Town and Country*. While decorators had previously treated mirrors as discrete, decorative objects surrounded by elaborate frames, the new fashion promoted large, frameless mirrors or entire mirrored walls that served, in effect, to magically open new vistas and unexpected views.[11] Gottscho mastered the difficult task of photographing these vast reflective surfaces by carefully positioning his camera to remain invisible while creating alluringly complex spaces on film. Sometimes the effects were surreal: rooms revealed only in reflection were further veiled by etchings and other embellishments decorating the mirrored walls. Likewise, Gottscho's dramatic photographs of the Beekman Place townhouse of radio magnate William Paley heightened the interior's aura of spectacle and voyeurism. The opulent bathroom featured mirrored walls, furniture, and vertical columns of built-in lighting. Another mirrored wall doubled the apparent width of the townhouse's narrow foyer and extended it beyond the frame of Gottscho's image to suggest spatial infinity—an alluring illusion of limitless horizons in the constrained Depression era.

Both natural and artificial illumination animated and dramatized Gottscho's interiors. He claimed to rely exclusively on the room's existing illumination, artfully combining indirect lighting in coves, natural light bouncing off mirrors, and task lighting from table lamps. In some interiors, Gottscho included nighttime-illuminated skyscrapers visible outside a window to give a sense of glamour and importance to an otherwise ordinary space. Often called upon to create such images of apartments and offices, Gottscho recounted how these effects were achieved: as darkness fell, he waited until the light value of the distant buildings approximately equaled the reading of the lighted interior and then exposed the film. Through his technical mastery and visual artistry, Gottscho created interiors that were simultaneously theatrical and stylish, warm and inviting.

10 Robert A.M. Stern, Gregory Gilmartin, and Thomas Mellins, *New York 1930: Architecture and Urbanism Between the Two World Wars* (New York: Rizzoli, 1994), 395.

11 I am grateful to Assistant Professor Sandy Isenstadt, Yale University, for his observations on the role of mirrors in American domestic architecture.

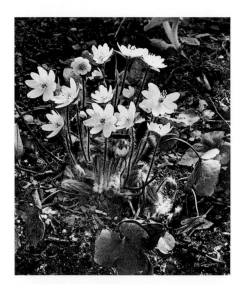

Wildflower study, 1952

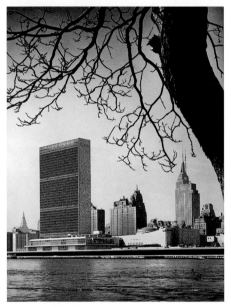

United Nations complex, 1952
Board of Design, Wallace K. Harrison,
Director of Planning

Manipulating lighting was also a key strategy in Gottscho's interior photographs of consumer goods. Automobiles, shoes, and refrigerators, which he treated with a style and sophistication typically reserved for works of art, were reflected and magnified in plate glass windows, spotlighted against backdrops of glittering new materials, and brought to life by being set on shiny floors dappled with sunlight streaming in through walls of glass.

Gottscho's interest in New York architecture and design in the 1930s would culminate with the New York World's Fair of 1939–40, which represented the hopes and aspirations of Depression-era Americans for a better future. He visited the site thirty times, working for the owners of pavilions and also taking pictures for his own amusement, during which, like so many other visitors, he experimented with new Kodacolor film. "The whole place was fantastic," he later remembered, "extravagant, even unreal and the most magnificent use of light as display that had ever been seen before, even dwarfing New York's famed white way."

Opening the same year as the outbreak of war in Europe, the New York World's Fair symbolized for Gottscho "the end of an era" in New York and the United States. The late 1930s also witnessed changes in Gottscho's personal and professional lives. In 1935, Gottscho developed a partnership with William Schleisner, who a few years later became his son-in-law, to form the firm Gottscho-Schleisner. Schleisner soon took on commissions of his own. While he lacked Gottscho's extraordinary visual flair, his partnership with Gottscho allowed the elder man to shift his emphasis to nature photography. During these years, Gottscho was especially interested in taking images of wildflowers in their natural settings, which regularly appeared in leading magazines and newspapers. He also photographed specimens for the New York Botanical Garden in the Bronx and wrote the book *Wildflowers: How to Know and Enjoy Them* (1951). Gottscho's shifting of focus away from architectural photography coincided with America's entry into the war in 1941, a time that saw a halt in the construction of buildings in New York City. Although construction boomed after the war ended in 1945, Gottscho-Schleisner never again achieved the perfect synchronicity between city and photography, experience and image, that had characterized their earlier work. Gottscho-Schleisner continued to photograph major postwar architectural projects in New York including the United Nations and the Seagram Building. However, the simple, boxlike forms and sleek minimalism of these structures proved less inspiring than had the decorative setback silhouettes of prewar New York architecture. Leading postwar architects in New York City found a more empathetic eye with a new group of photographers, most notably Ezra Stoller, who came to dominate the field with images that took a more scientific, "truthful" approach. Rather than the contextual and urbanistic sweep of Gottscho's pictures, their images focused on individual buildings and key details that succinctly and eloquently represented major elements of the new architecture.[12]

Today, Gottscho's iconic portraits of 1930s New York remain his hallmark. The interwar metropolis he captured was a mythic one, frozen in a particular moment in the city's life and projecting the illusion of New York as the ultimate modern city, pulsing with visual energy night and day. Gottscho's luminous images offered views that are revelatory and dreamy, familiar and new. It visualized the city most famously described by F. Scott Fitzgerald in his 1925 novel, *The Great Gatsby*—"[New York] seen from the Queensboro bridge is always the city seen for the first time, in its first wild promise of all the mystery and the beauty in the world."[13]

12 By the mid-1950s, Schleisner was taking on much of the firm's work with Gottscho serving as art director. After Schleisner's death in 1962, Gottscho continued to work in order to support his daughter and grandson until his death in 1971.

13 F. Scott Fitzgerald, *The Great Gatsby* (New York: Charles Scribner's Sons, 1925), 82.

BRIDGING
THE
CITY

View of Carl Schurz Park
and the East River from
95 East End Avenue, 1927

Gottscho signaled this new
building's modernity by
focusing the viewer's attention
on the metal-framed Hell
Gate bridge, seen through
the building's equally
contemporary metal-framed
casement windows.

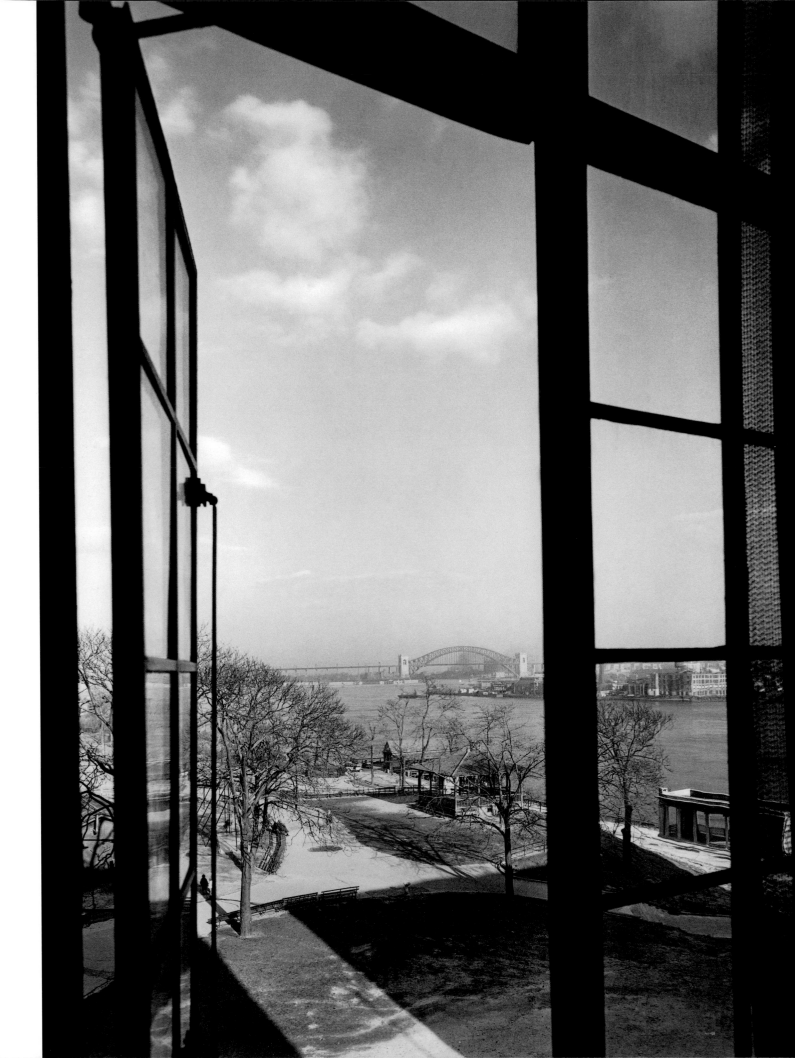

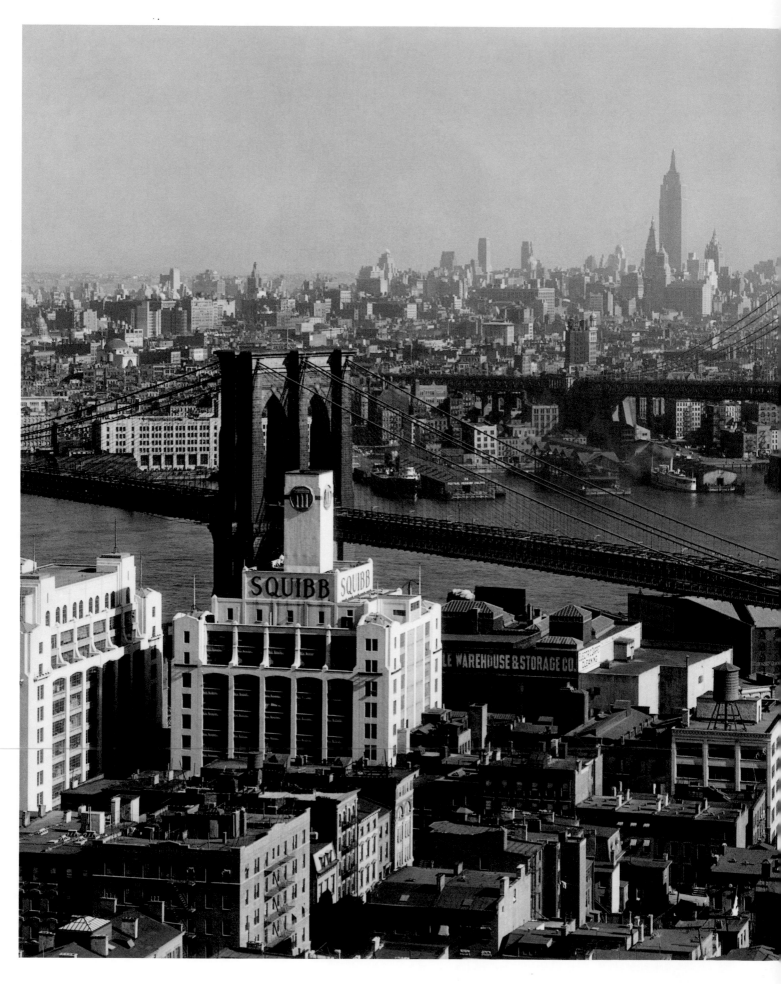

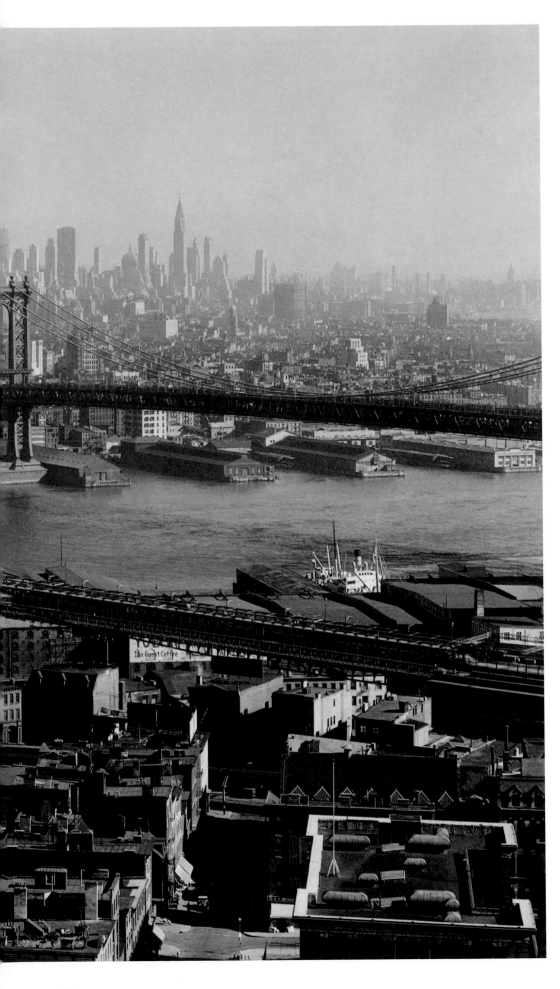

View of Manhattan from the
roof of the St. George Hotel,
Brooklyn, 1932

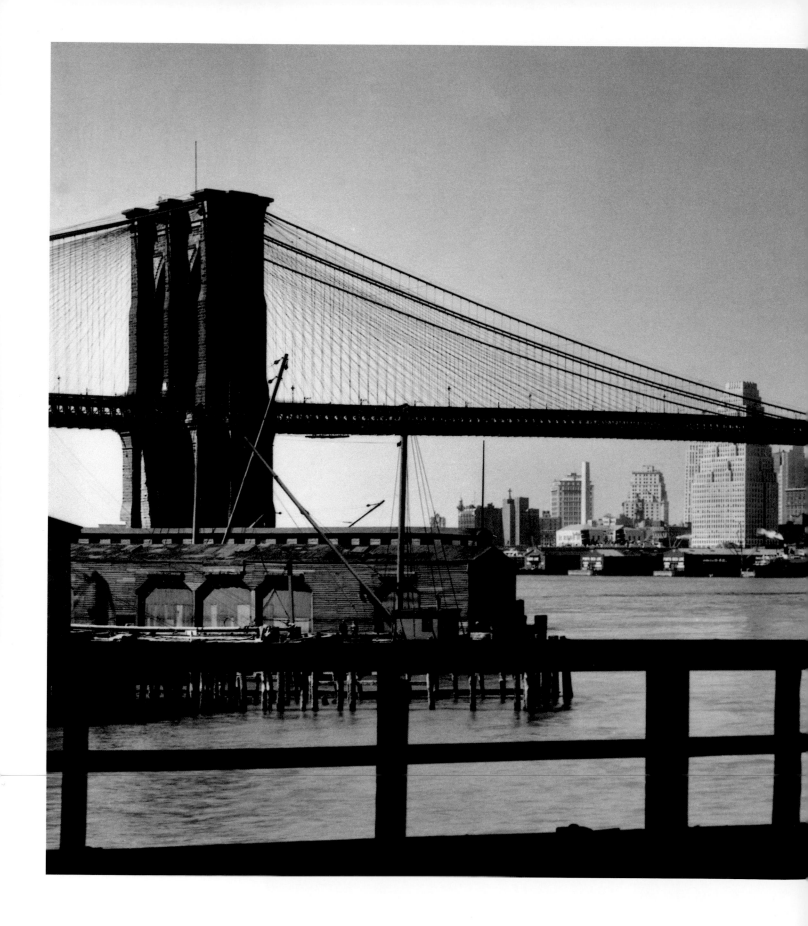

Lower Manhattan and the
Brooklyn Bridge from the
foot of the Manhattan Bridge,
1932

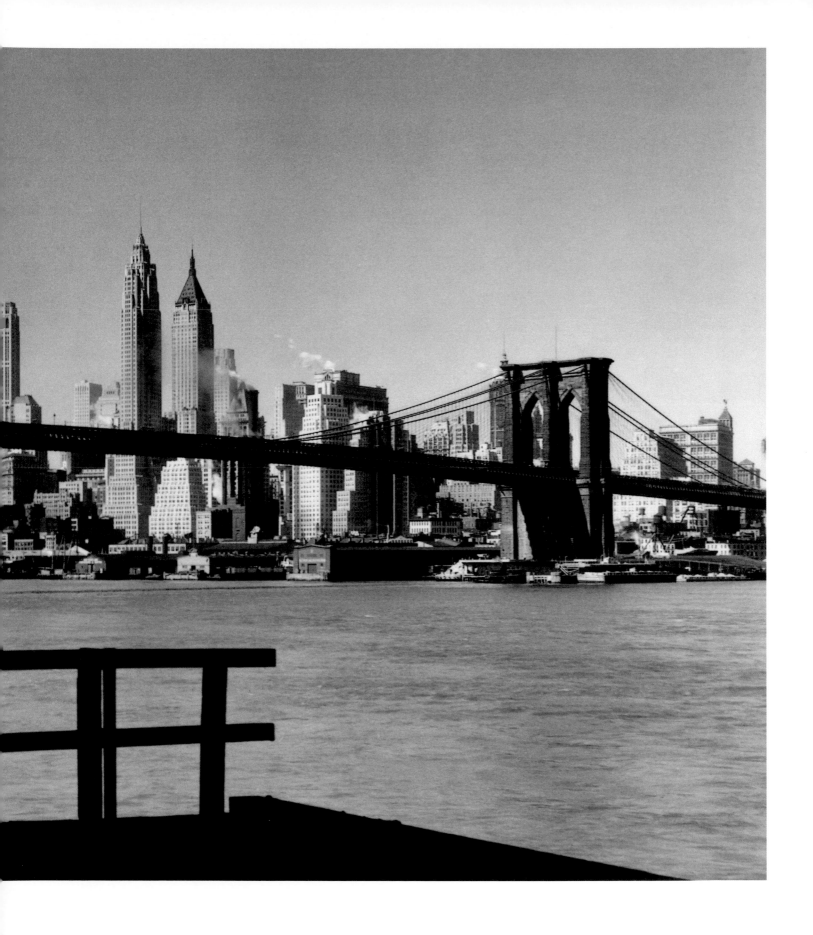

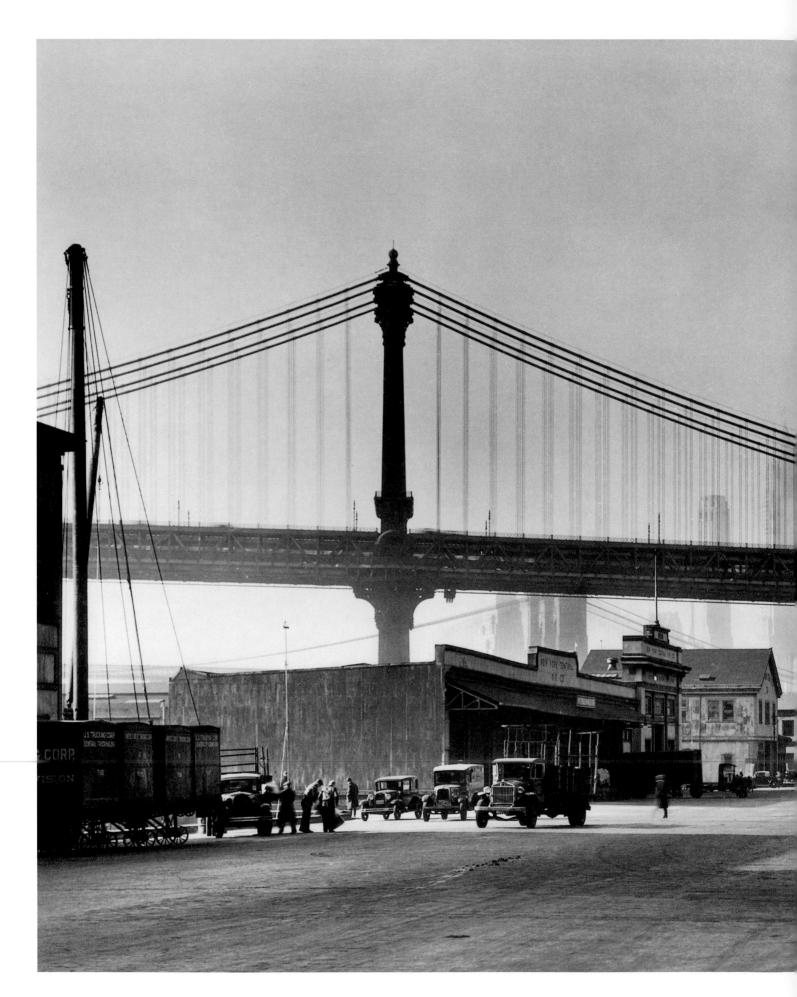

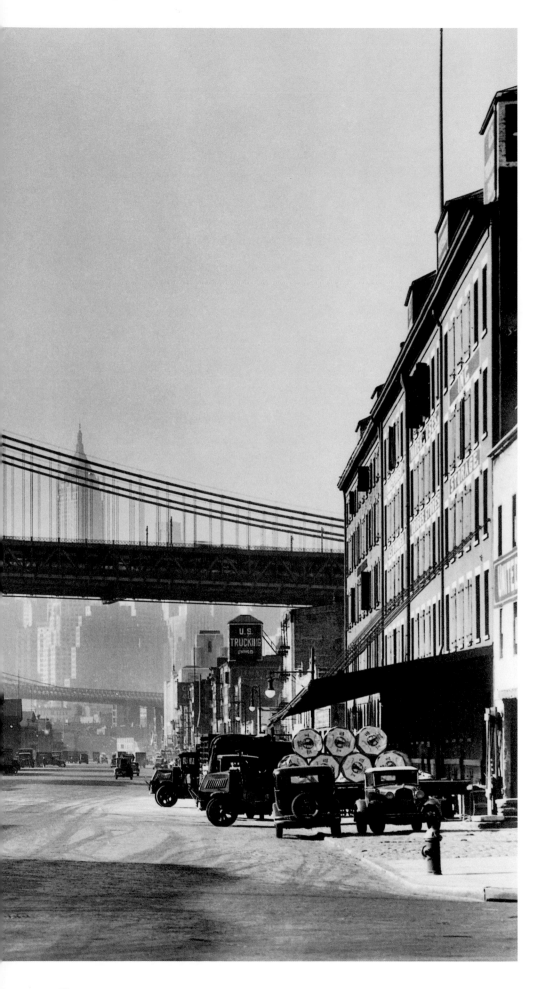

South Street under the
Manhattan Bridge, 1933

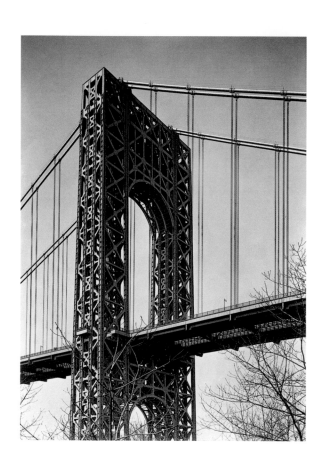 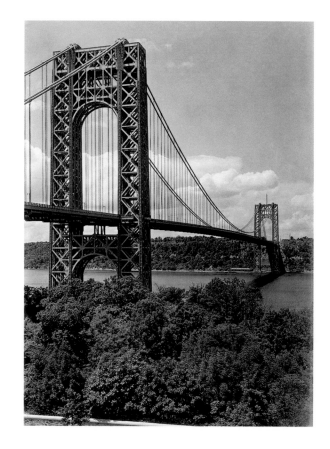

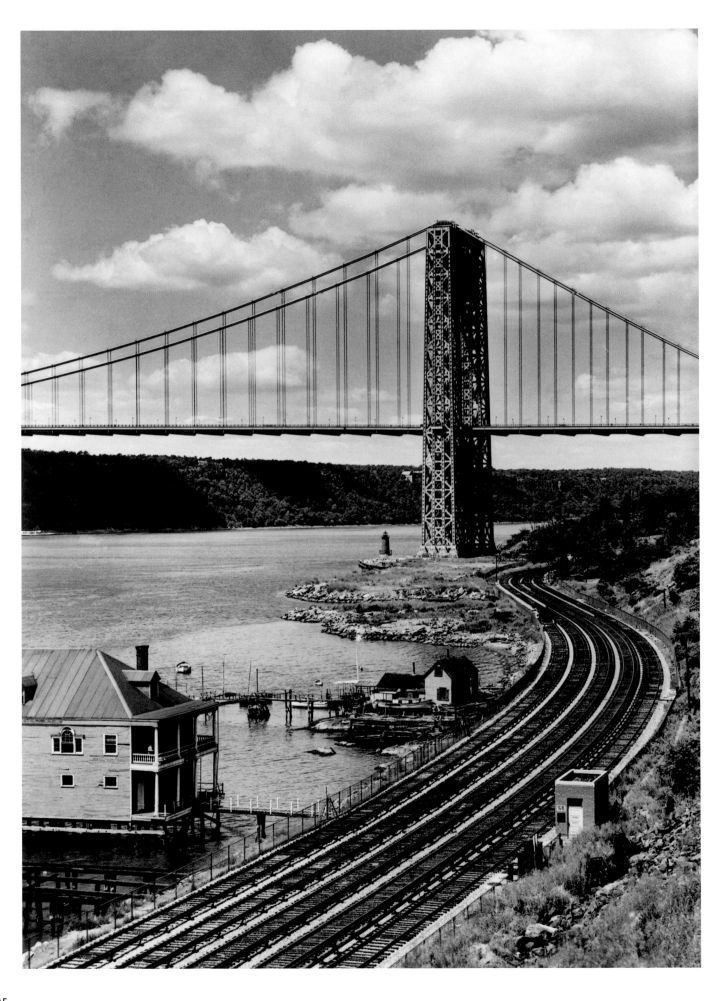

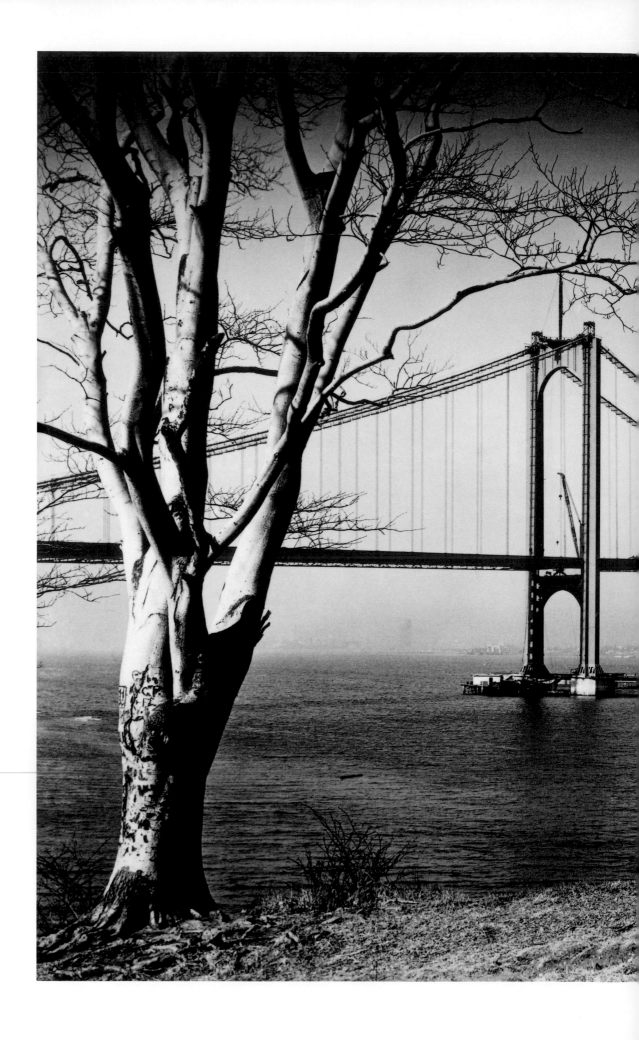

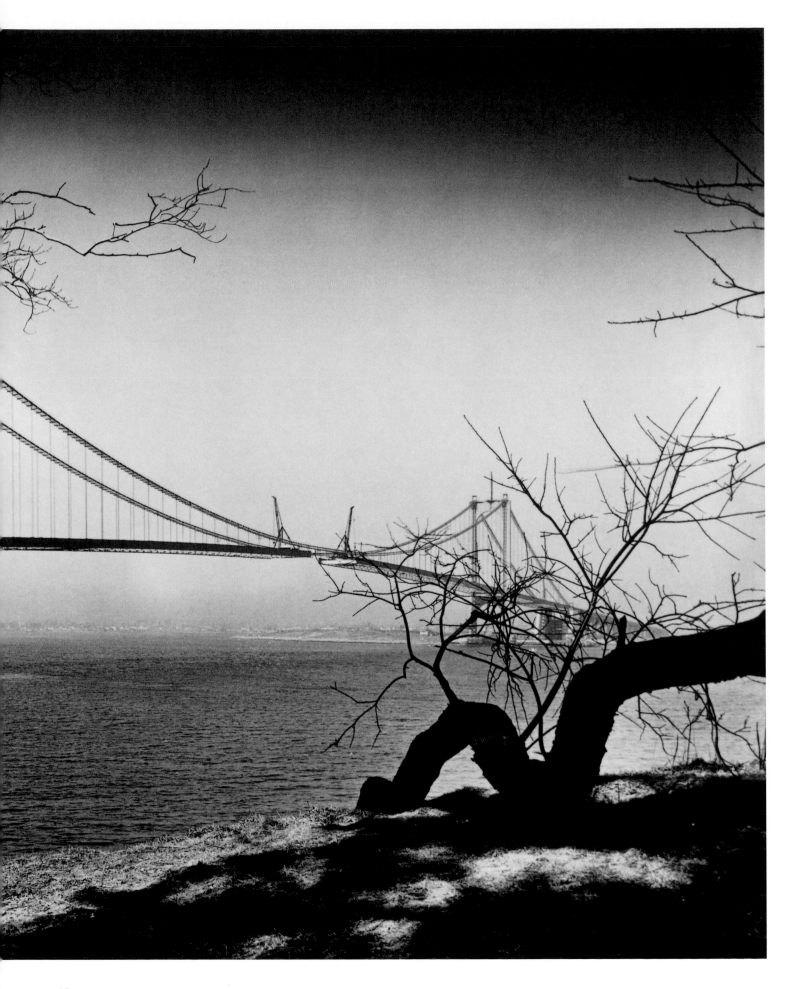

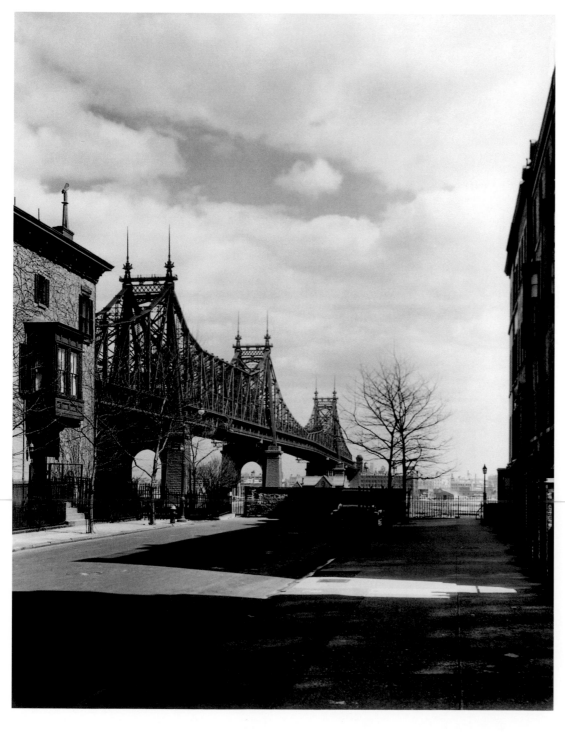

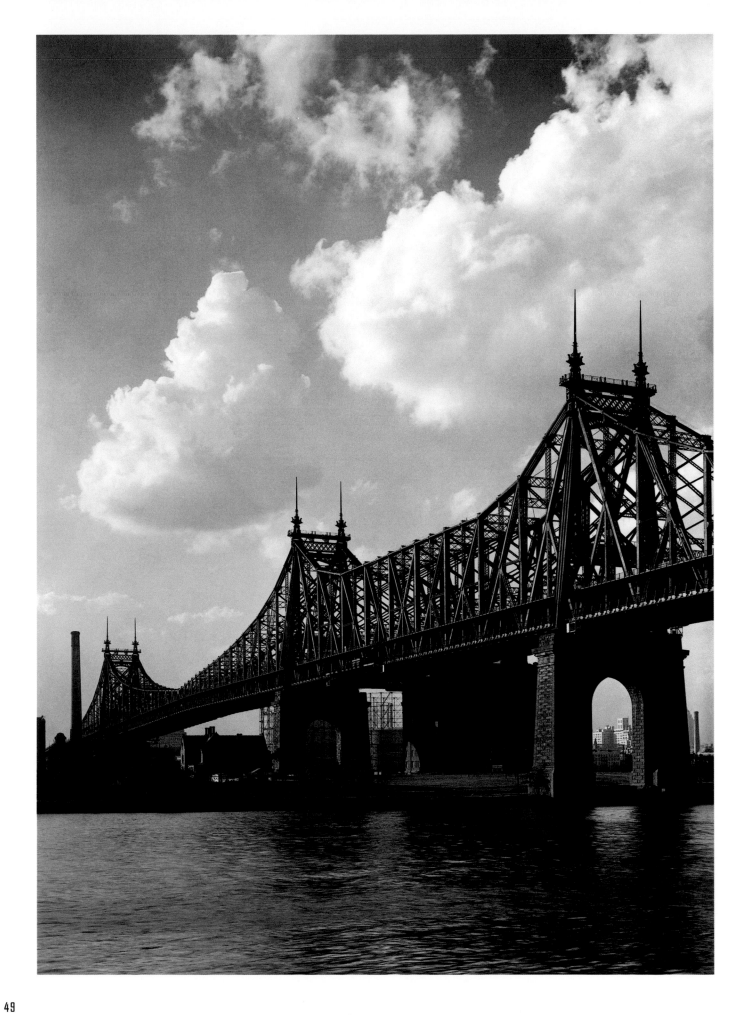

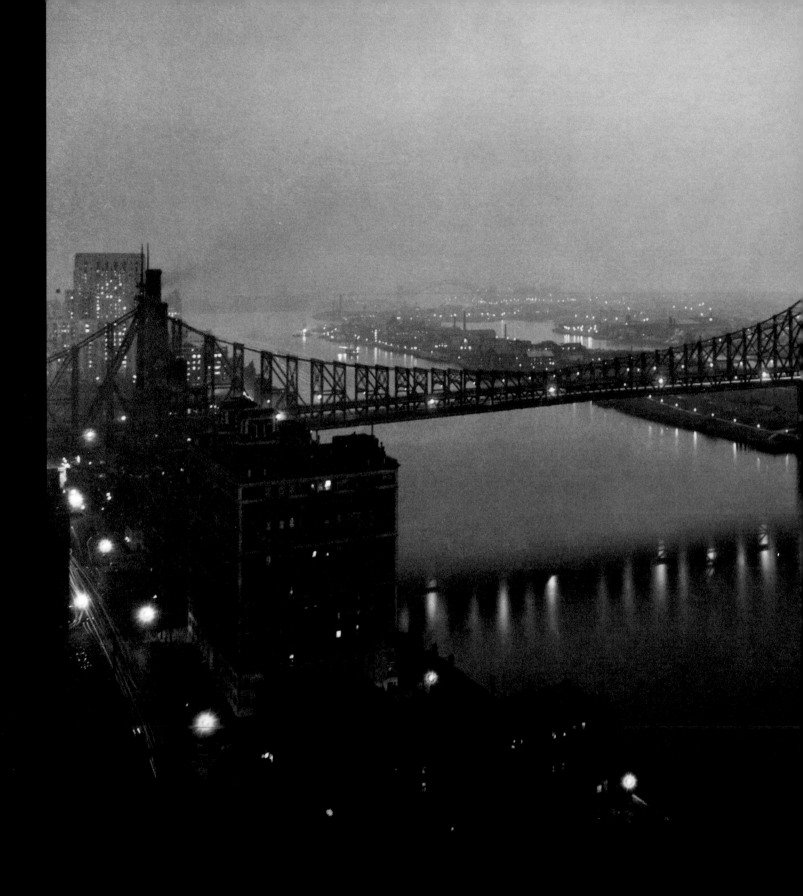

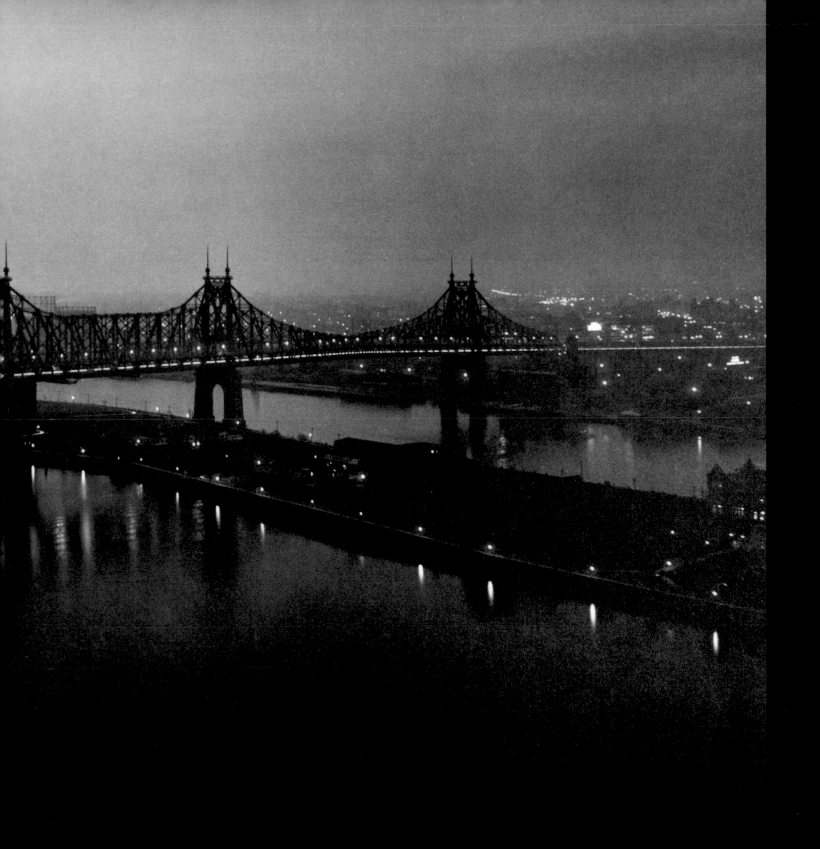

Queensboro Bridge from
Manhattan, 1932

THE

NOCTURNAL CITY

OF

POPULAR CULTURE: TIMES SQUARE

BELOW:
View looking south from
Forty-eighth Street, 1932

OPPOSITE:
RKO Mayfair and Palace
Theatres, 1930

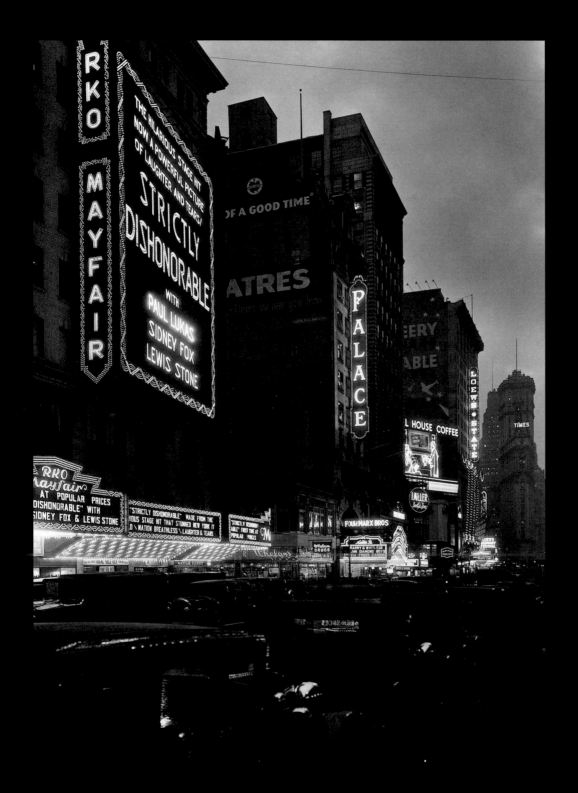

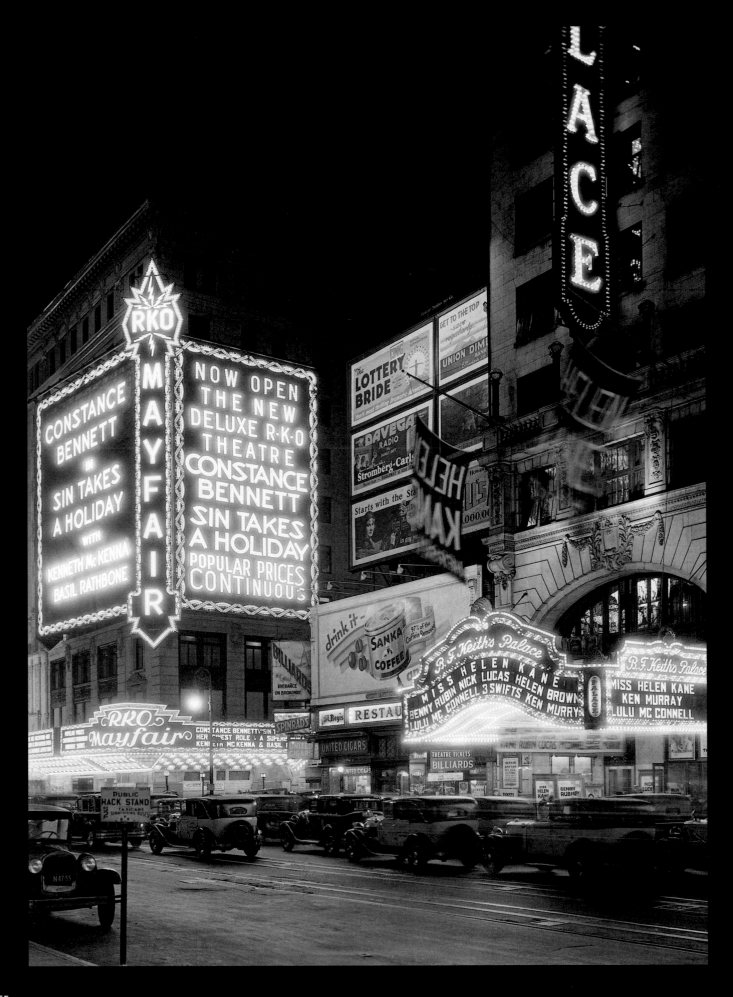

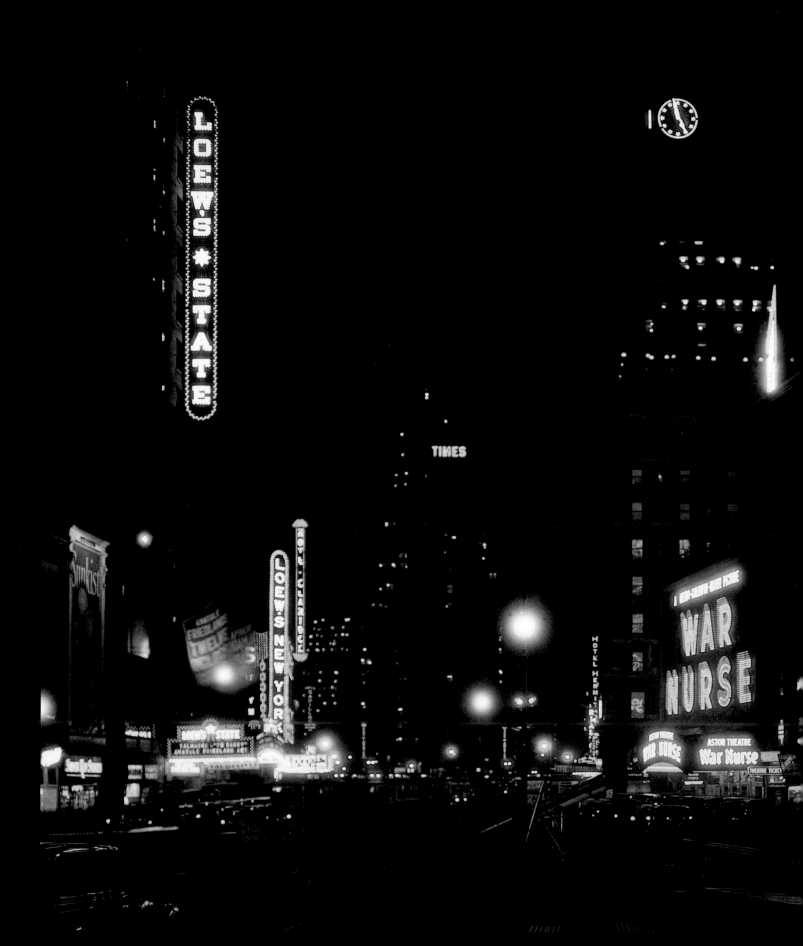

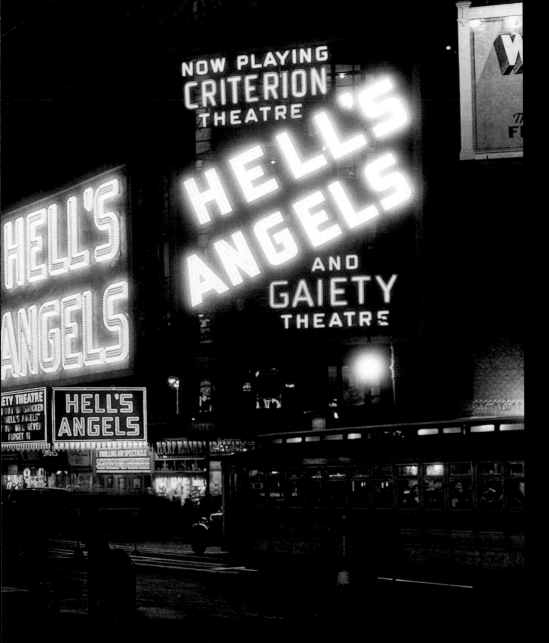

View looking south toward
the New York Times Building,
1930

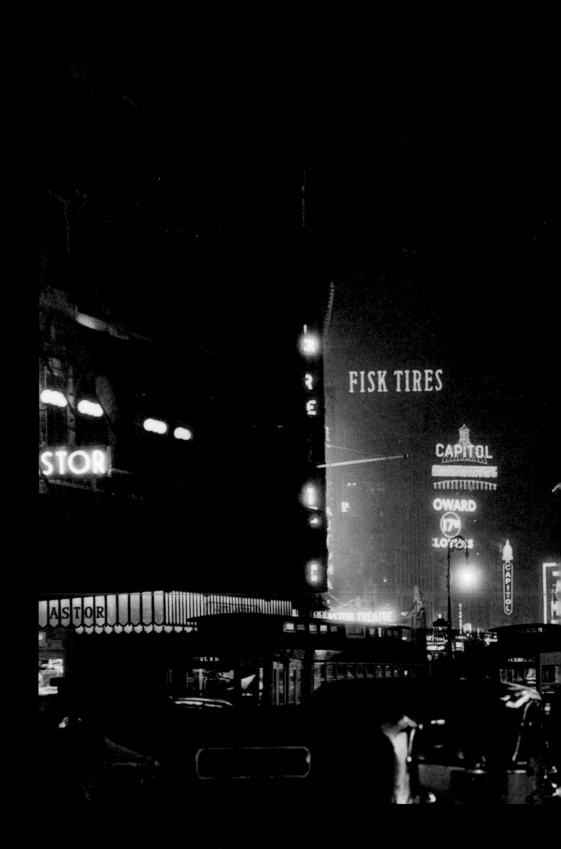

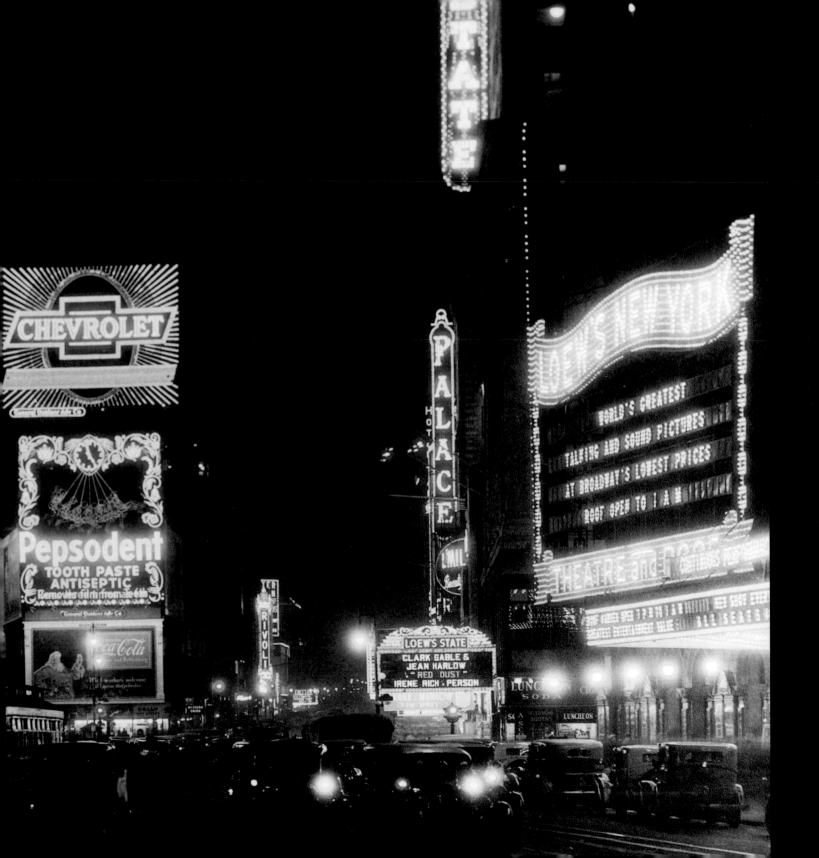

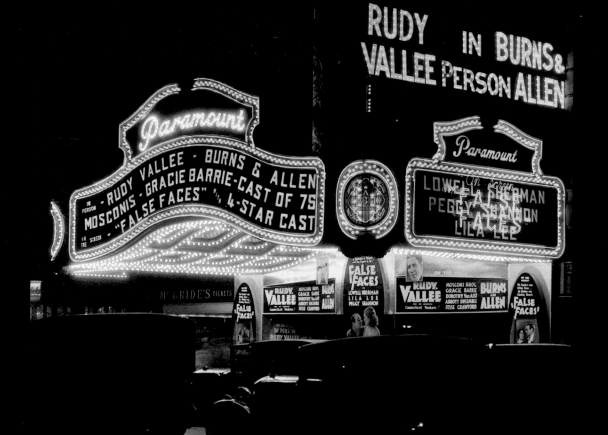

ABOVE:
Paramount Theater, 1932

OPPOSITE:
View looking down toward
Times Square from the
Continental Building, 1932

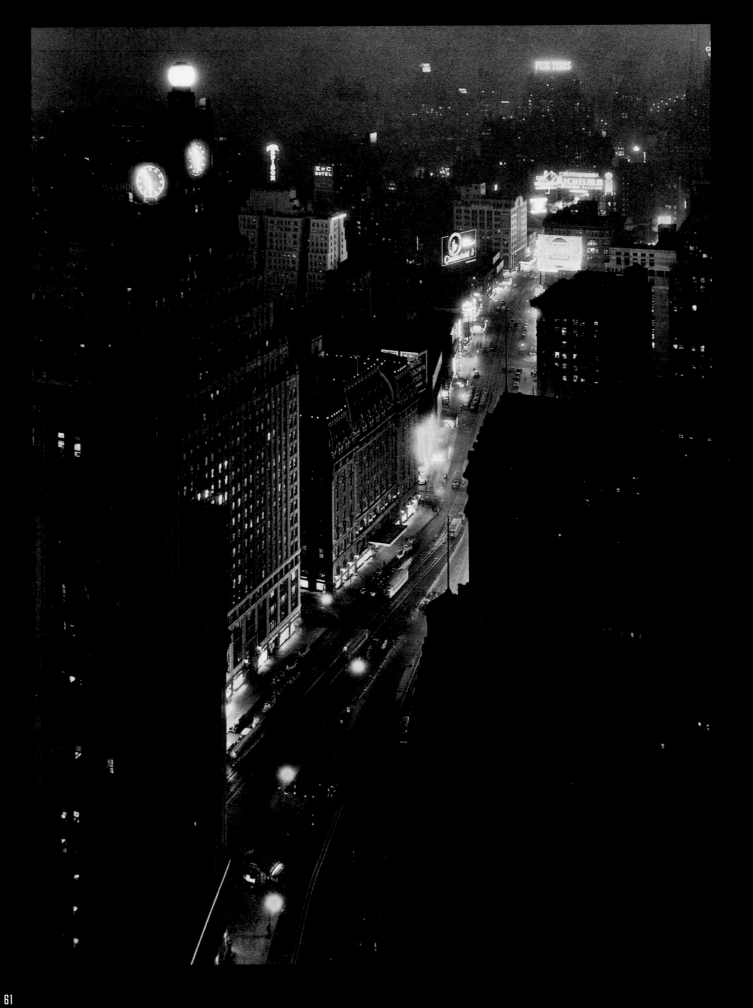

THE CITY OF BUSINESS

View looking south through the rooftop loggia of the Barbizon Hotel, 1932

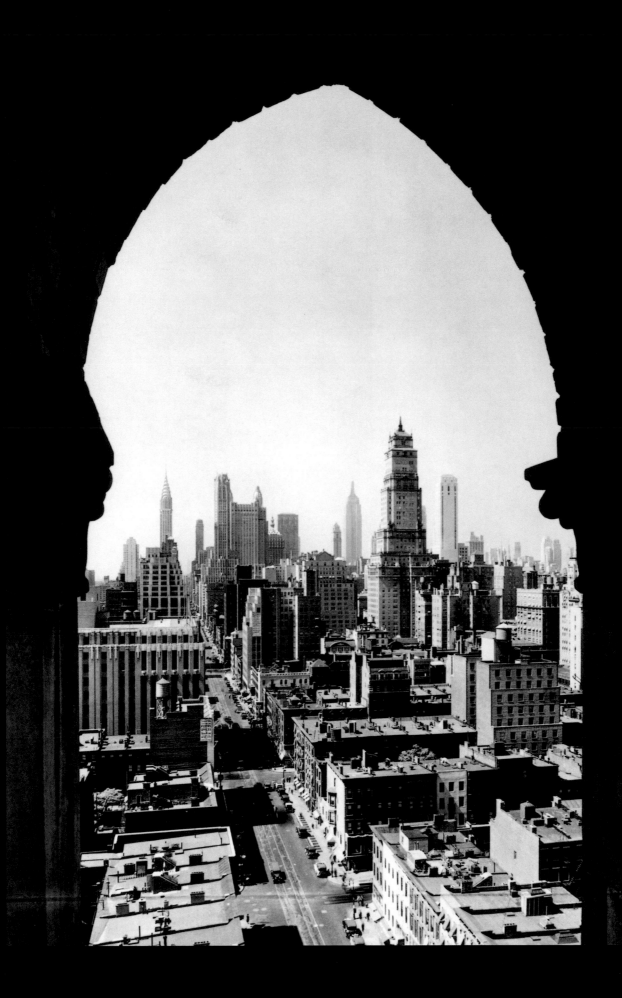

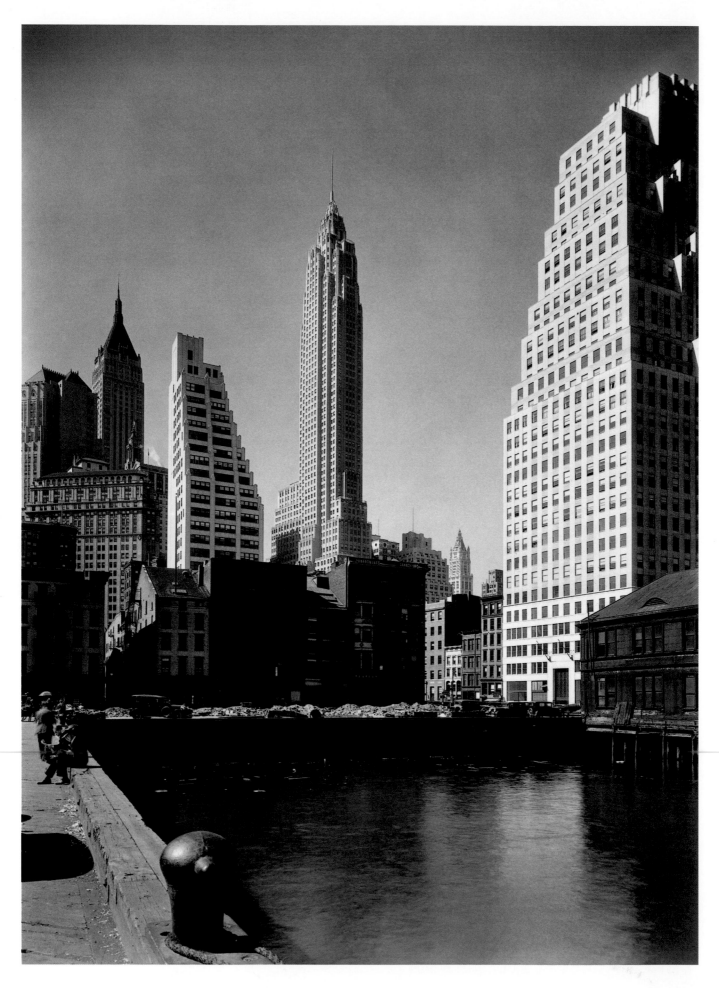

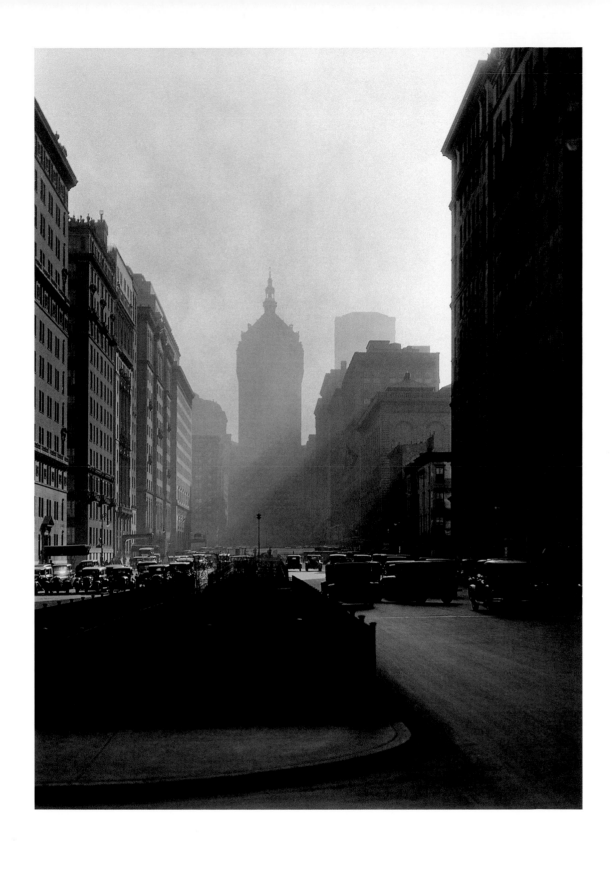

Financial District from
Pier 10, 1932

Park Avenue looking south
from Fifty-sixth Street with
New York Central Railroad
Building, 1930

Gottscho dutifully noted
in his photography log that
he took this picture at
3:30 p.m., precisely when
the setting February sun
created these dramatic
light-and-shadow effects.

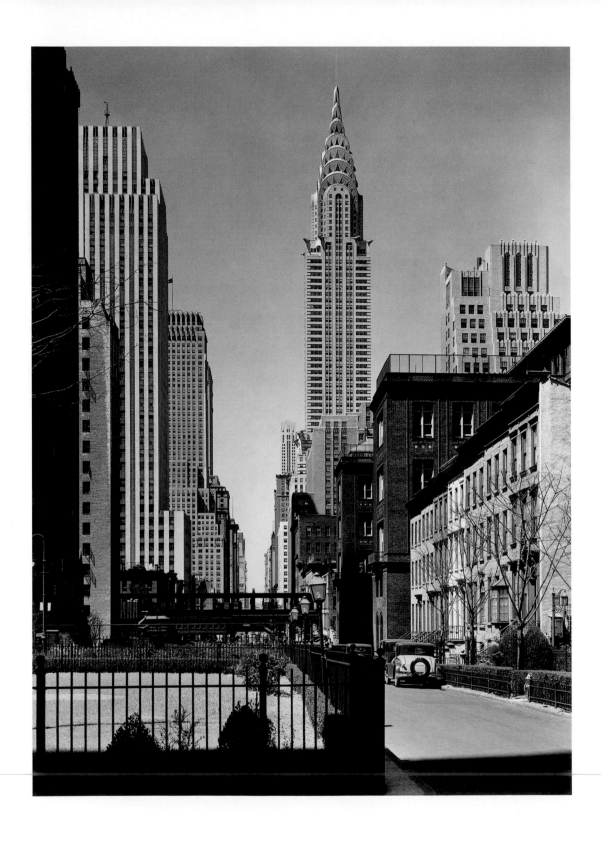

View down Forty-second Street
from Tudor City with Chrysler
Building, 1932

View of the Financial District
under elevated railroad at
Coenties Slip with Irving Trust
Building (center), 1932

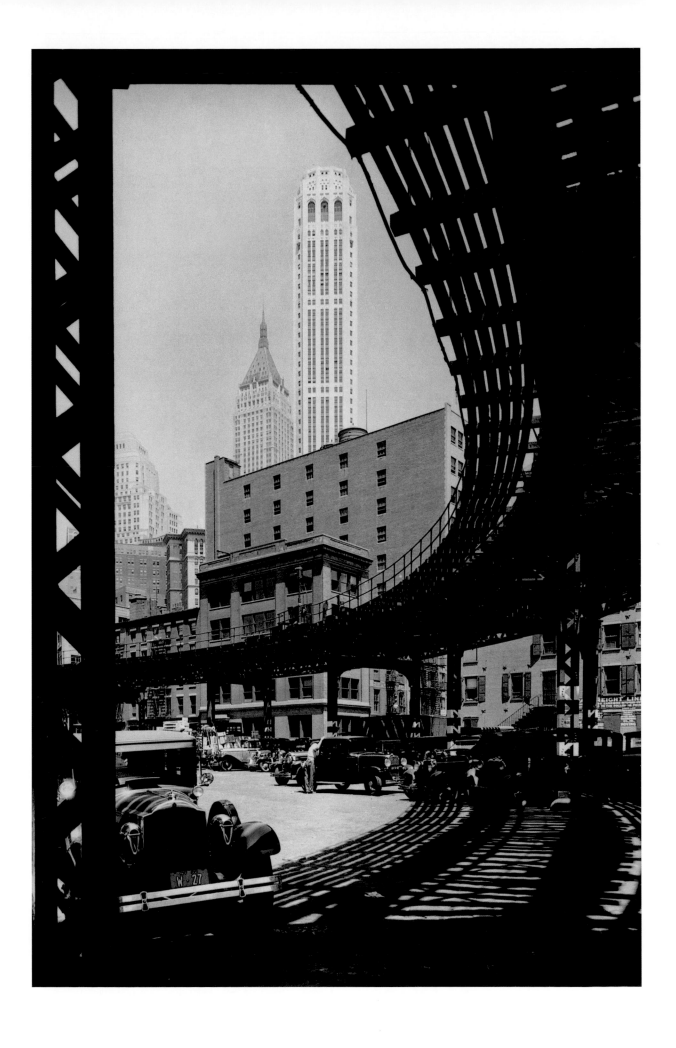

McGraw-Hill Building,
330 West Forty-second Street,
1931
Raymond Hood, Godley, and
Fouilhoux, Architects

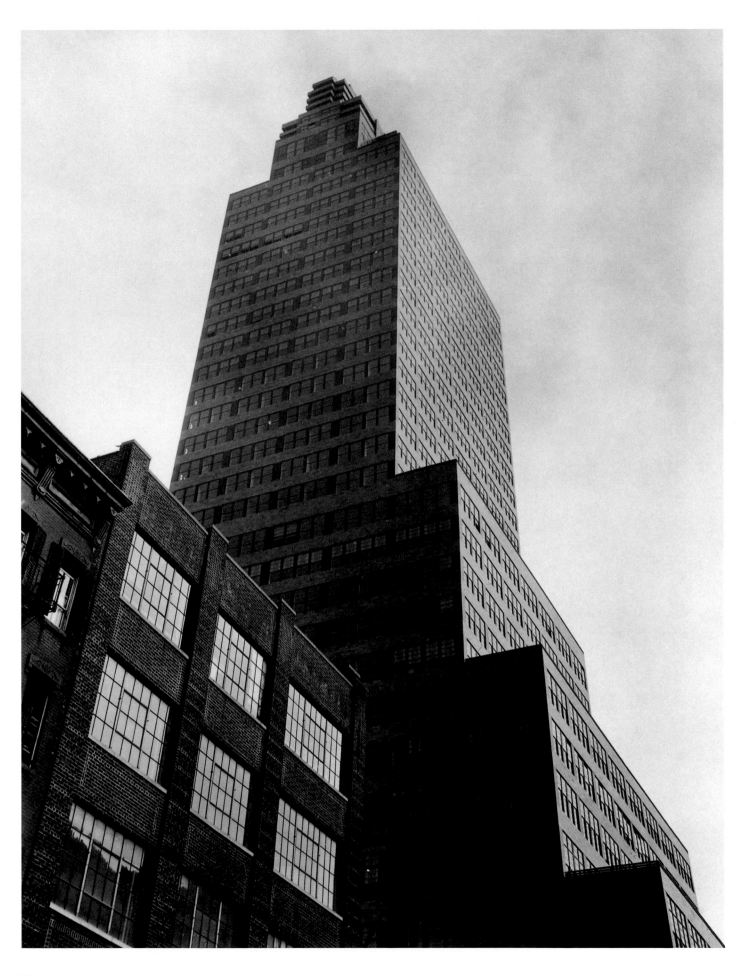

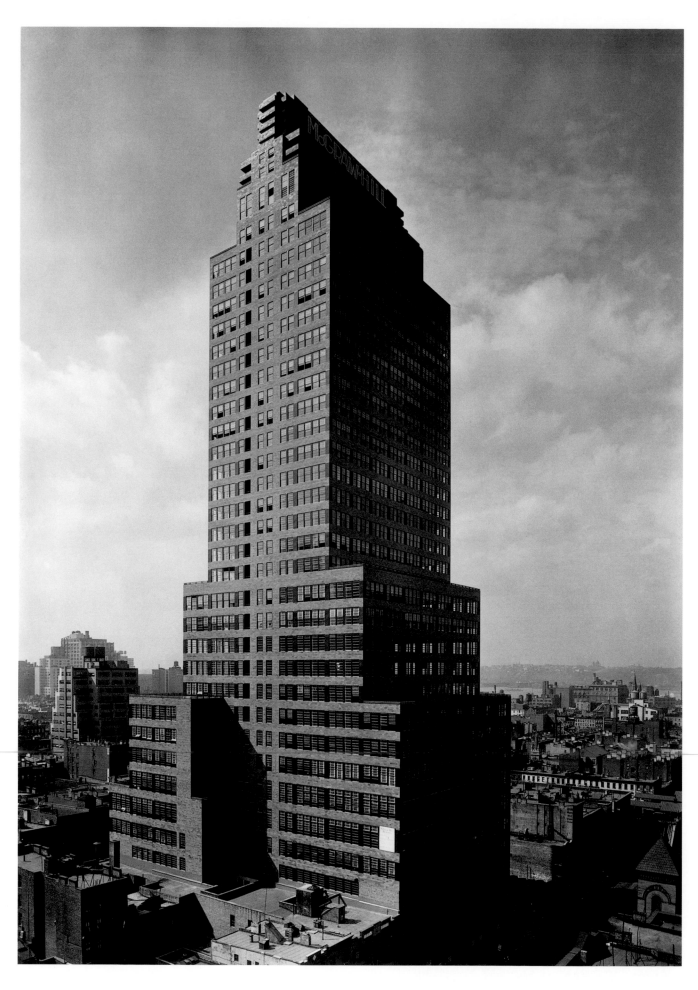

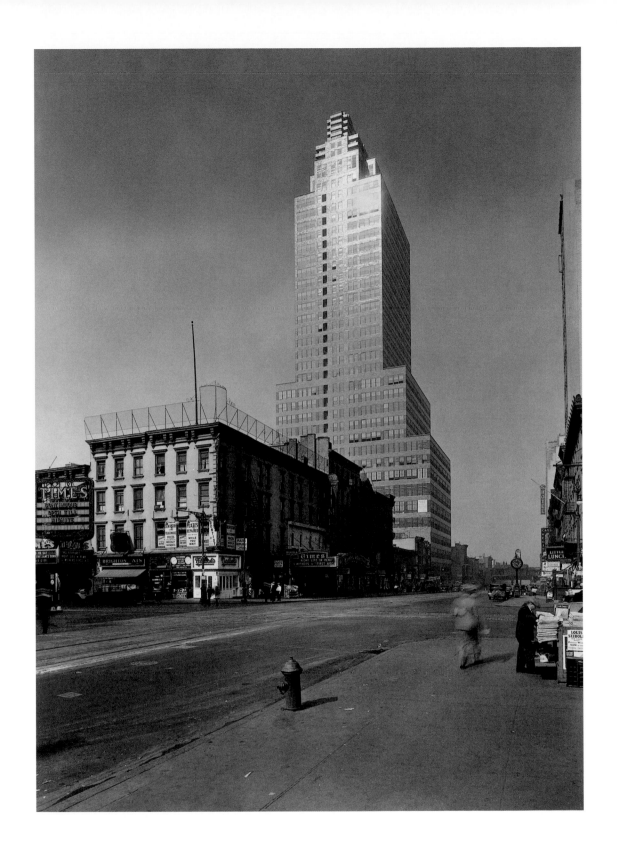

McGraw-Hill Building, 1931

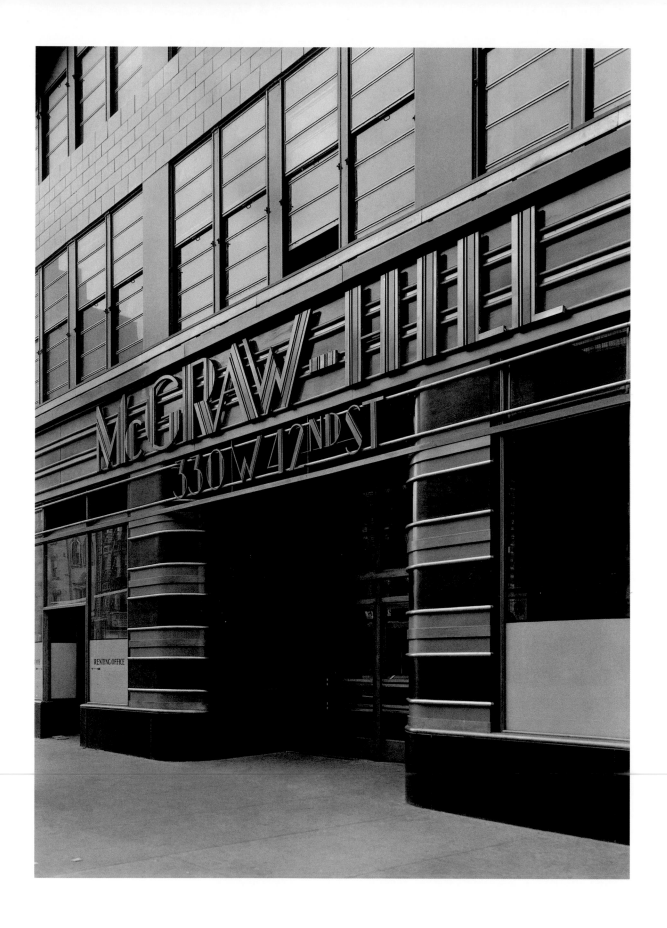

Entrance of McGraw-Hill
Building, 1931

Lobby of McGraw-Hill
Building, 1931

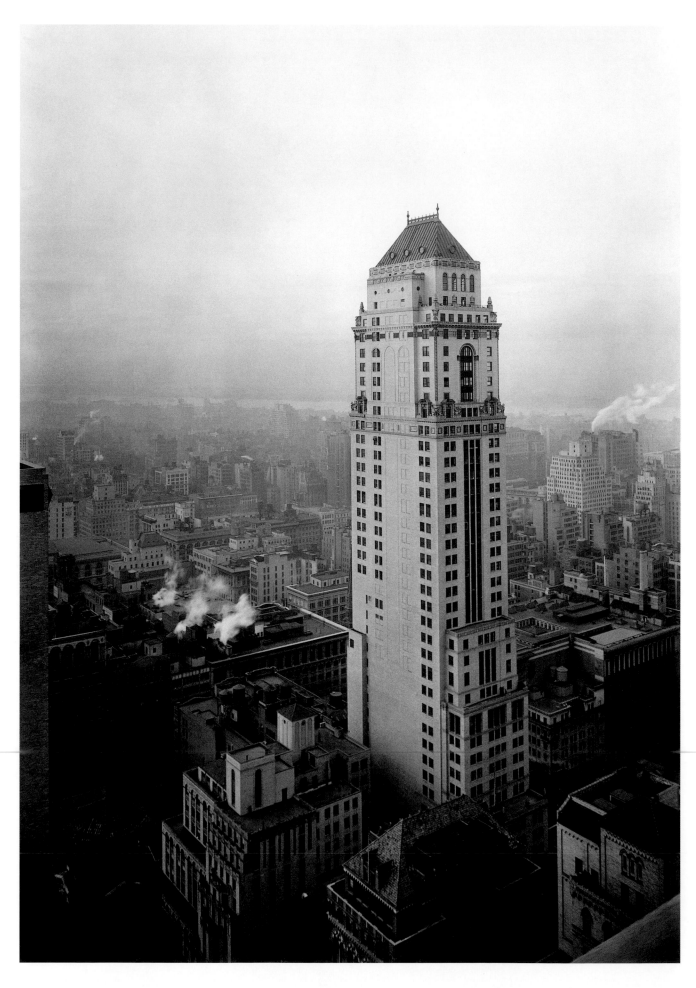

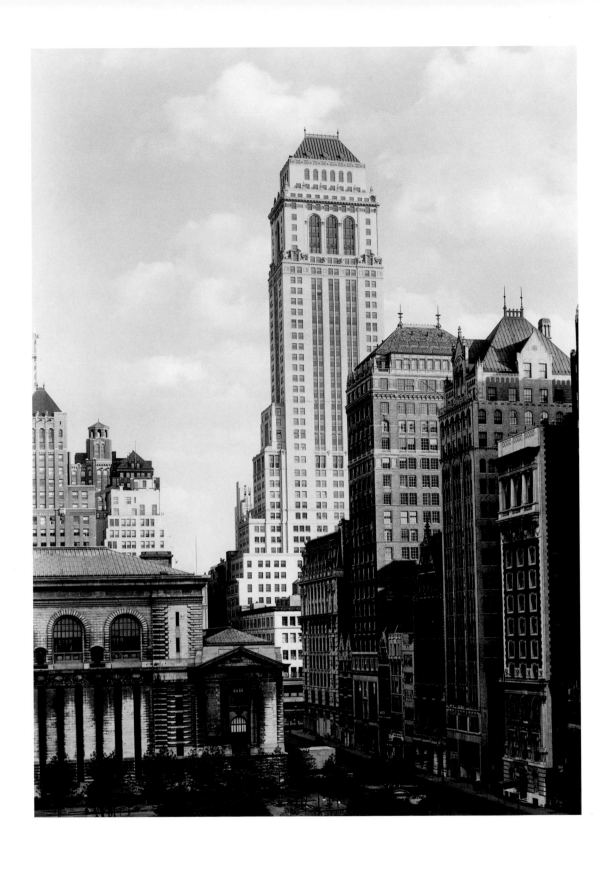

OPPOSITE:
10 East Fortieth Street
Building taken from the
Lincoln Building, 1930
Ludlow and Peabody,
Architects

ABOVE:
10 East Fortieth Street
Building, 1929

75

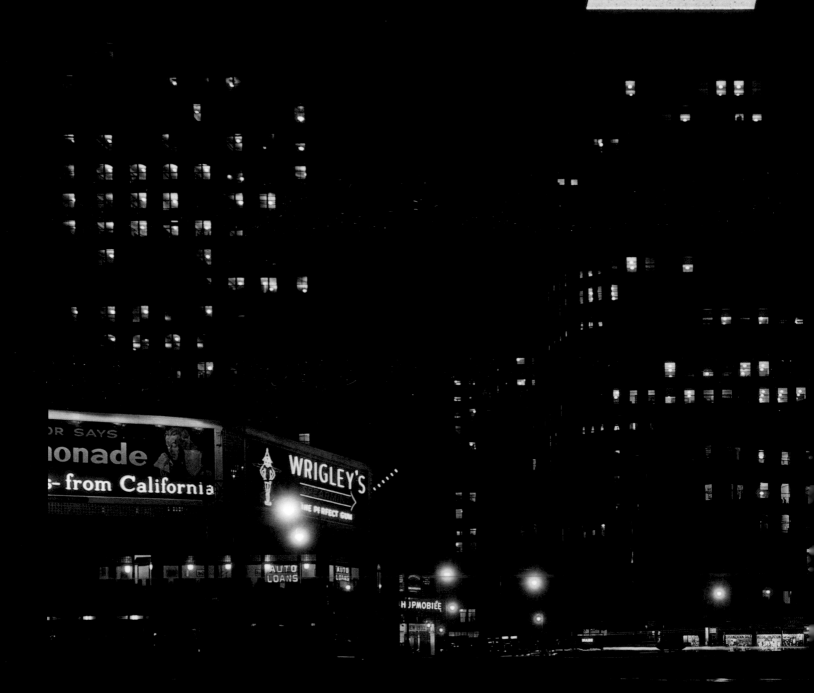

Columbus Circle with General
Motors Building taken from
Central Park, 1932

THE CITY WITHIN THE CITY: ROCKEFELLER CENTER

Rockefeller Center under
construction, 1932
Associated Architects

Gottscho's close relationship
with Raymond Hood, one
of the primary architects of
Rockefeller Center from whom
he received many commissions
before World War II, offered
Gottscho unusual access to
the Center's buildings
and interiors. Claiming to
be the Center's unofficial
photographer, he documented
it from its construction in
the spring of 1932 through
the completion of various
tenant spaces at the end of
the decade.

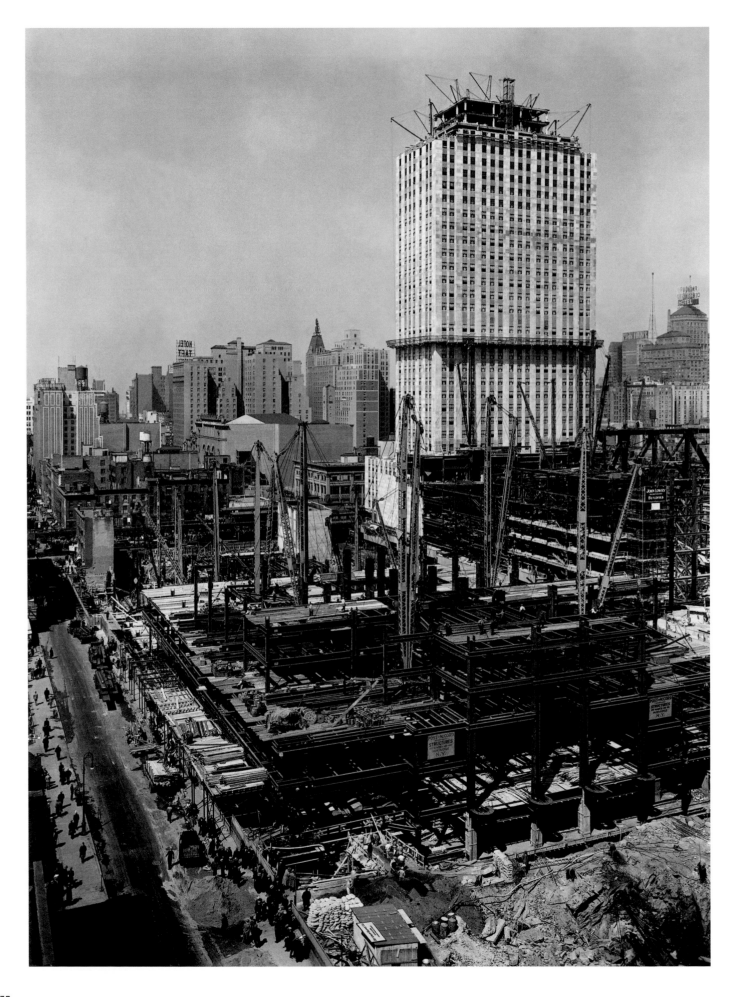

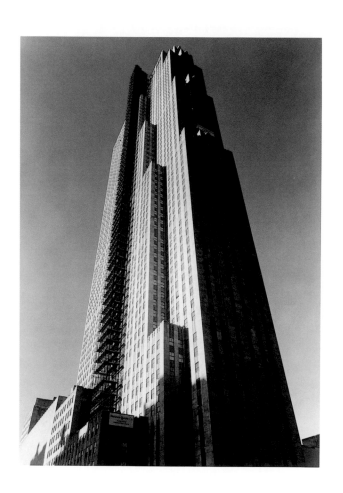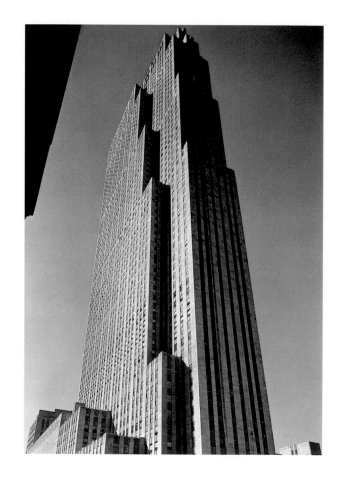

30 Rockefeller Plaza, 1933
Associated Architects

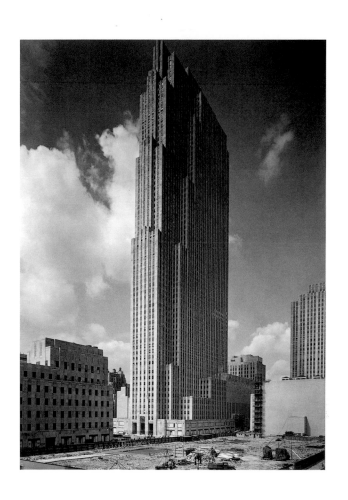

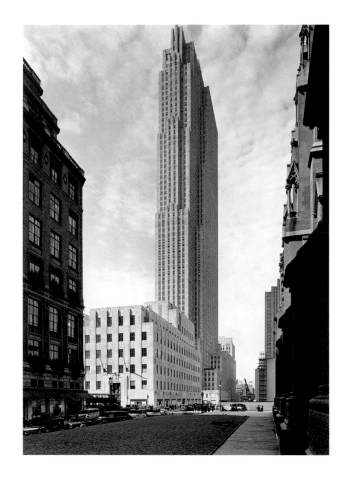

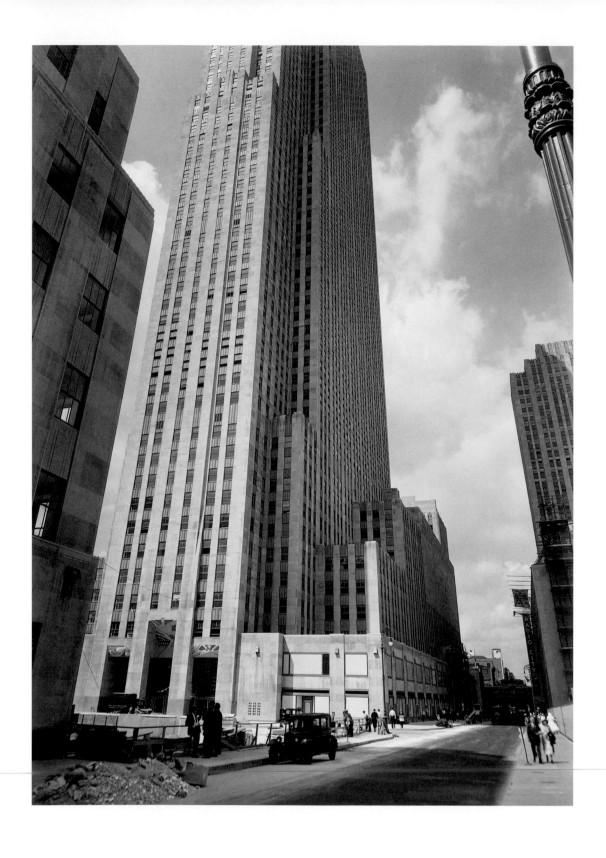

30 Rockefeller Plaza under
construction, 1933

30 Rockefeller Plaza, 1933

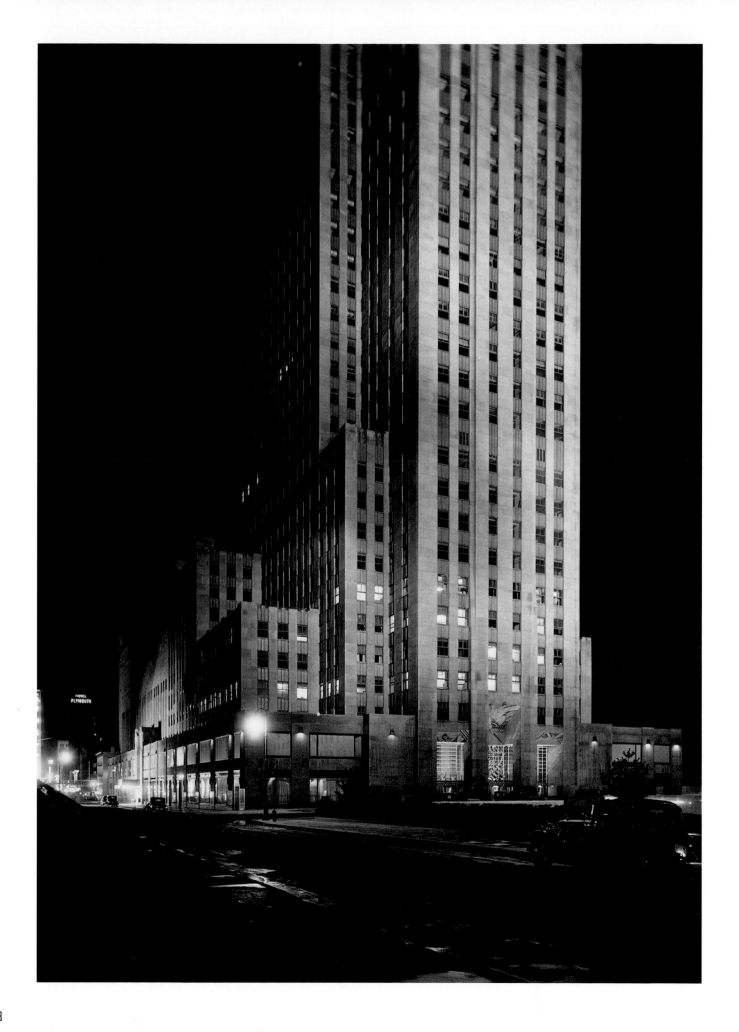

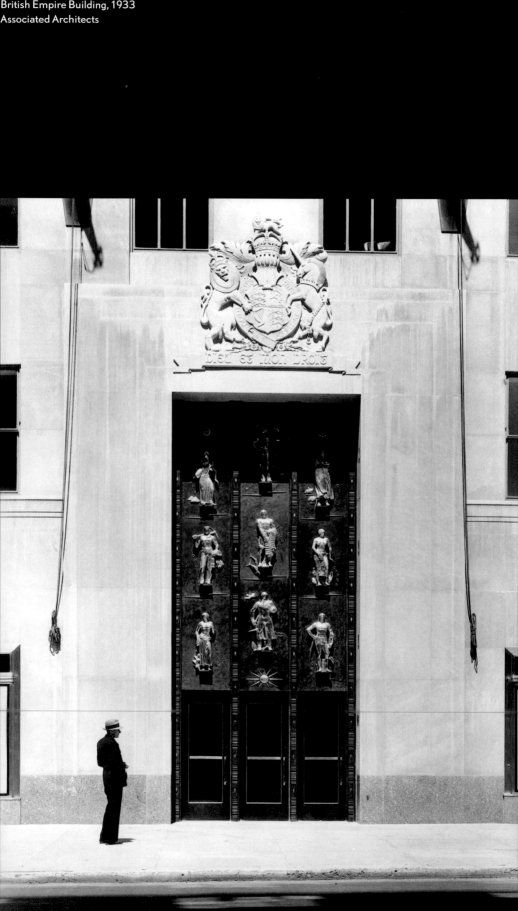

British Empire Building, 1933
Associated Architects

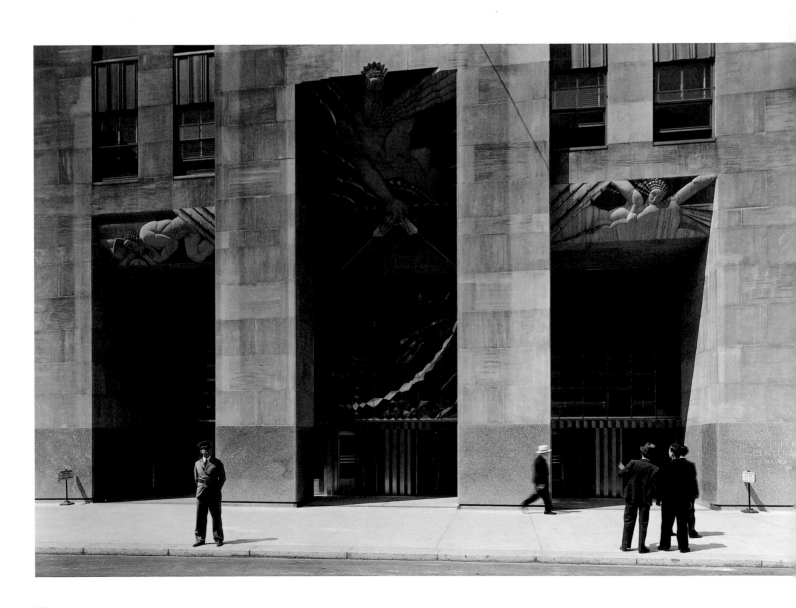

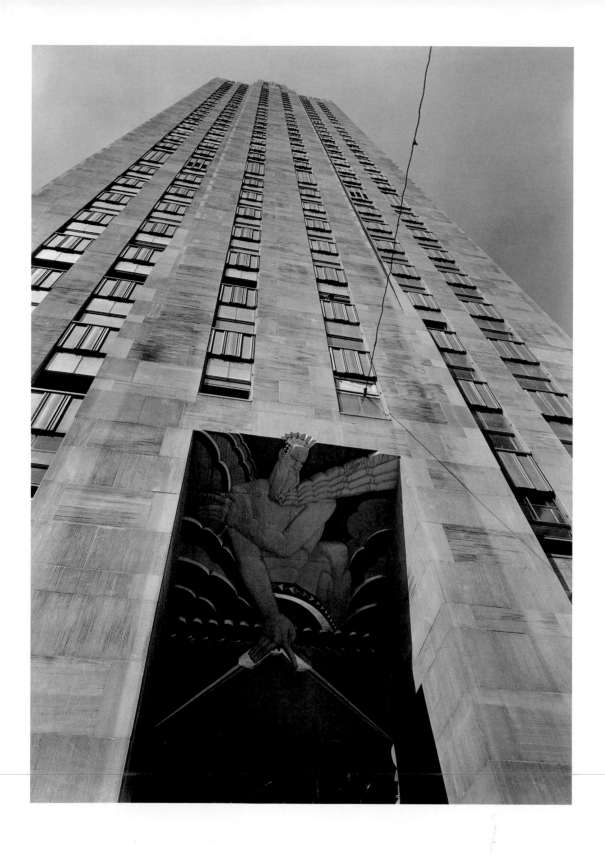

Main entrance of
30 Rockefeller Plaza,
1933

Sixth Avenue entrance of
30 Rockefeller Plaza, 1933

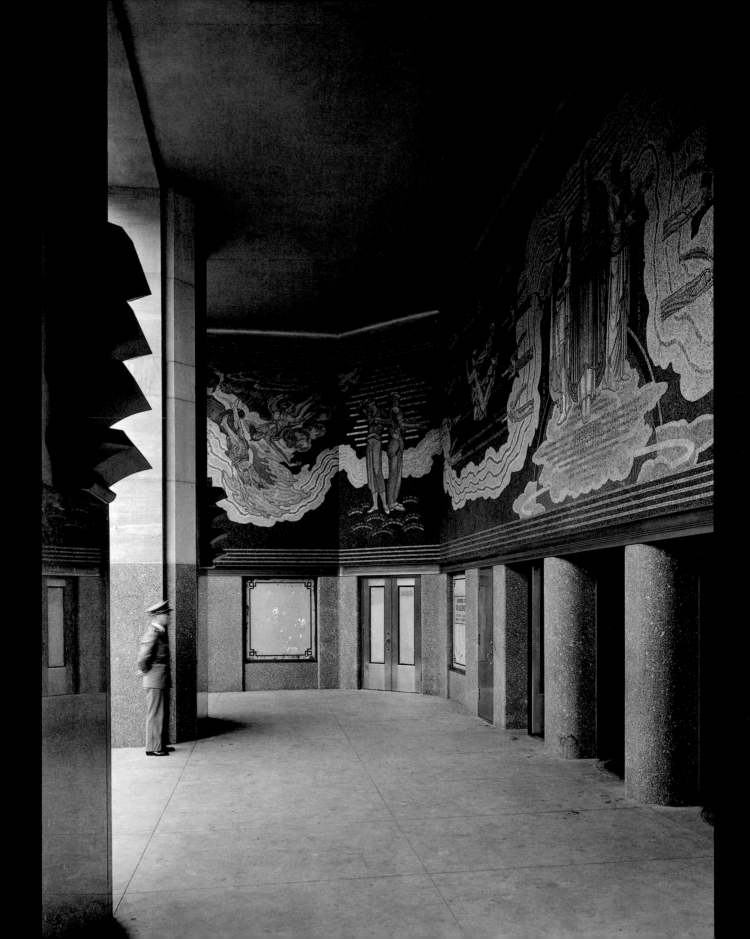

Views of a City Garden Club exhibition and the fountain in front of 30 Rockefeller Plaza, 1934

As depicted in Gottscho's images of the Garden Club's geometrically shaped planting beds, Rockefeller Center offered visual delight not only to pedestrians, but also to workers in the surrounding office towers. The aerial view was taken from the Center's British Empire Building.

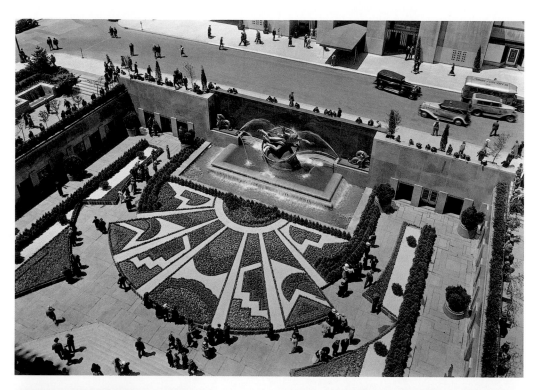

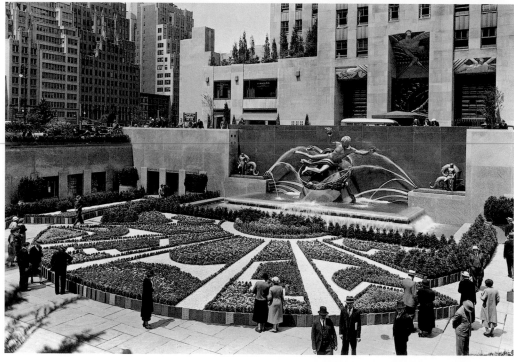

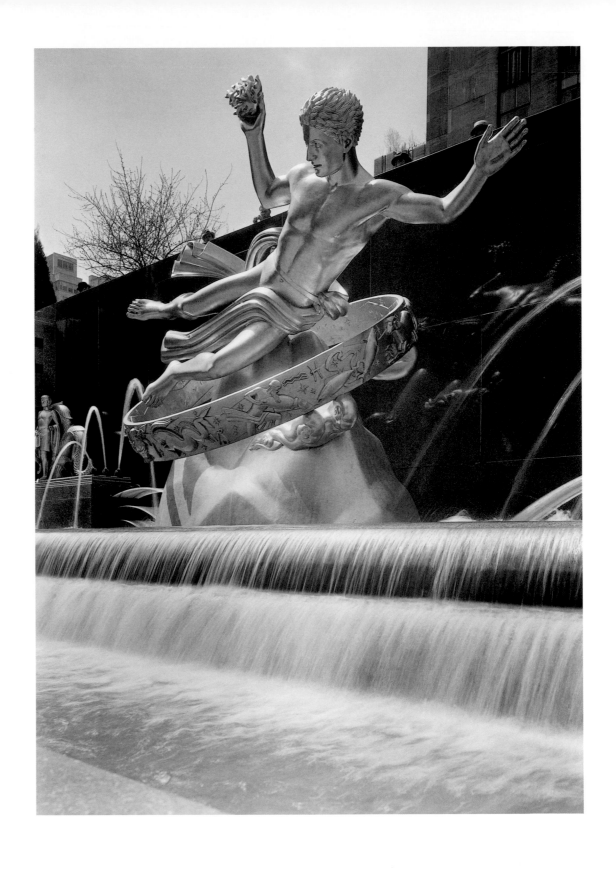

Statue of Prometheus and
fountain, 1934
Paul Manship, Sculptor

30 Rockefeller Plaza framed
by British Empire Building
(right) and La Maison
Française, 1933

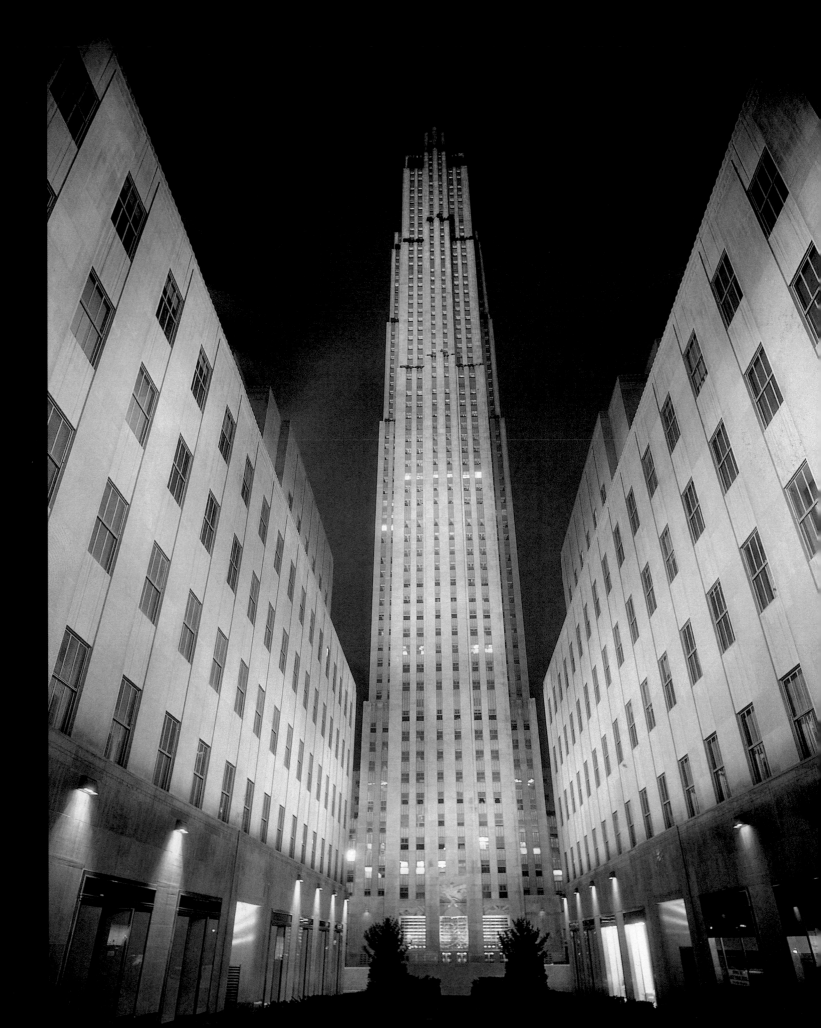

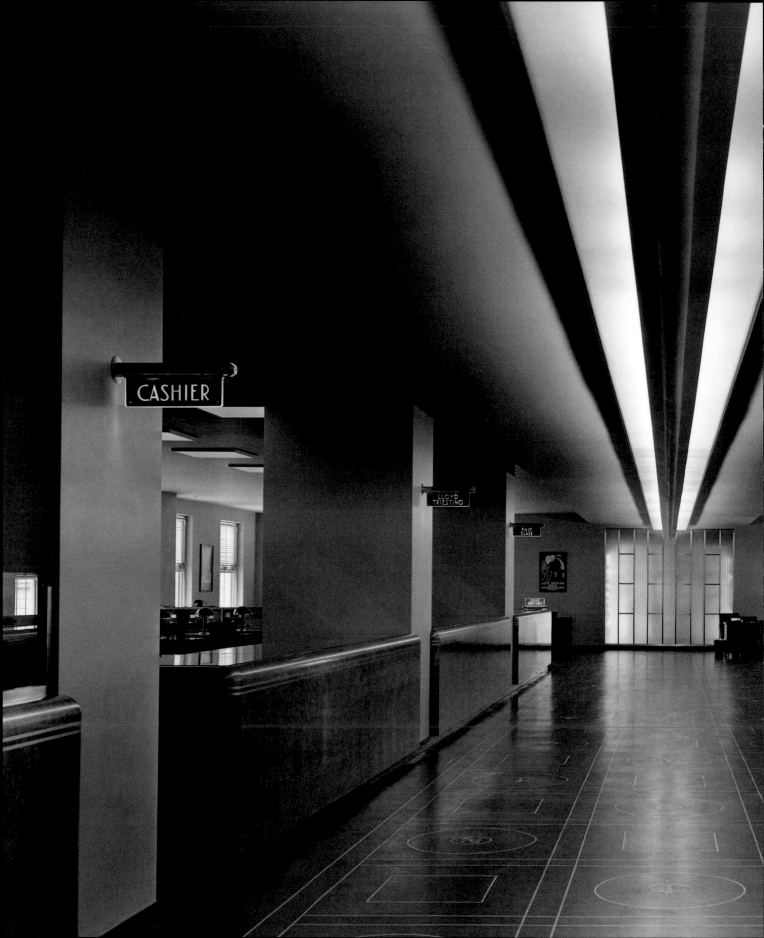

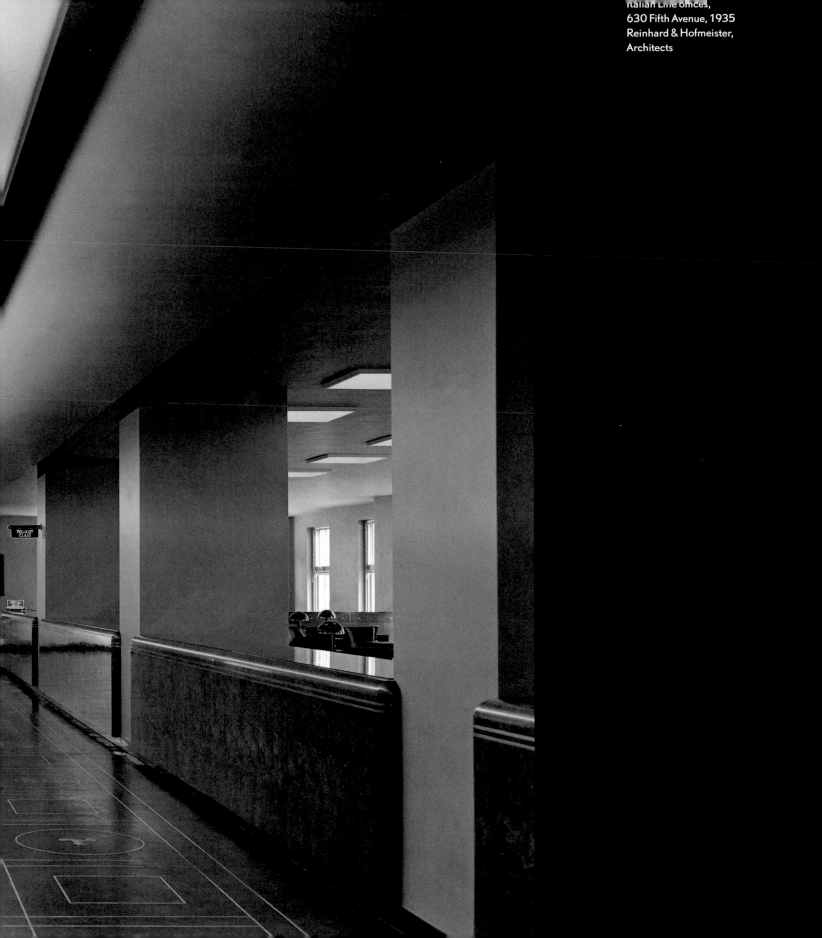

Italian Line offices,
630 Fifth Avenue, 1935
Reinhard & Hofmeister,
Architects

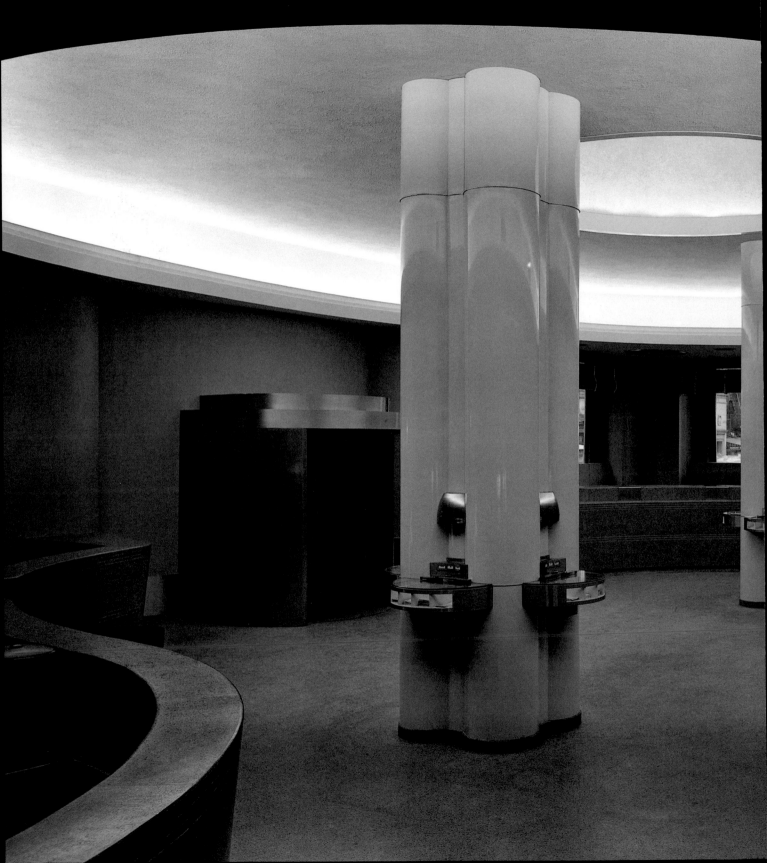

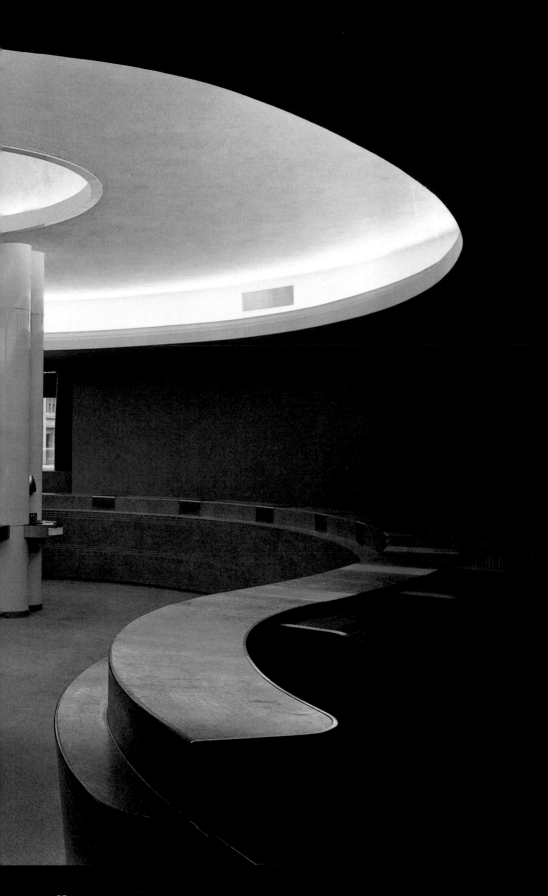

Interior of Chase National
Bank, 9 Rockefeller Plaza,
1937
Reinhard & Hofmeister,
Architects

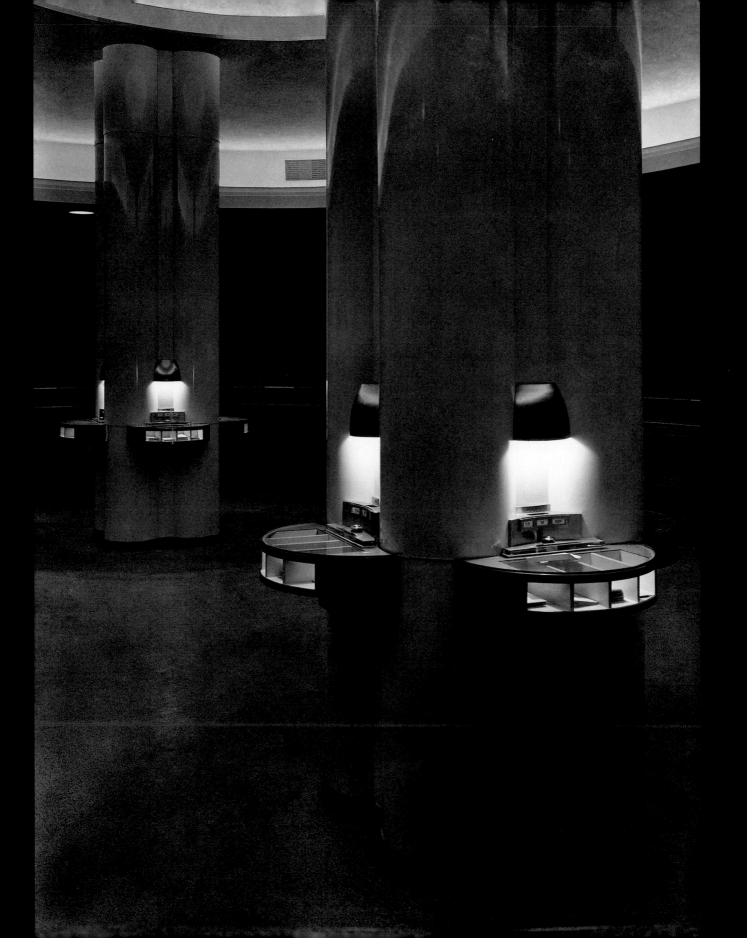

Entrance of
Chase National Bank,
1937

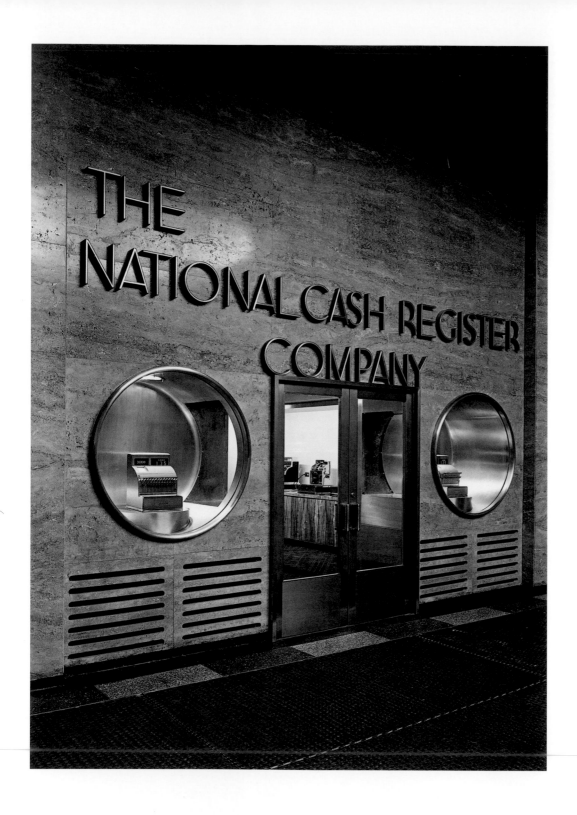

Lobby entrance
(with detail of display
window at right) of the
National Cash Register
Company showroom and
offices, Associated Press
Building, 1938
Reinhard & Hofmeister,
Architects

The company's showroom and
offices were located on the
ground and second floors of
the Center's Associated Press
Building and could be entered
from the street or the interior
lobby shown here. Gottscho's
superb manipulation of light
converted the cash registers
in circular display niches into
works of consumer art.

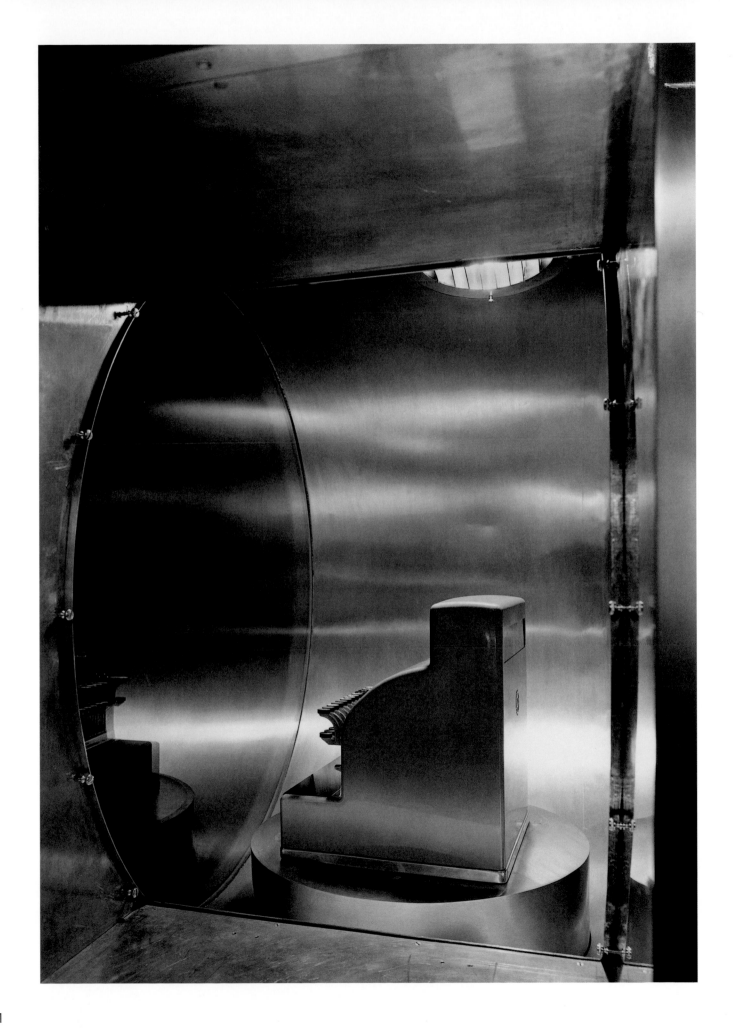

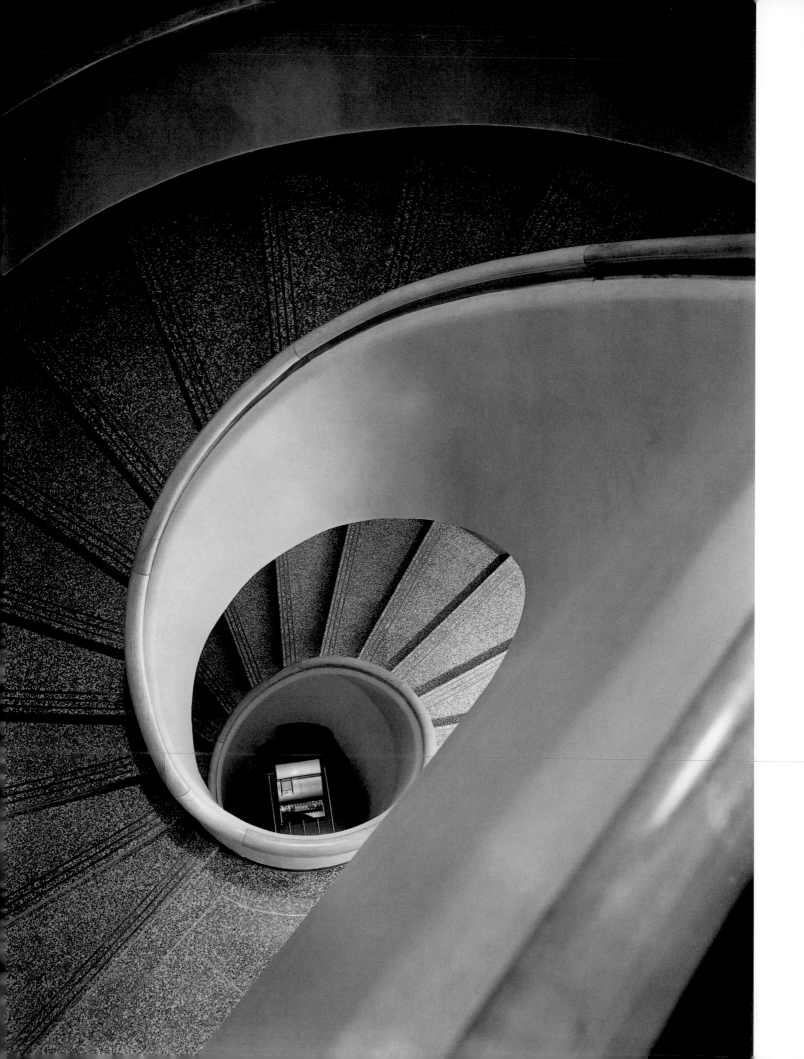

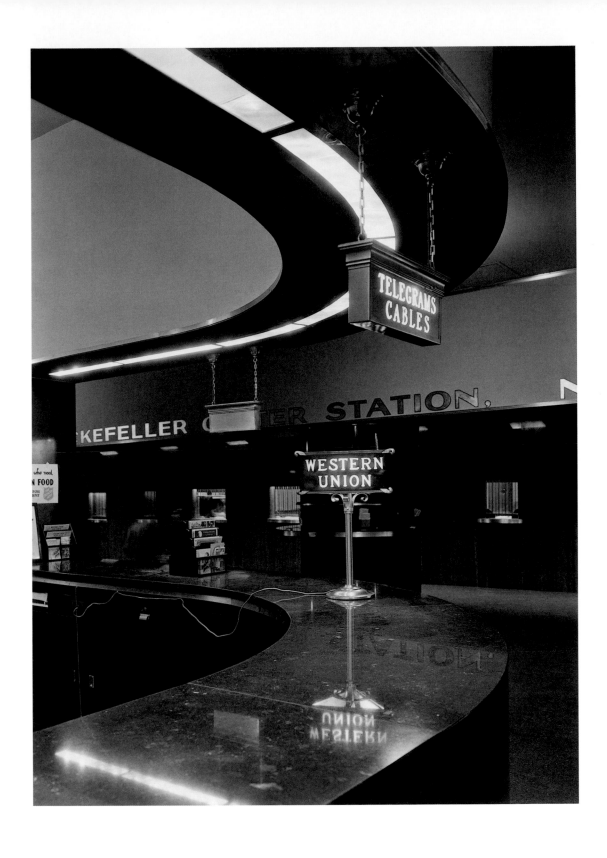

Stairway in the National Cash
Register Company showroom
and office, 1939

Western Union Telegraph
office, 30 Rockefeller Plaza,
1934

Rainbow Room lounge at the
top of 30 Rockefeller Plaza,
1934

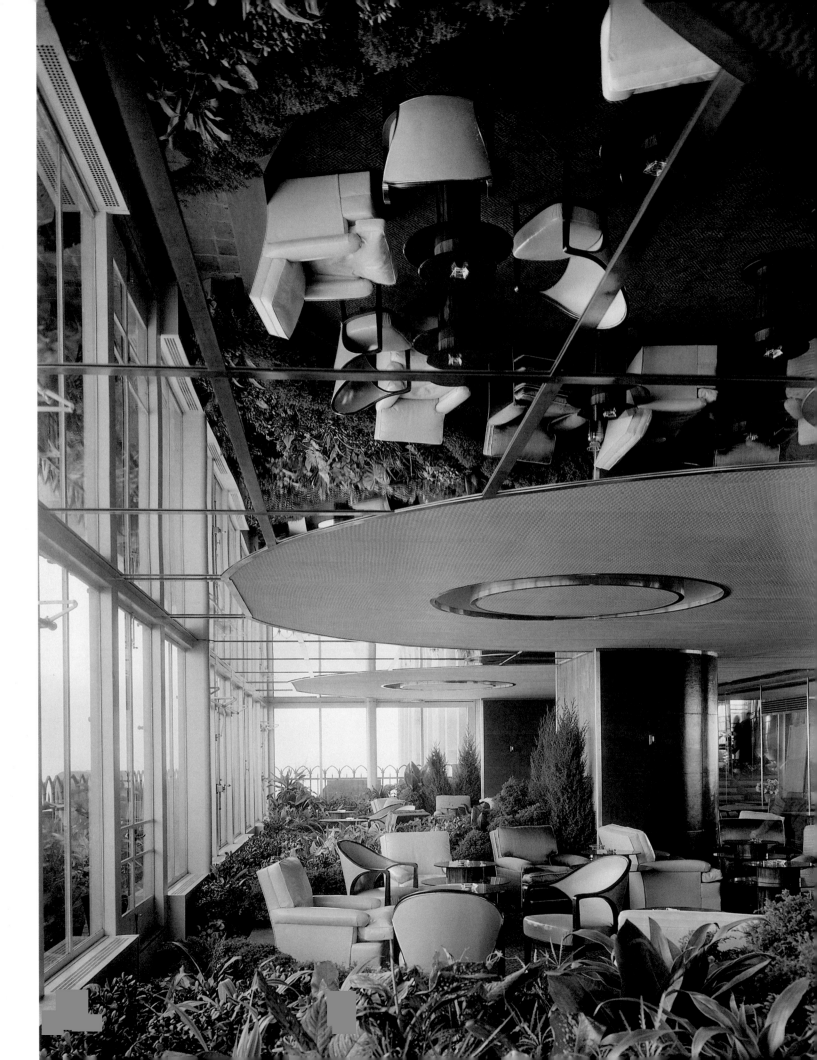

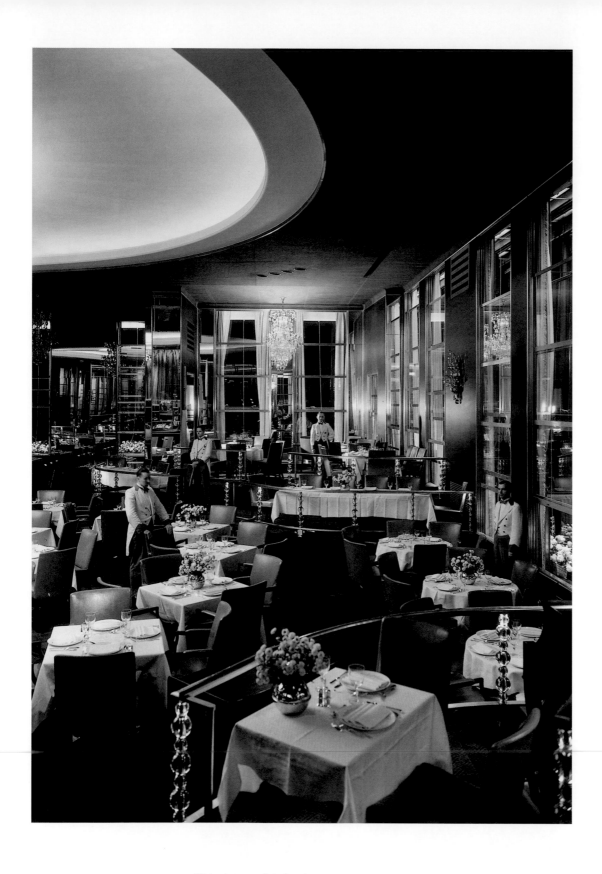

This photograph is dated
September 24 in Gottscho's
photography log book,
suggesting that he and his
camera gained special entrée
into the exclusive club,
which did not officially open
until about a week later.

Rainbow Room, 1934
Elena Schmidt, Interior
Designer

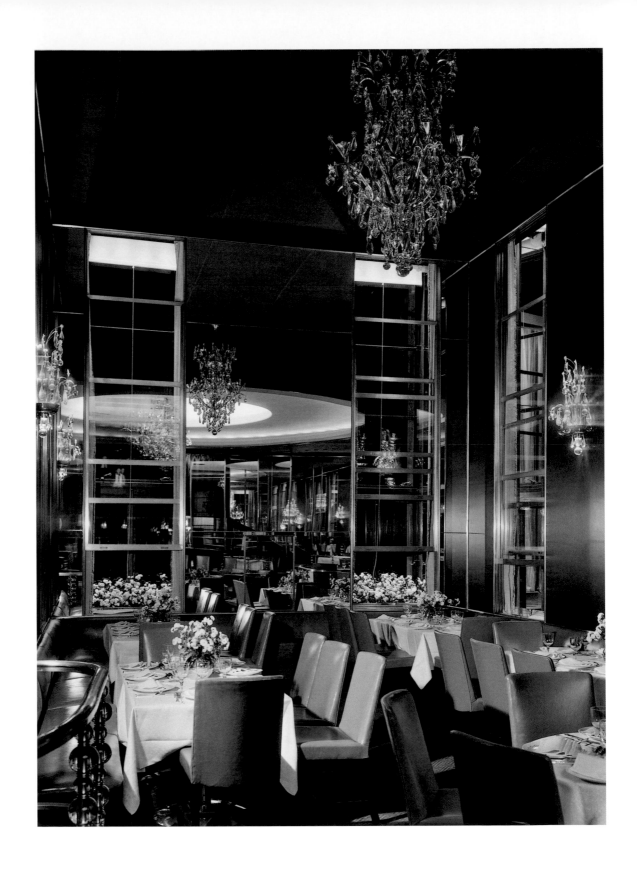

Rainbow Room, 1934

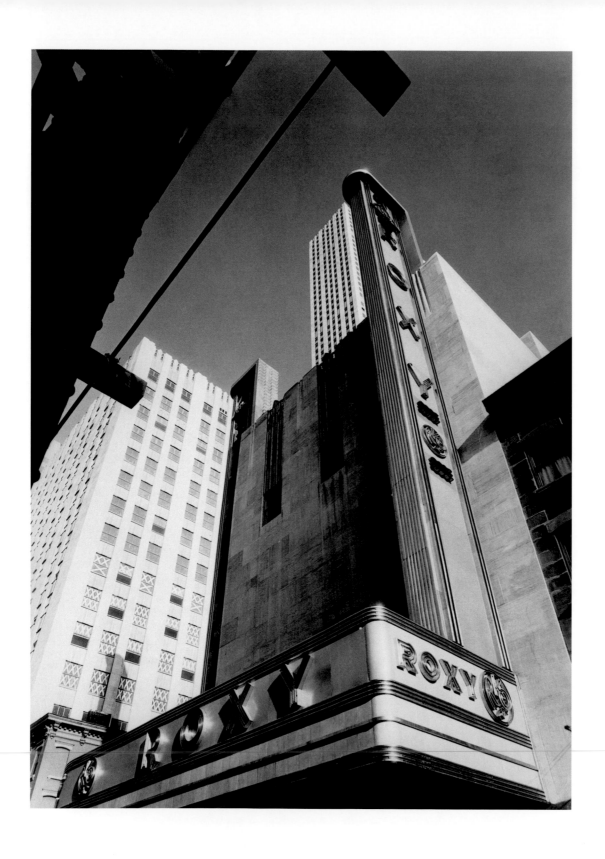

RKO Roxy Theatre,
Sixth Avenue and West
Forty-ninth Street, 1932
Associated Architects

RKO Roxy Theater,
Sixth Avenue and West
Forty-ninth Street, 1933

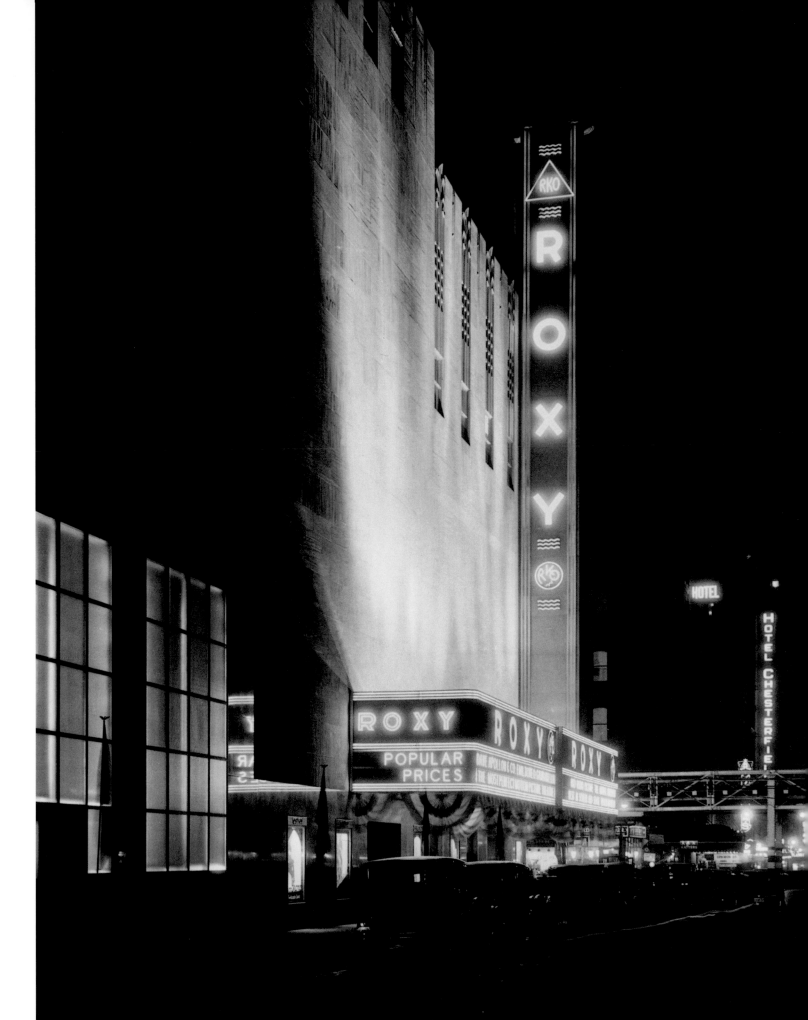

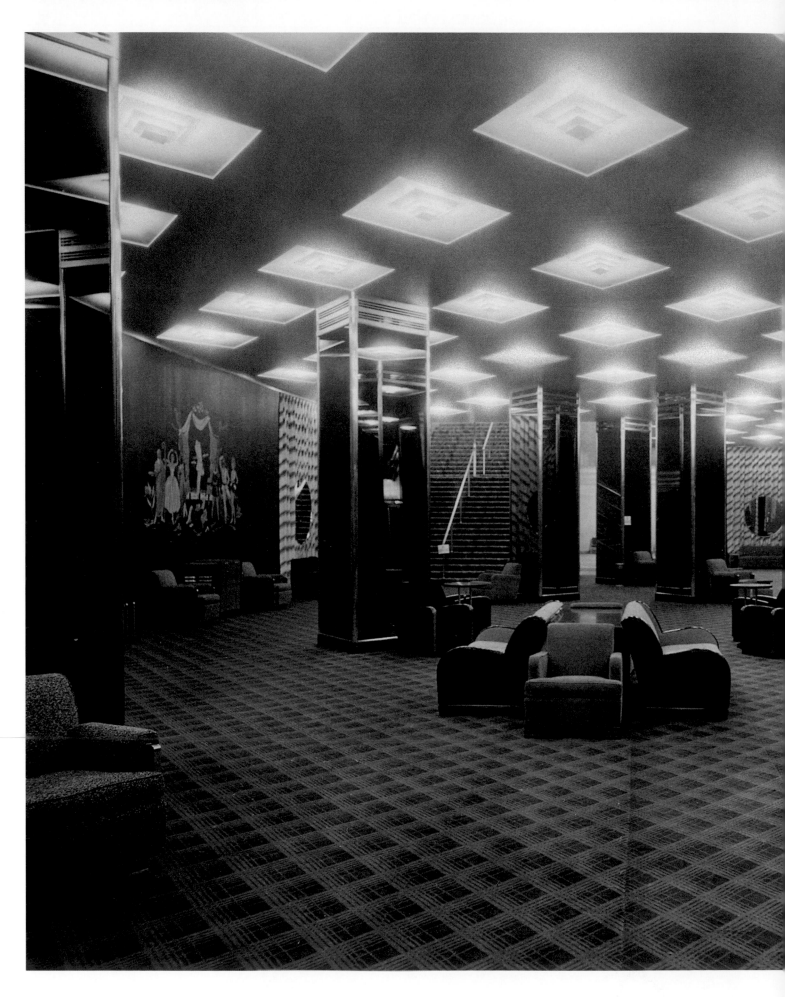

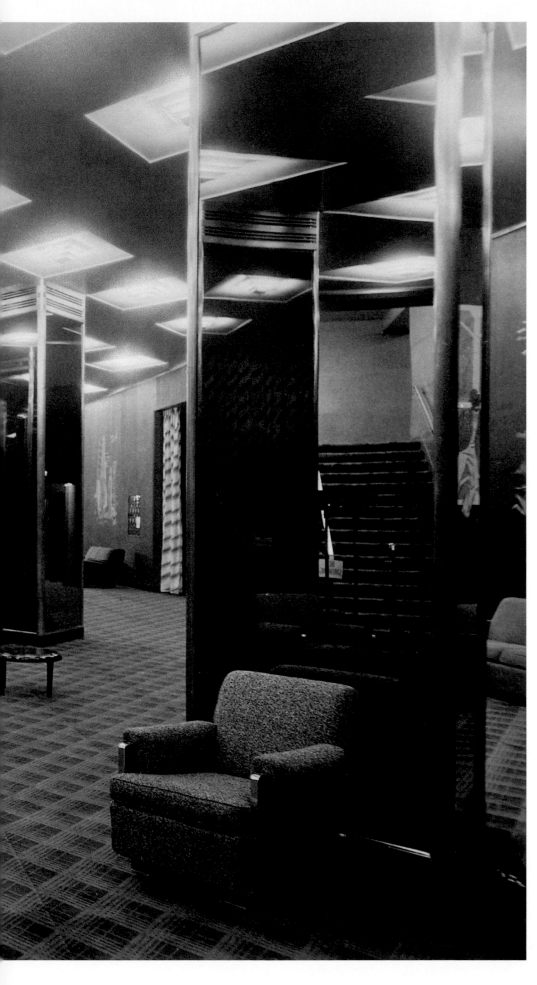

Lounge of Radio City
Music Hall, 1260 Sixth
Avenue, 1932
Associated Architects

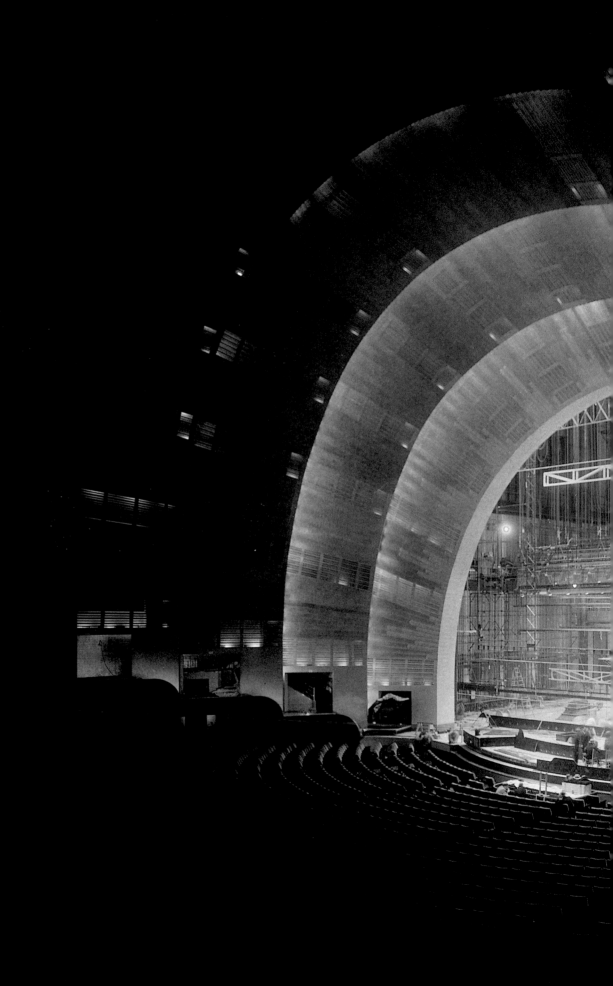

Auditorium of Radio City
Music Hall, 1932

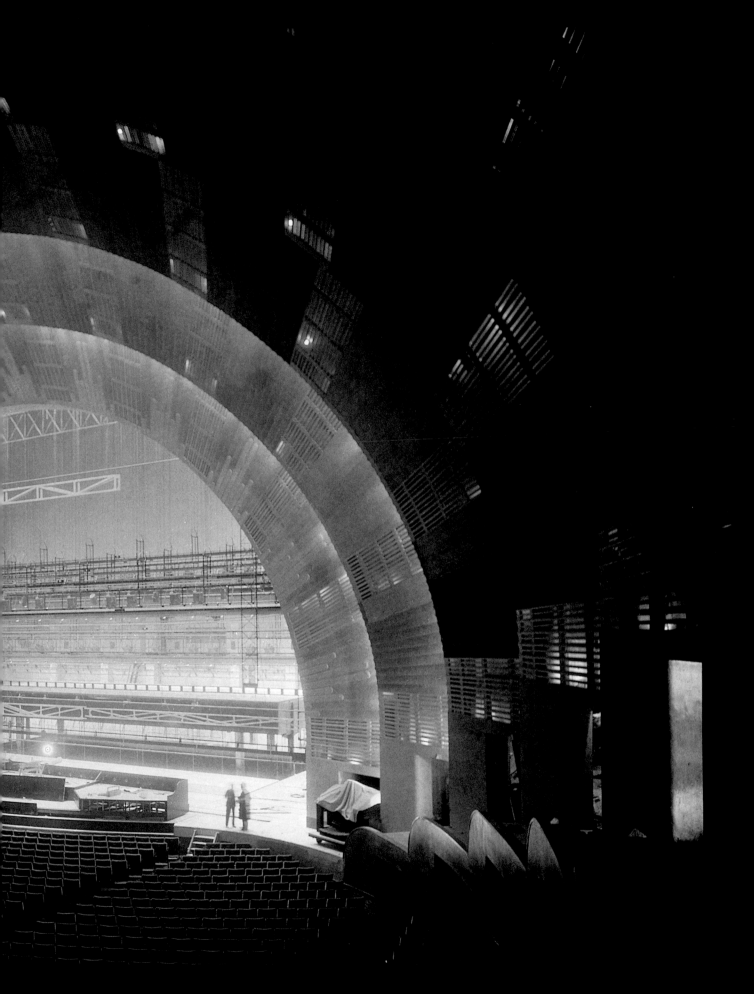

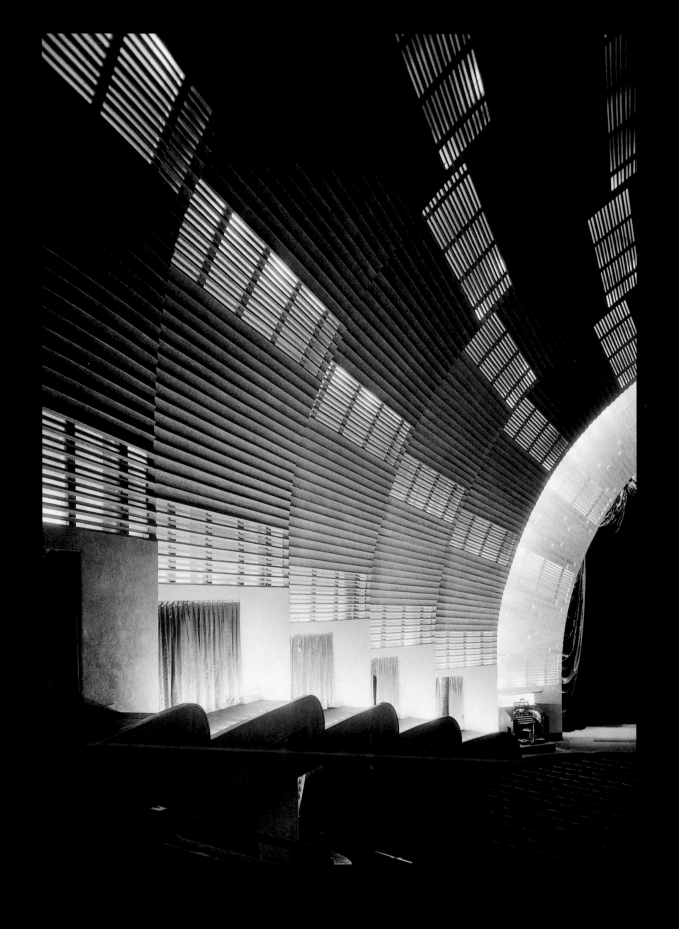

ABOVE & OPPOSITE:
Auditorium of Radio City
Music Hall, 1932

114

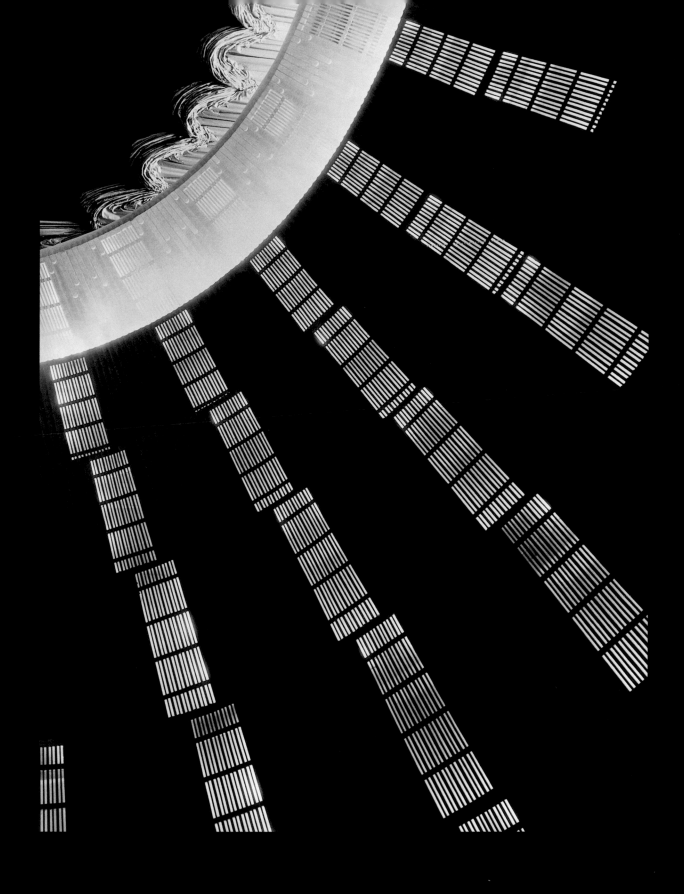

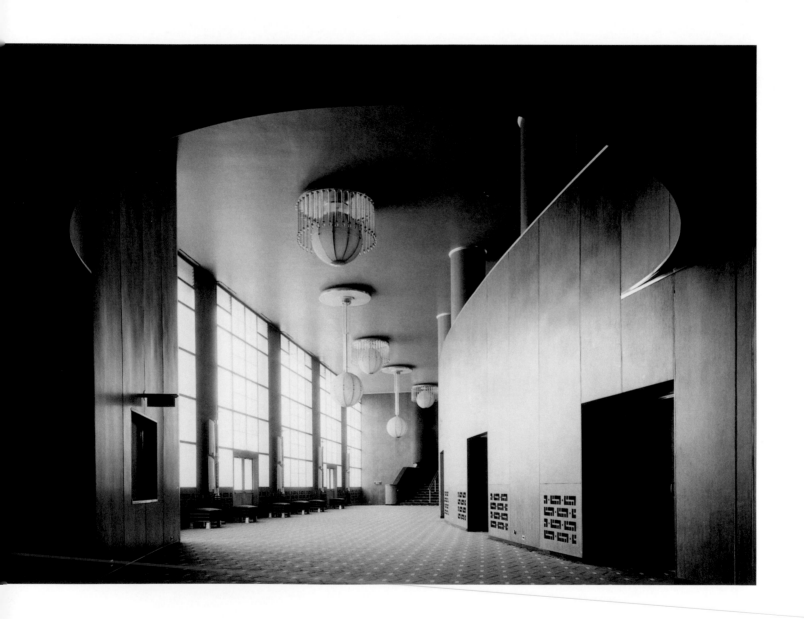

Lobby of the
RKO Roxy Theater,
ca. 1932
Eugene Schoen,
Interior Designer

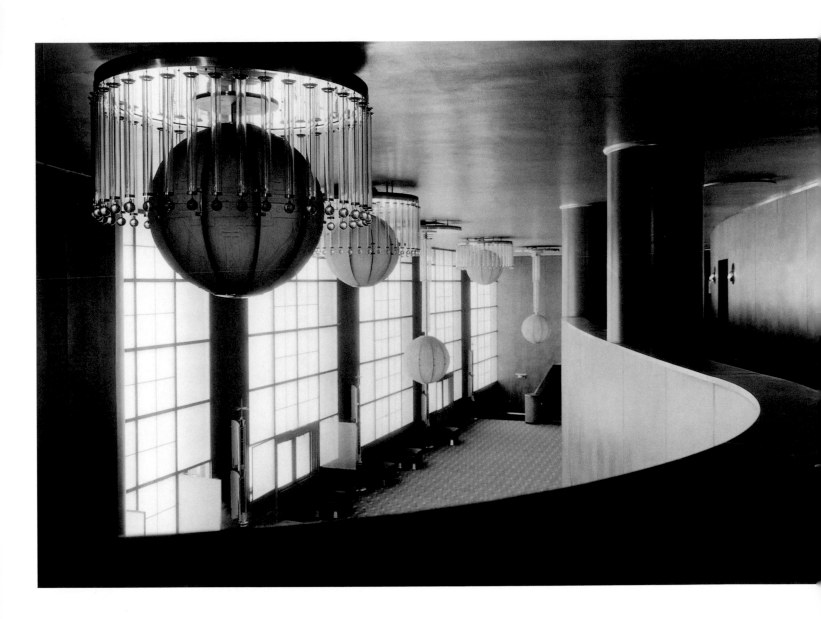

CITY

OF

COMMERCE

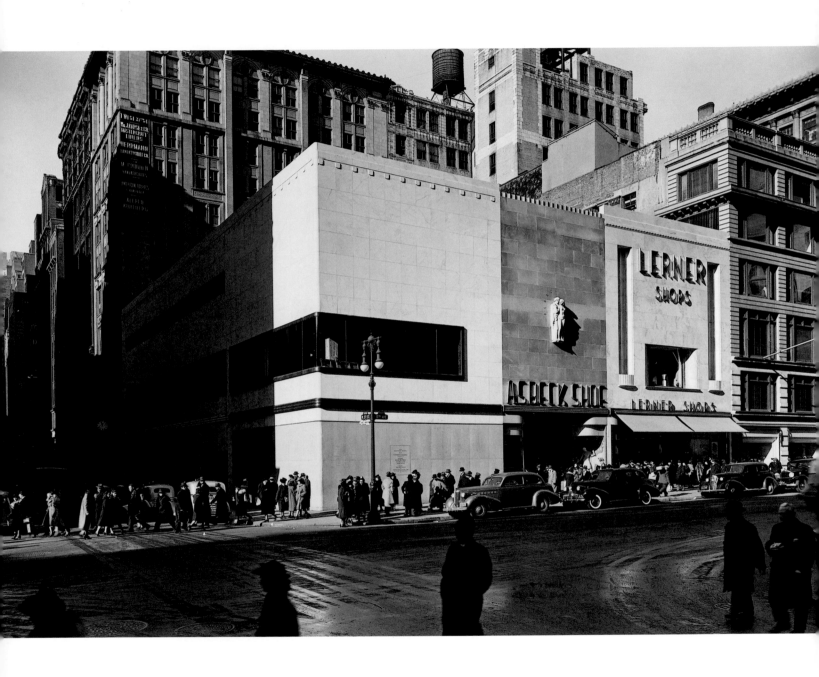

Northwest corner of
Fifth Avenue and
Thirty-seventh Street, 1939

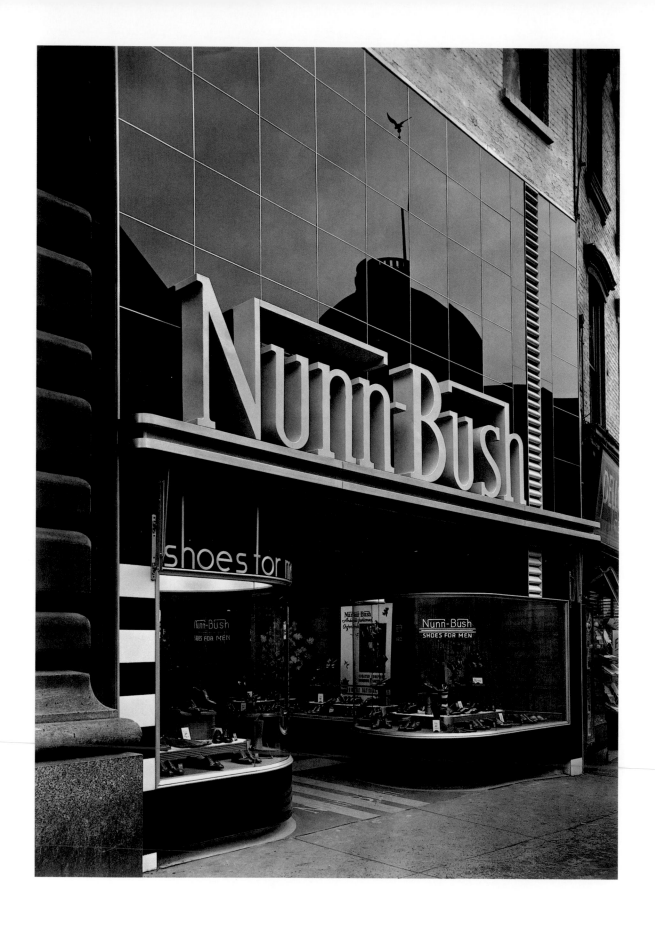

Nunn-Bush Shoe Store,
395 Fulton Street, Brooklyn,
1937

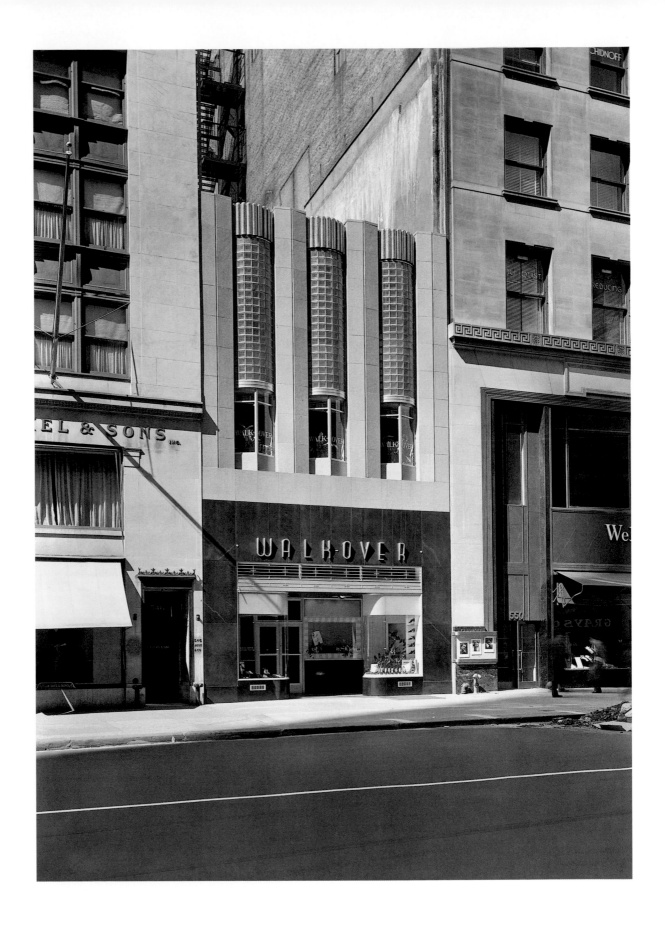

Walk-over Shoe Store,
548 Fifth Avenue,
1939

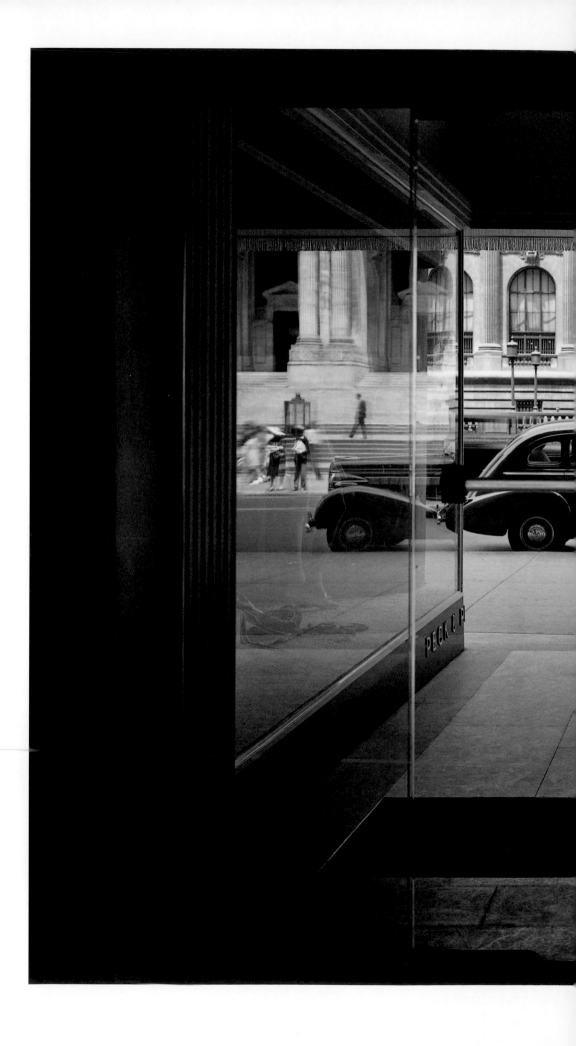

Peck & Peck,
475 Fifth Avenue, 1938

Although the Peck & Peck
store itself is not visible in this
photograph, which Gottscho
took from the interior looking
out toward Fifth Avenue,
the store's modernity was
signaled by his inclusion of a
contemporary automobile and
two stylishly dressed women
in silhouette. Gottscho also
contrasted transparent and
reflective glass doors and show
windows, equally symbolic of
modern urban life, with the
historicist New York Public
Library across the avenue.

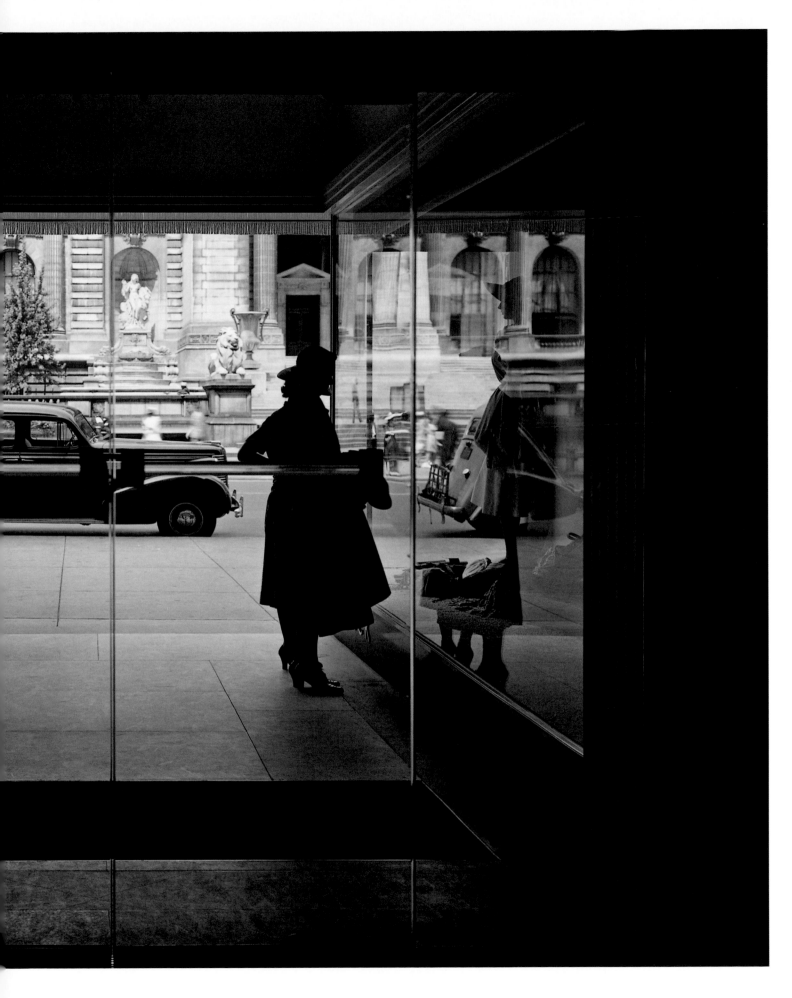

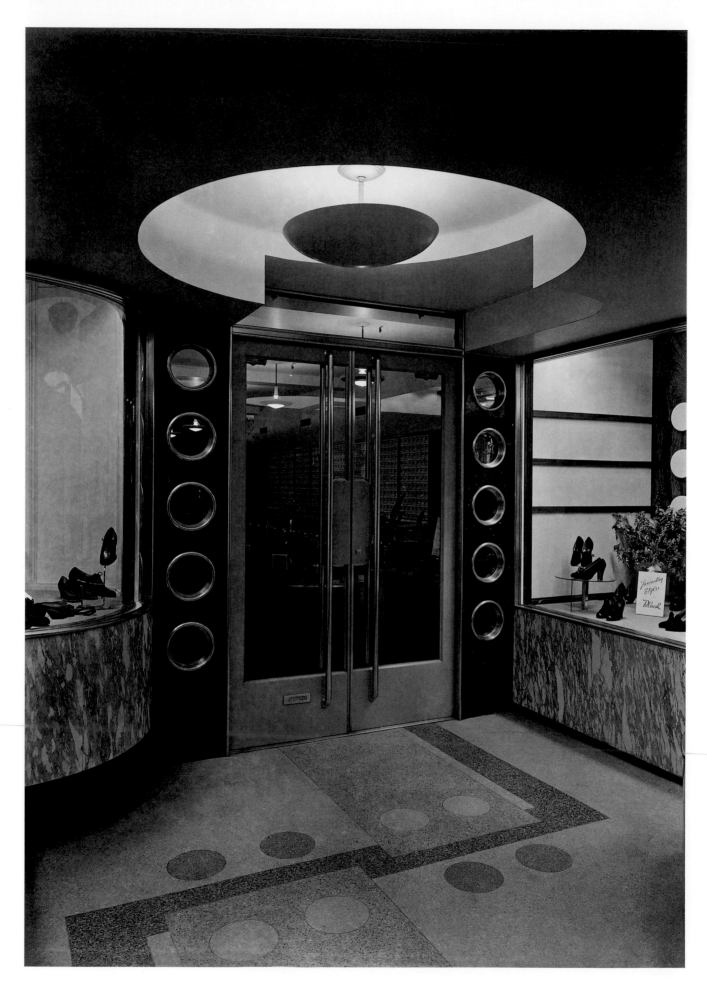

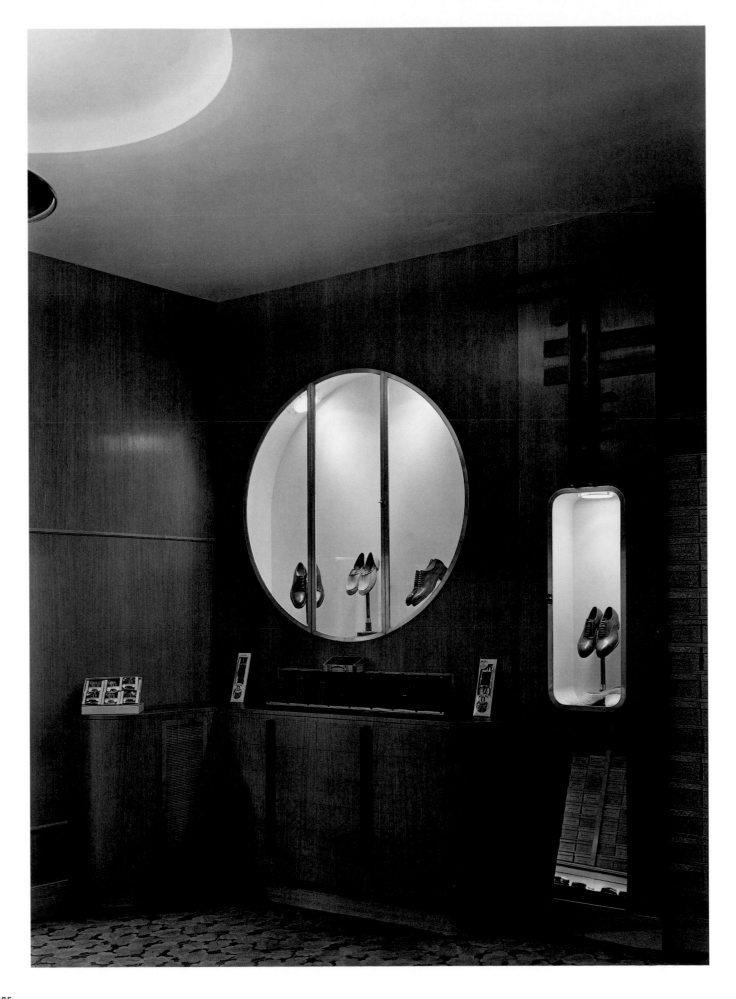

PREVIOUS SPREAD LEFT:
Entrance vestibule of the
Stetson Shoe Store,
385 Fifth Avenue, 1937

PREVIOUS SPREAD RIGHT:
Interior of Nunn-Bush Shoe
Store, Brooklyn, 1937

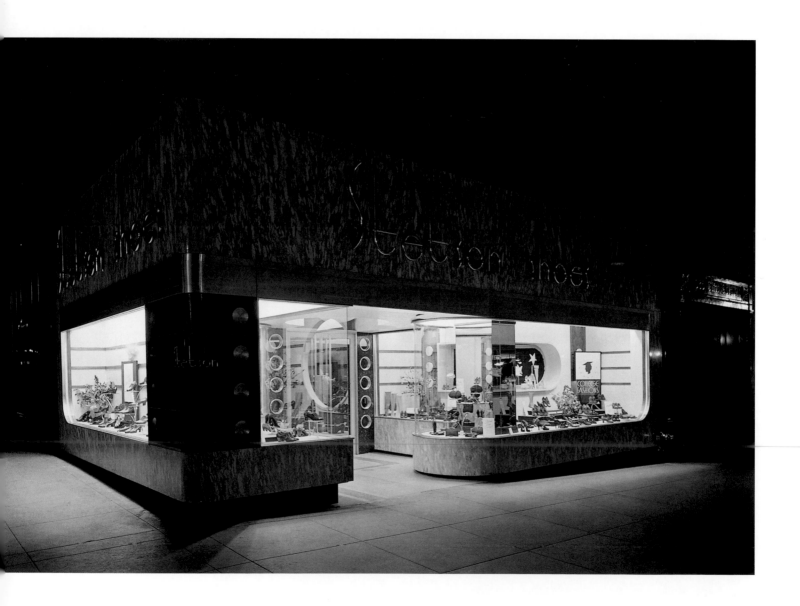

ABOVE:
Nighttime view of
Stetson Shoe Store, 1937

OPPOSITE:
Nighttime view of Standard
Sanitary showroom,
50 West Fortieth Street, 1937

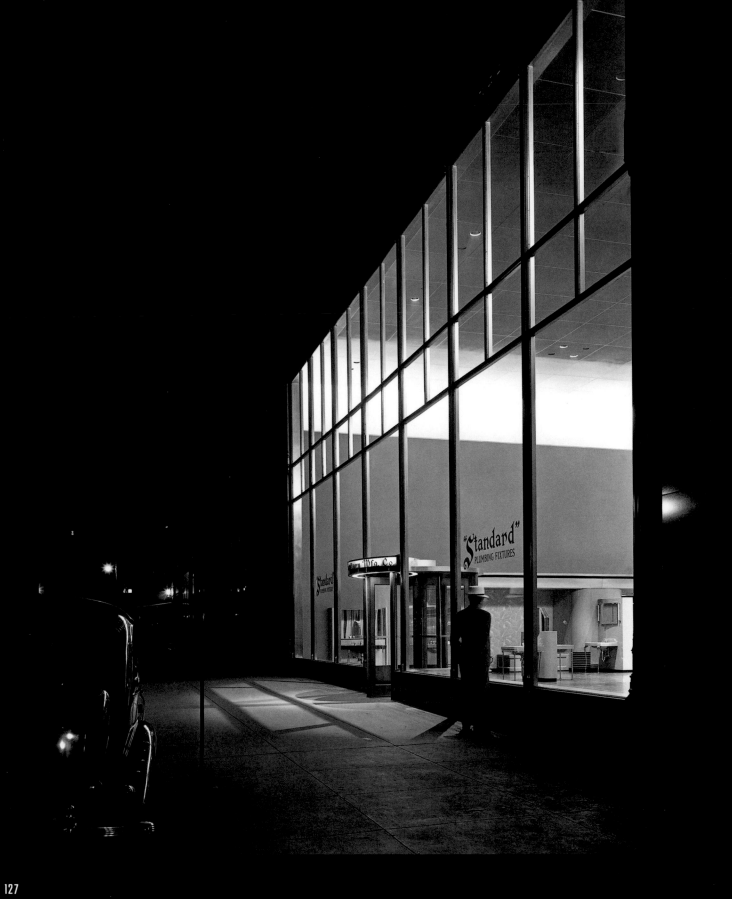

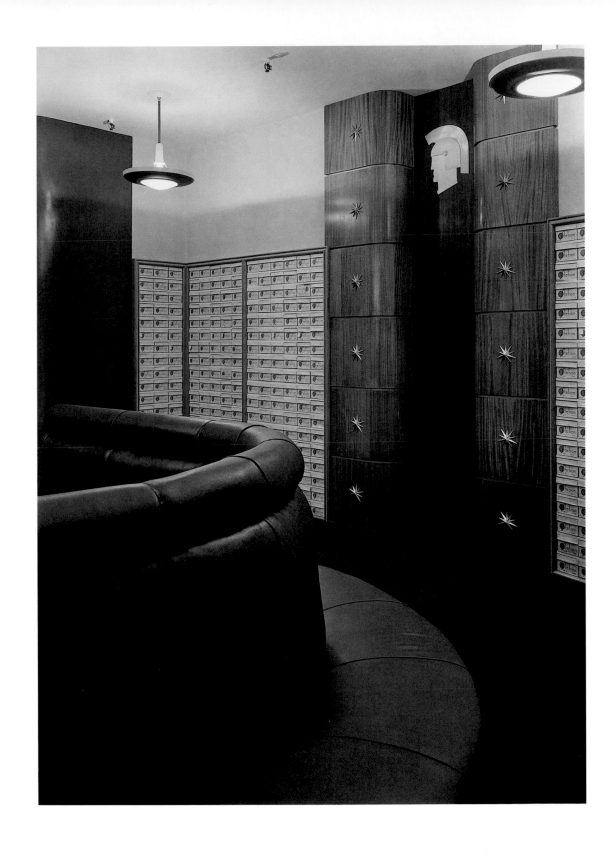

Stairway in the Steuben Glass
showroom of the Corning-
Steuben Building,
718 Fifth Avenue, 1937
Platt and Platt, Architects

Interior of Stetson Shoe Store,
1937

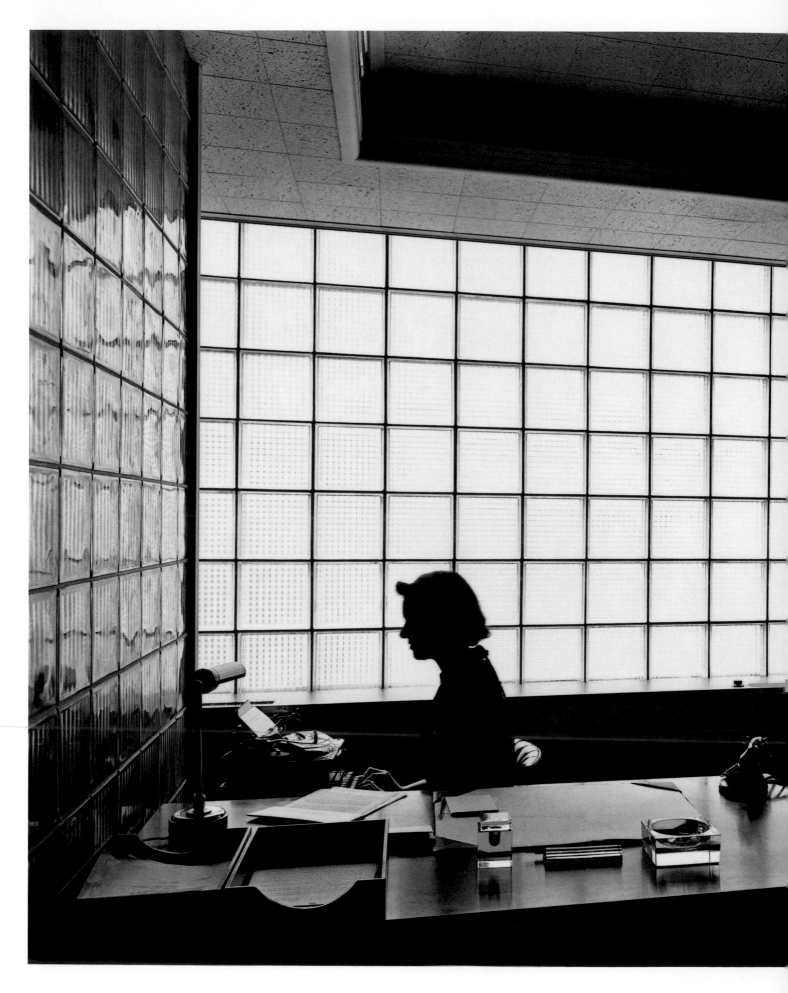

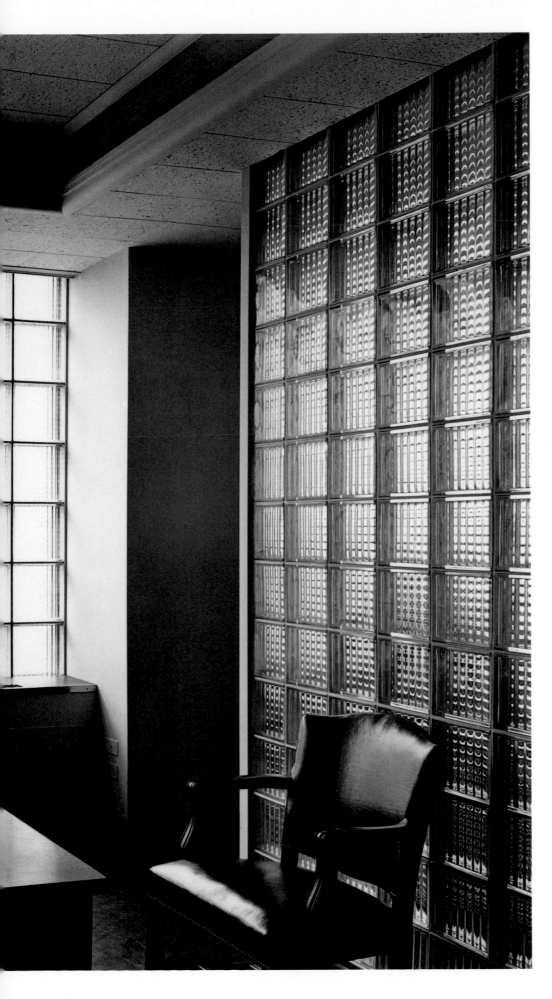

Office in the Corning-Steuben
Building, 718 Fifth Avenue,
1937

Gottscho was especially
adept at photographing new
materials with luminous
qualities. Corning Glass
Works, Steuben's parent
company, manufactured Pyrex
glass blocks and used its
new Manhattan building as a
dramatic advertisement for this
product. The building's
exterior featured walls of
3,800 glass blocks set within
walls of limestone panels.

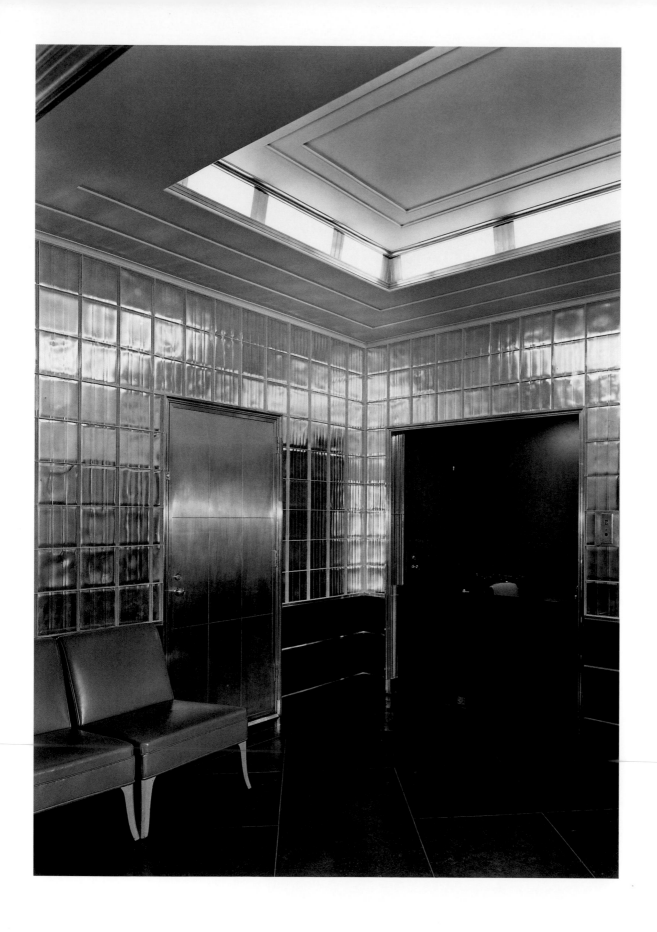

Steuben Glass showroom in
the Corning-Steuben Building,
1937

Steuben Glass showroom,
748 Fifth Avenue, circa 1933

This area was set up as a
residential entrance hall
to show customers various
Corning glass products
in a realistic setting.

BELOW & OPPOSITE:
Helena Rubenstein Salon
715 Fifth Avenue, 1936
Harold Sterner, Architect
Ladislas Medgyes and Martine
Kane, Interior Designers

Polish-born cosmetics magnate Helena Rubenstein, who promised her customers "hope in a jar," was one of the most eccentric tastemakers of the 1930s. Rubenstein's Fifth Avenue salon was a fashionable getaway for sophisticated women to receive instruction on skin care and beauty. The salon's theatrical interior combined modern and baroque elements. Unadorned streamlined walls and indirect lighting provided the backdrop for lavishly decorative furniture, and the result was a surreal, yet romantic, atmosphere.

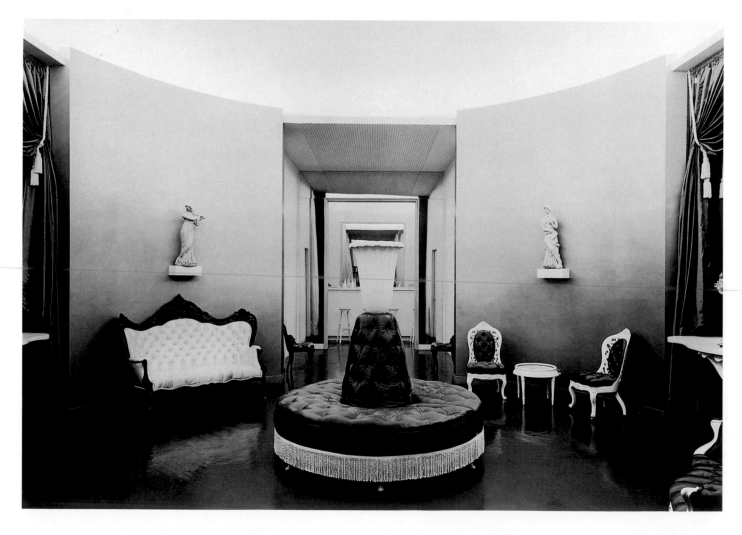

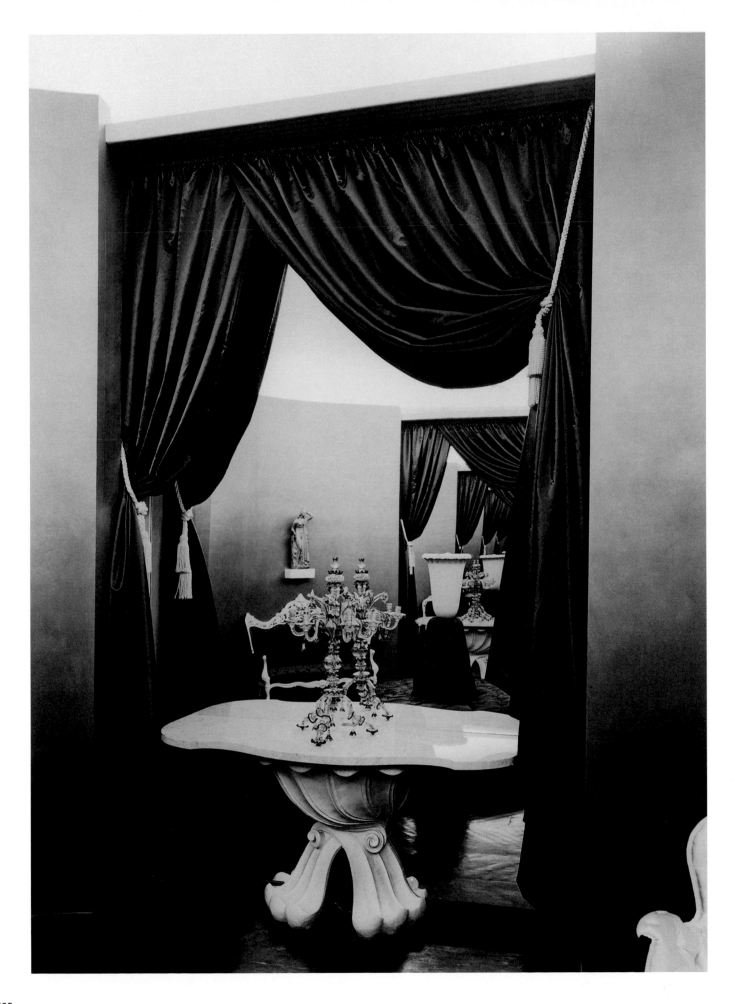

COMPANY

Lobby of the John B. Stetson
Company, 475 Fifth Avenue,
1938
John Hatton, Architect

This photograph and the one
on the following pages present
radically different views of
the same space. Gottscho
collapsed the lobby space into
a sequence of overlapping
glass doors in the image
on these pages, while he
telescoped the narrow lobby
into a dramatically angled
perspective in the one on the
following pages.

Lobby of the John B. Stetson
Company, 1938

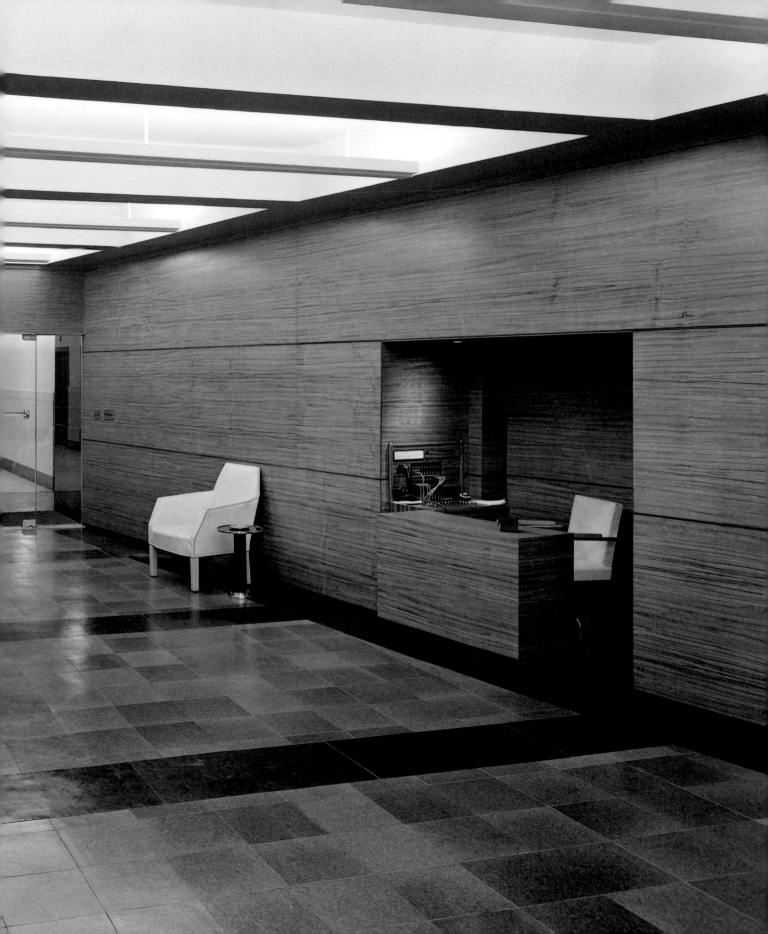

BELOW LEFT & RIGHT:
Rex Cole showroom,
6528–6530 Fourth Avenue,
Bay Ridge, Brooklyn, ca. 1932
Hood and Fouilhoux,
Architects

Rex Cole, a distributor of General Electric refrigerators, had showrooms in New York City, at least four of which were designed by Hood and Fouilhoux in the early 1930s. These buildings conflated architecture and advertising by copying the shapes, finishes, and logos of refrigerators in their designs. Gottscho took full advantage of the buildings' large expanses of glass and reflective surfaces to portray them as sunlight-filled shrines to the latest must-have appliance in the American home.

OPPOSITE:
Rex Cole, 137–55 Northern Boulevard, Flushing, Queens, 1931
Hood and Fouilhoux,
Architects

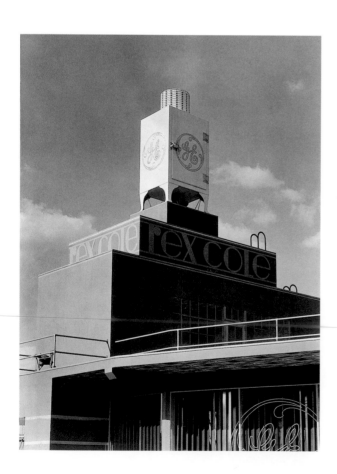

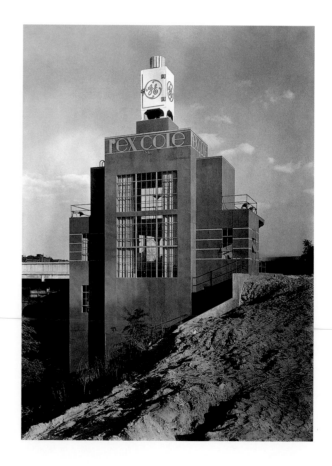

Rex Cole, 137–55 Northern
Boulevard, Flushing, Queens,
1931

Rex Cole showroom,
6528–6530 Fourth Avenue,
Bay Ridge, Brooklyn, 1931

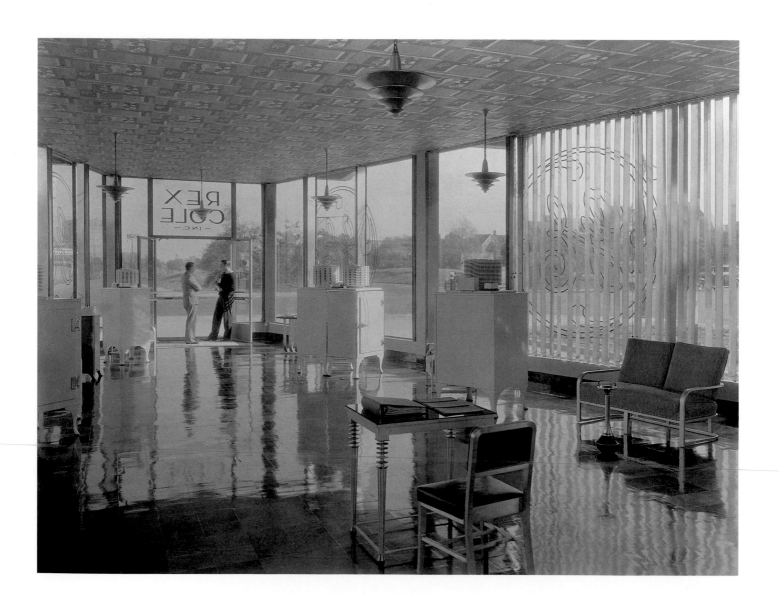

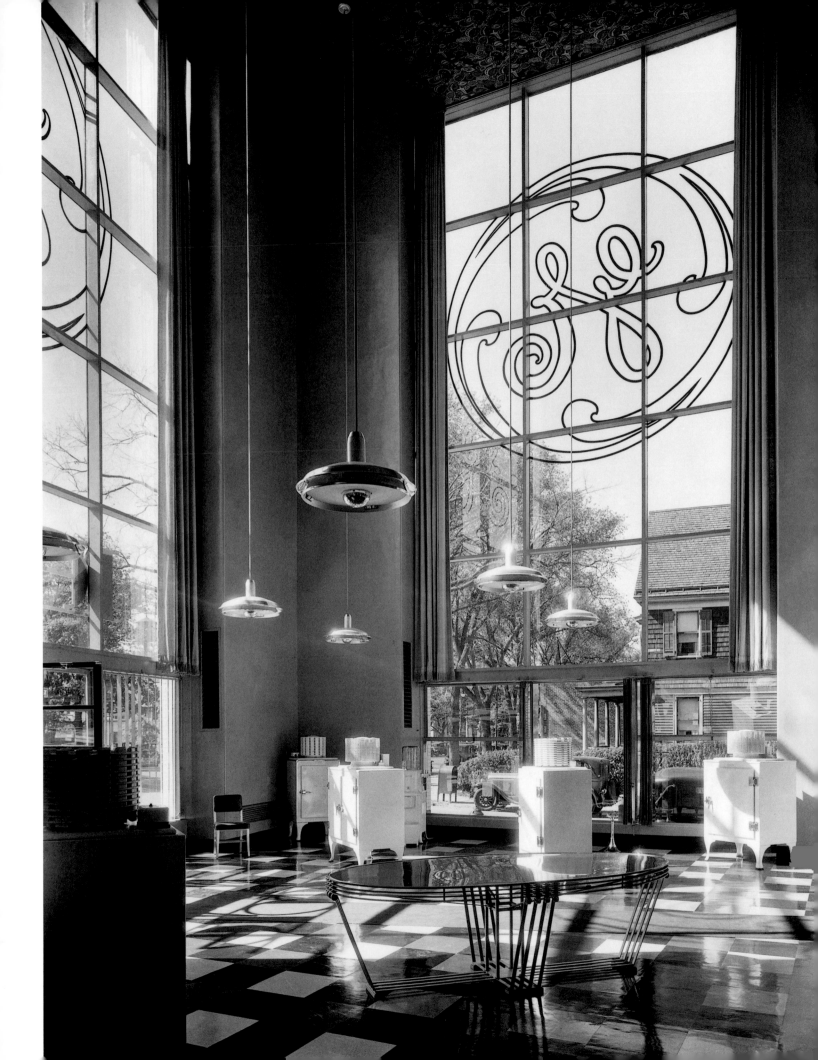

Chrysler Automobile Salon,
Chrysler Building,
405 Lexington Avenue, 1936
Reinhard & Hofmeister,
Architects of salon

The Chrysler showroom's
windows were curved, making
them virtually invisible
from the street and giving
pedestrians unimpeded views
of the interior. Gottscho took
advantage of this display
device to create a kaleidoscopic
image of automobiles—real
and reflected—that was worthy
of early twentieth-century
Italian Futurist painters.

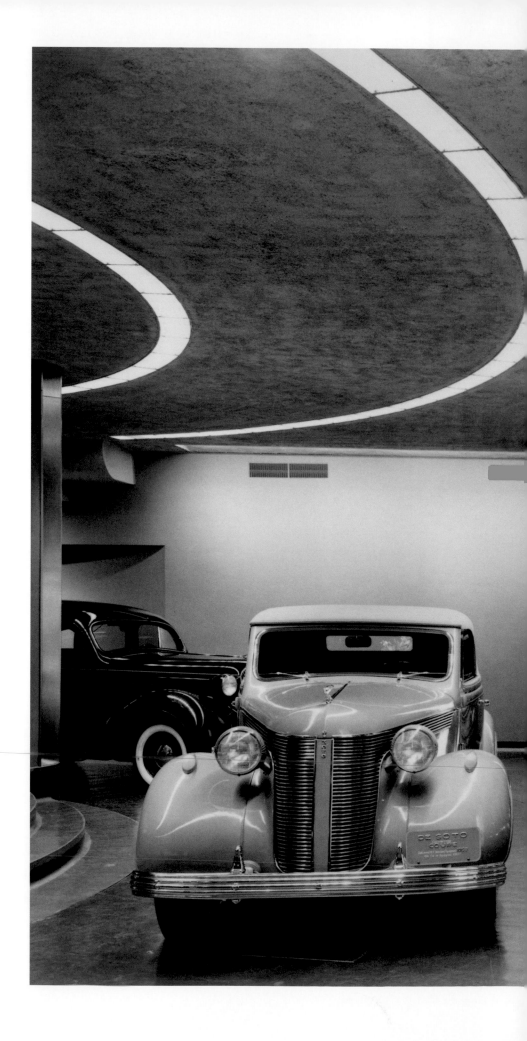

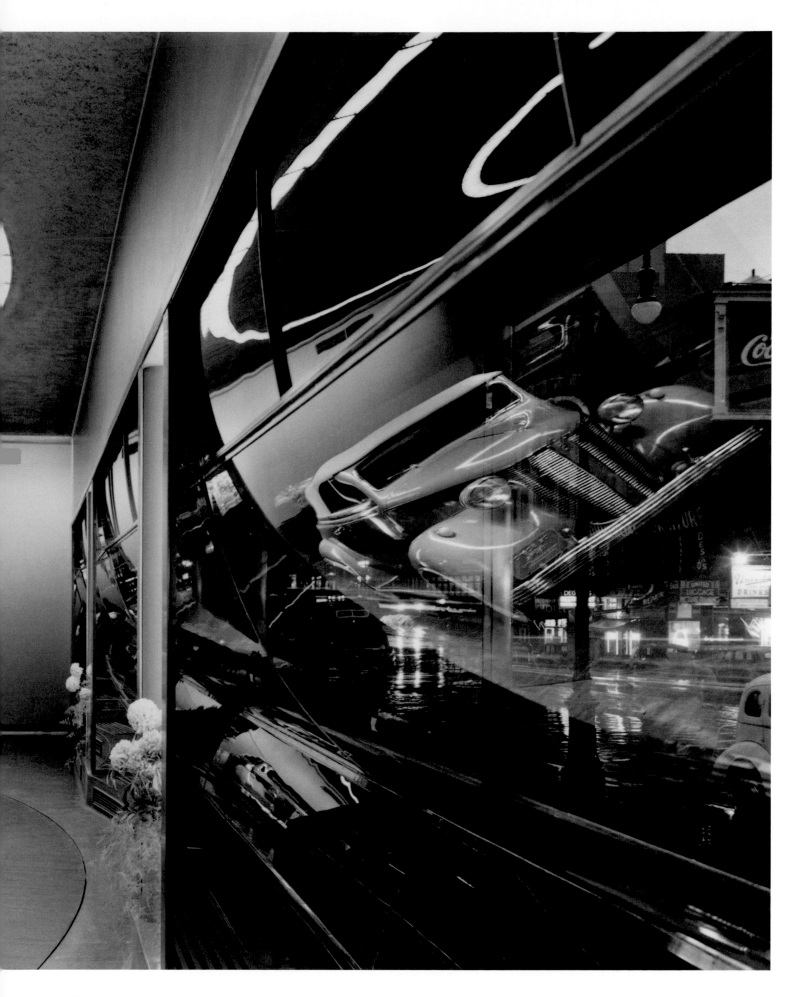

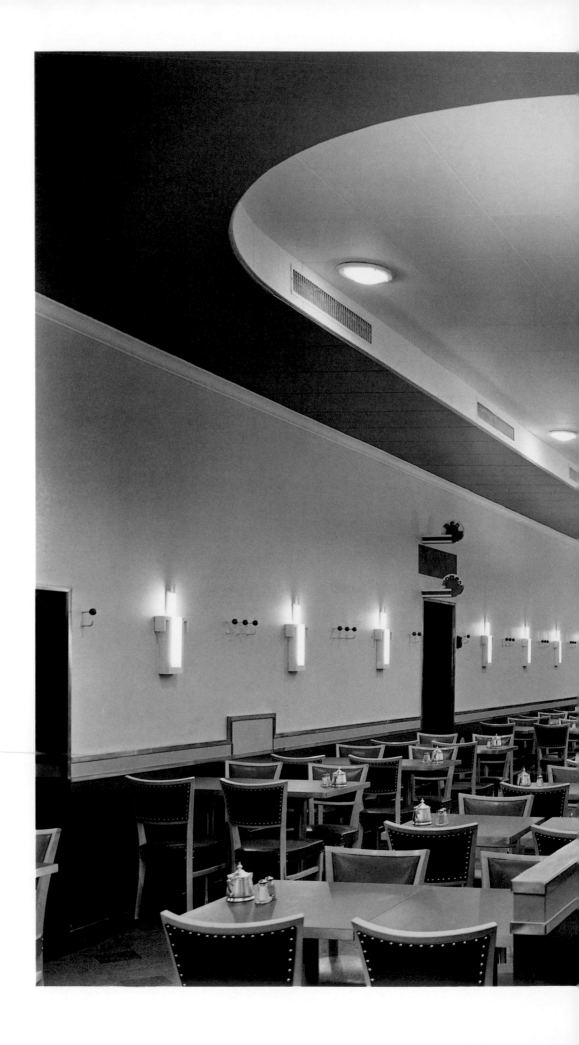

Steinberg's restaurant,
2270 Broadway, 1934
Morris Lapidus, Architect

Gottscho's fascination with
luminosity made him the ideal
photographer for Morris
Lapidus, whose commercial
interiors of the 1930s
abounded in indirectly lit
recessed niches and modern
light fixtures.

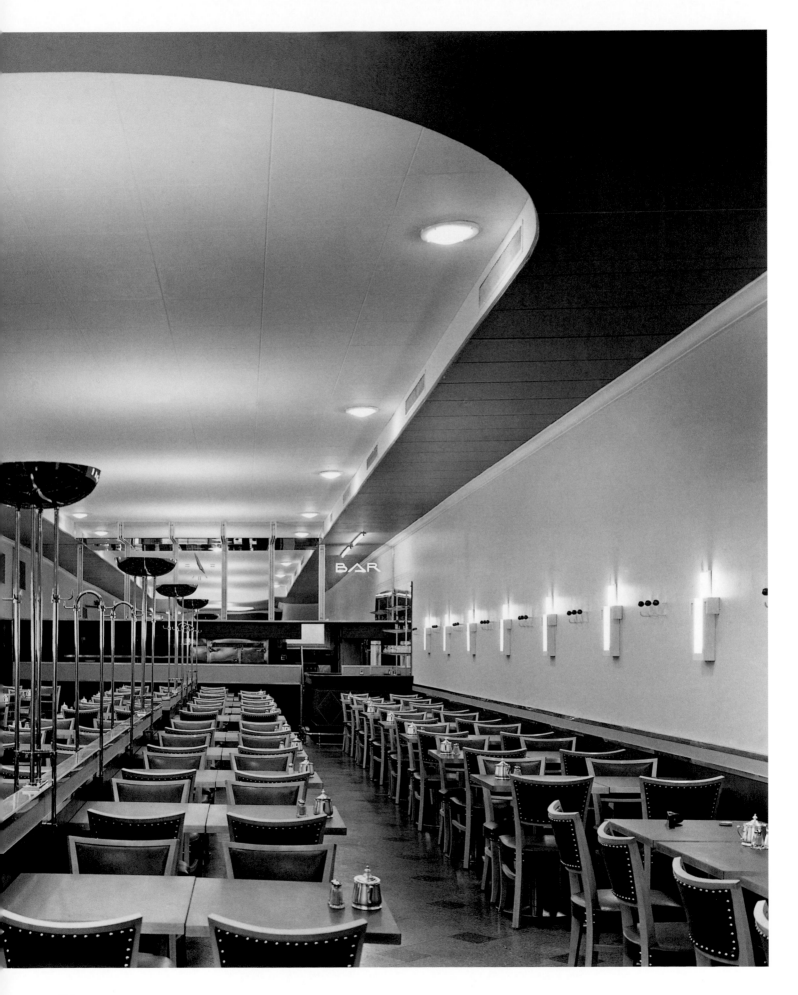

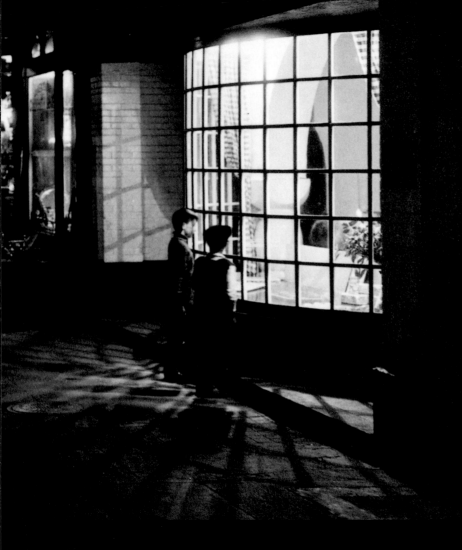

Nighttime view of Fifty-ninth
Street looking east with
Queensboro Bridge at left,
1933

"Hungry children gazing at a
bakery," Gottscho wrote in
his autobiography of this image
of the Gnomes Products shop
at the right, "so pathetically
set forth by Hans Christian
Anderson was recalled to me
when I started to take this
night picture of the bakery."

CITY LIVING: APARTMENTS HOTELS AND SOCIAL CLUBS

River House seen from Welfare Island in the East River, 1931 Bottomley, Wagner & White, Architects

Among Gottscho's most important residential commissions was the River House, perhaps the city's most exclusive apartment building. Typically, Gottscho used this opportunity to create glamorous images of the building to use as marketing tools for the builders and architects, as well as to photograph the city from a new vantage point. (See pages 16–17.) Starting in 1931 the apartment's builders, James Stewart and Company, hired Gottscho to take views of the building, which was then under construction, in order to supplement the plans used to sell apartments. Gottscho was also hired by the building's architects, Bottomley, Wagner, and White, to photograph the exterior as well as the grand entrance foyer and gallery.

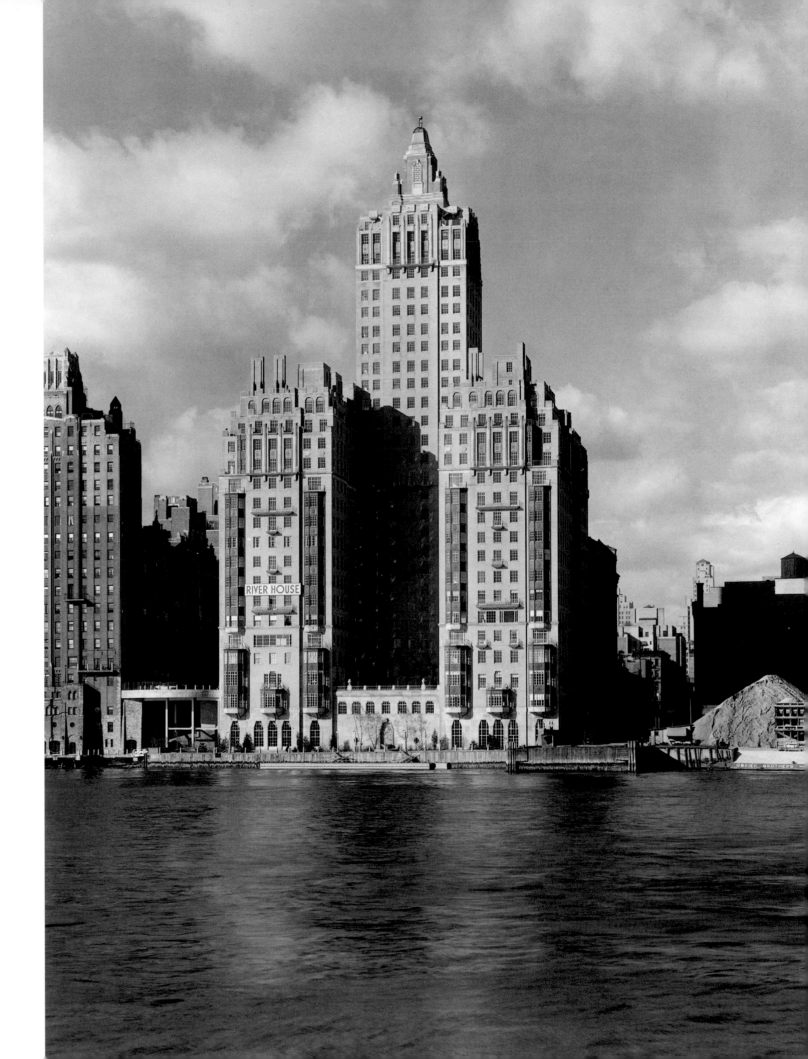

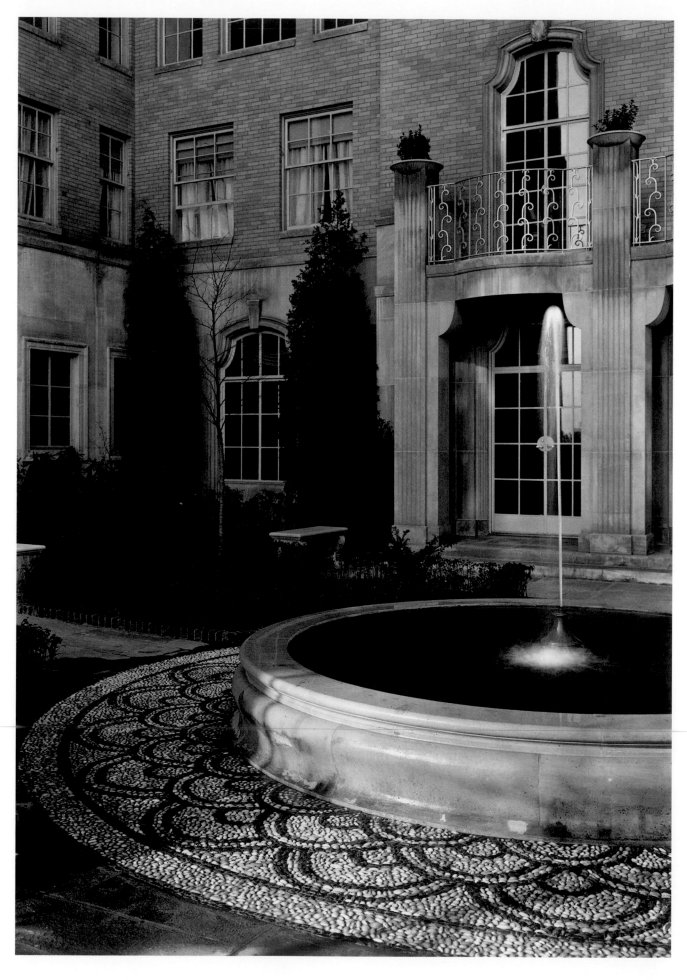

OPPOSITE:
Garden fountain at
River House, 435 East
Fifty-second Street, 1931

BELOW:
East River boat dock of River
House, 1931

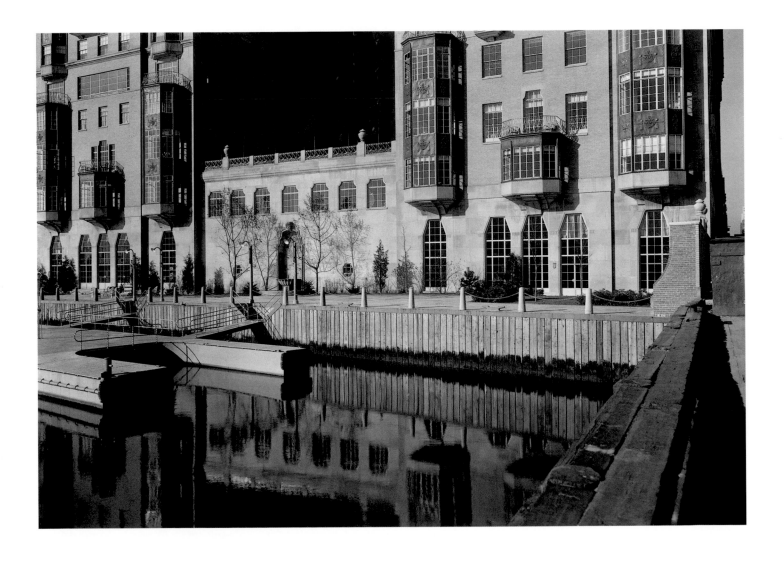

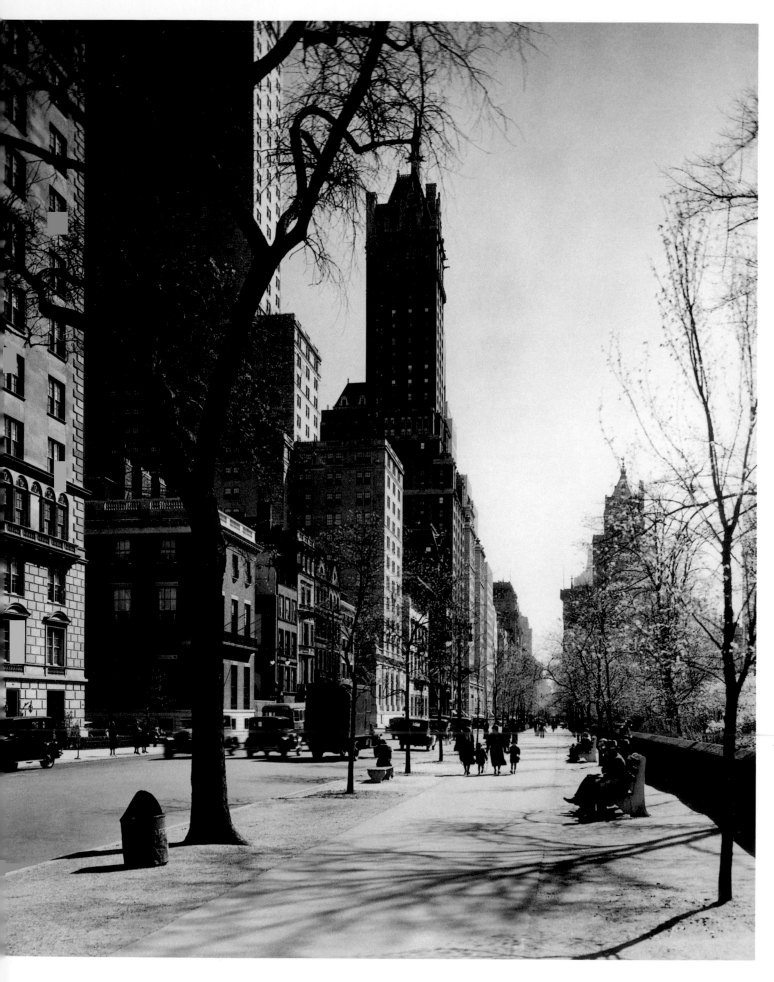

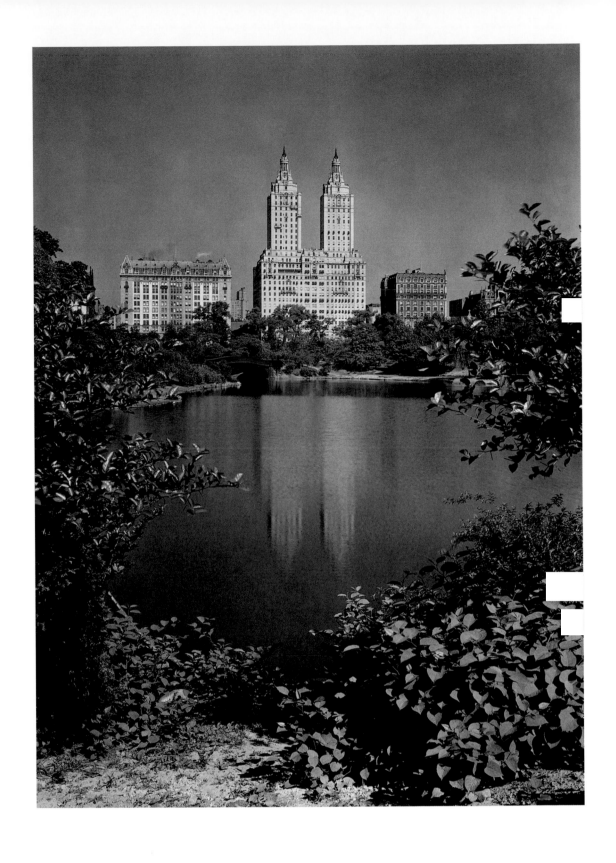

OPPOSITE:

View down Fifth Avenue at
Sixty-third Street with Central
Park at right, 1932

ABOVE:

San Remo Apartments,
145–146 Central Park West,
1932
Emery Roth, Architect

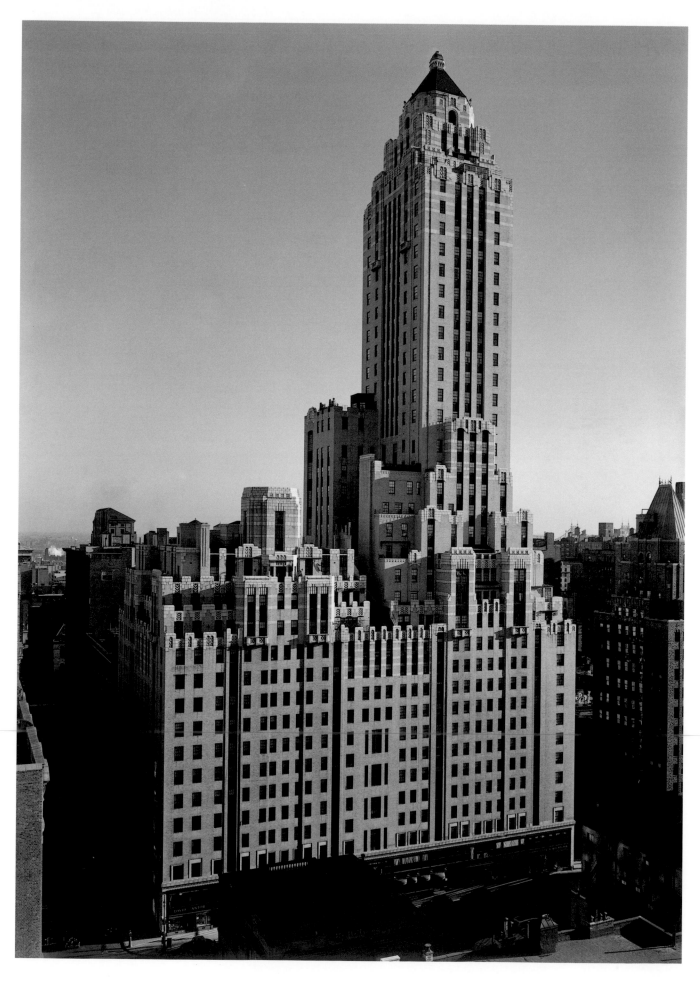

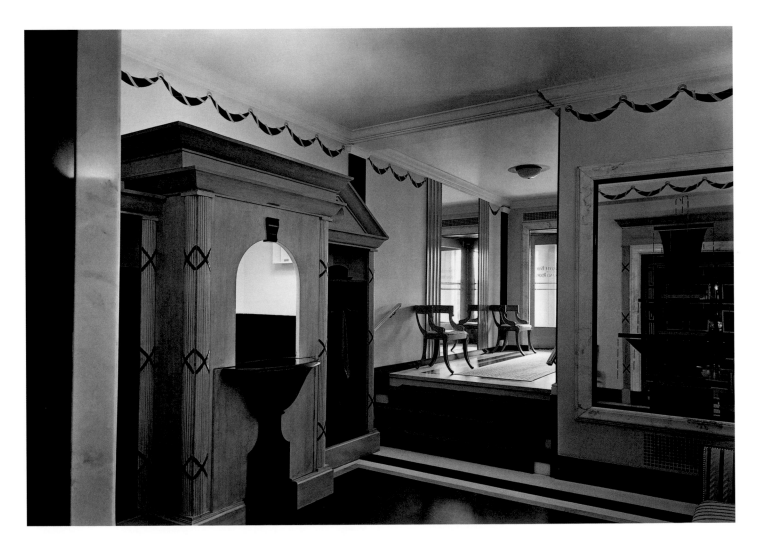

OPPOSITE:
Carlyle Hotel, Madison
Avenue between Seventy-sixth
and Seventy-seventh streets,
1938
Bien and Prince, Architects

ABOVE:
Interior in the Carlyle Hotel,
1938
Dorothy Draper,
Interior Designer

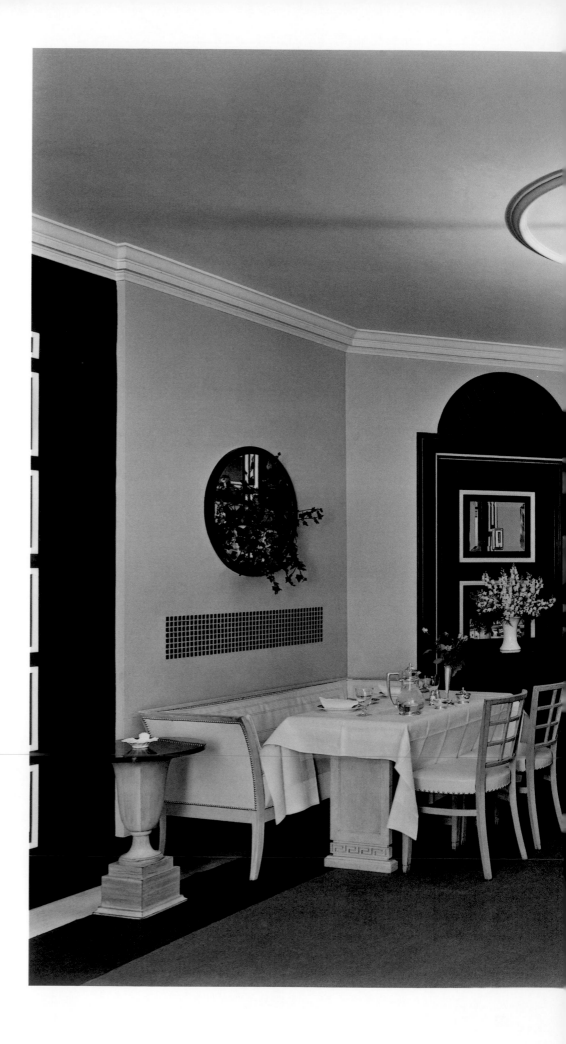

Foyer to the dining room at
the Carlyle Hotel, 1938
Dorothy Draper,
Interior Designer

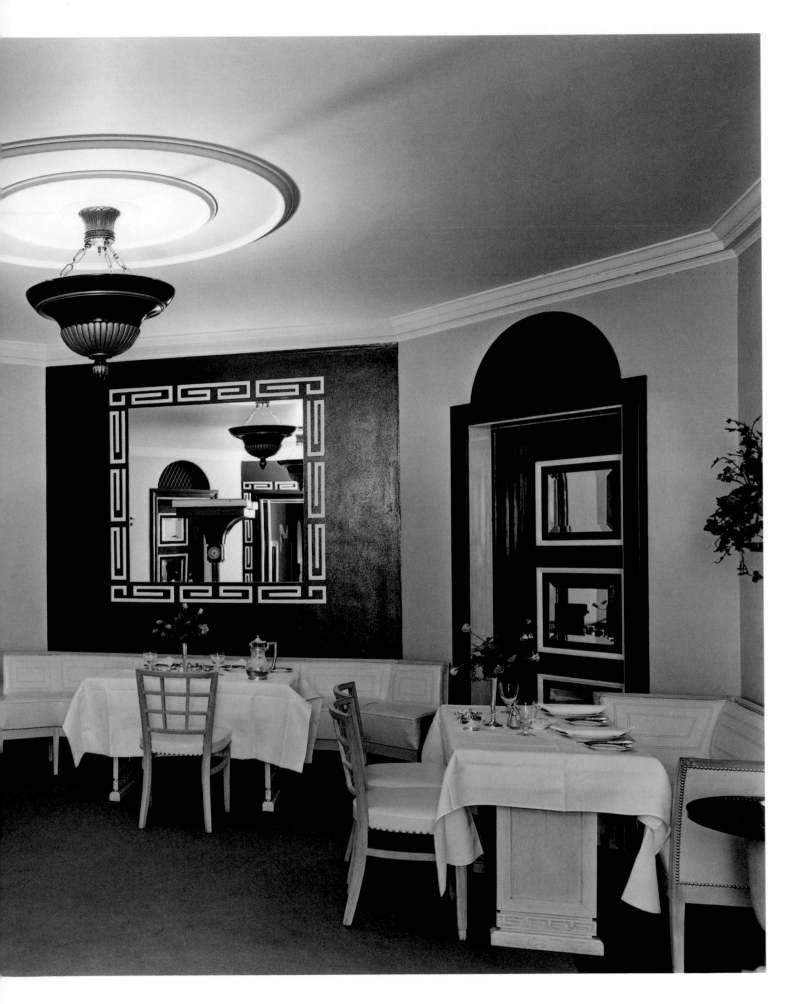

BELOW & OPPOSITE:
**Beaux-Arts Apartments,
307 and 310 East Forty-
fourth Street, 1930
Raymond Hood and Kenneth
Murchison, Architects**

Photographing the Beaux-Arts Apartments was one of many commissions that Gottscho received in the 1930s from architect Raymond Hood, one of New York's leading modernists. Hood had become acquainted with Gottscho in the mid-1920s, when the photographer sent the architect some nighttime photographs of his 1924 American Radiator Building across from New York's Bryant Park. The Beaux-Arts Apartments consisted of two identical buildings located directly across from each other on Forty-fourth Street, creating a kind of urban courtyard.

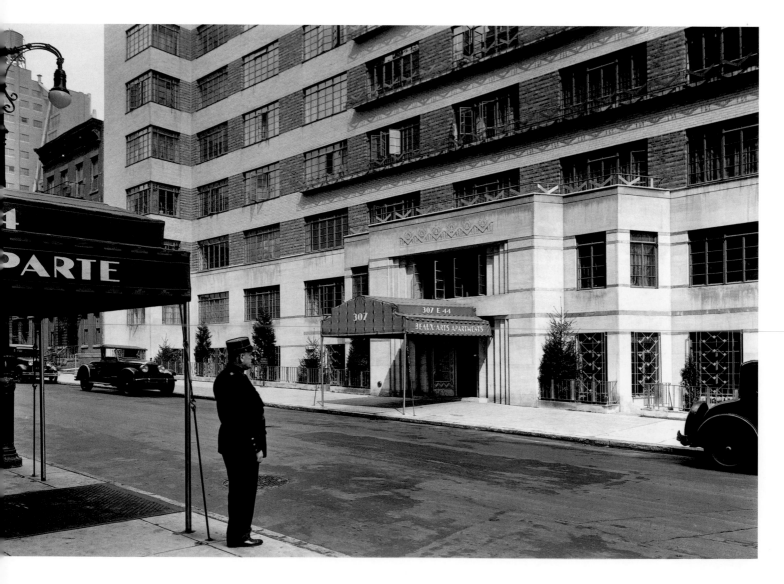

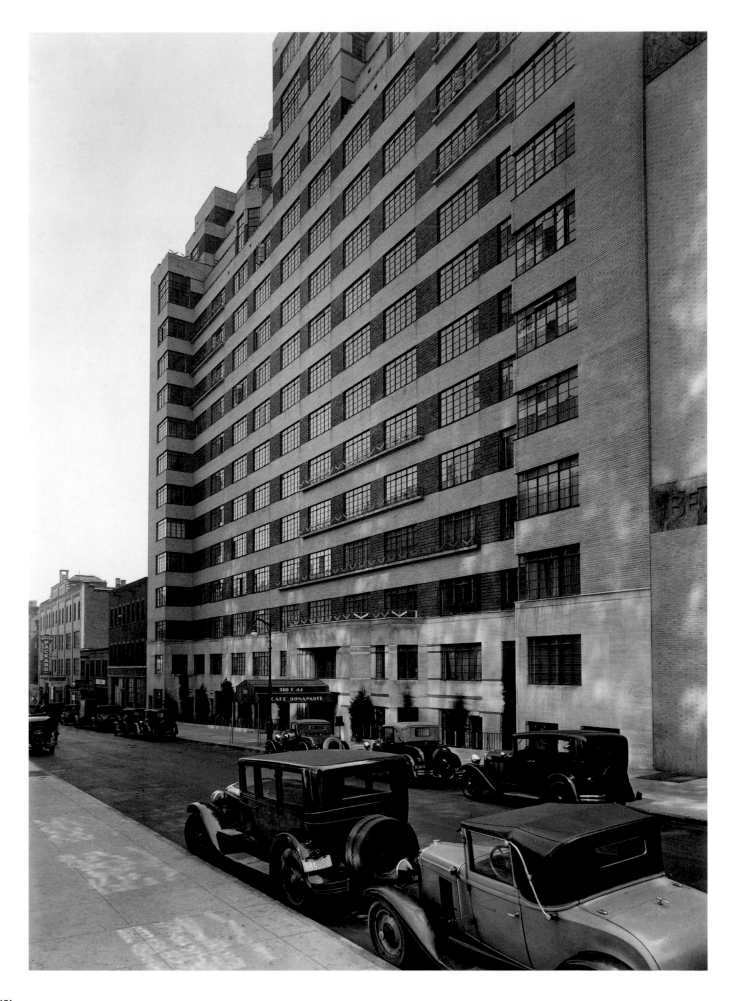

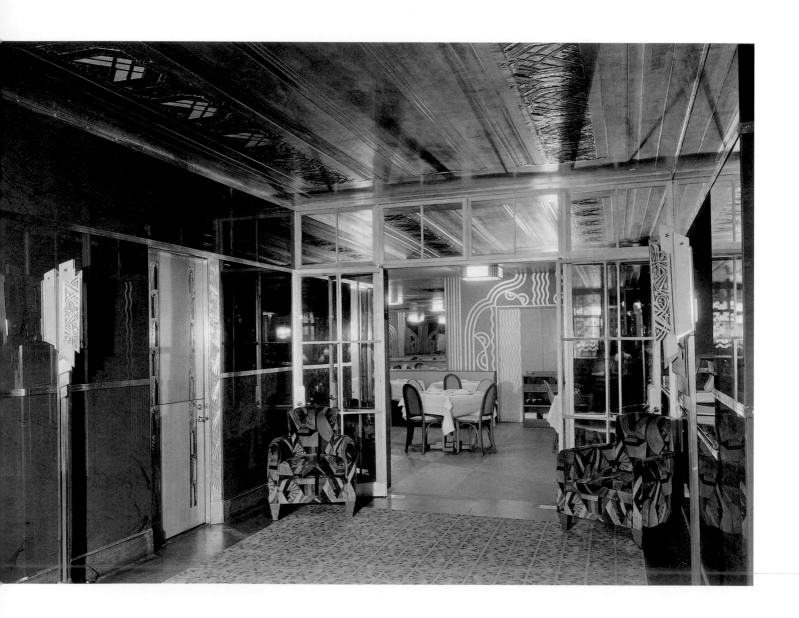

Entrance to the restaurant of
the Beaux-Arts Apartments,
1930

Picture window with view
of backyard, East Sixty-first
Street, 1942

Gottscho's extreme
foregrounding of the bibelot-
covered table in this image
draws the viewer into the
frame, bridging the interior
and exterior.

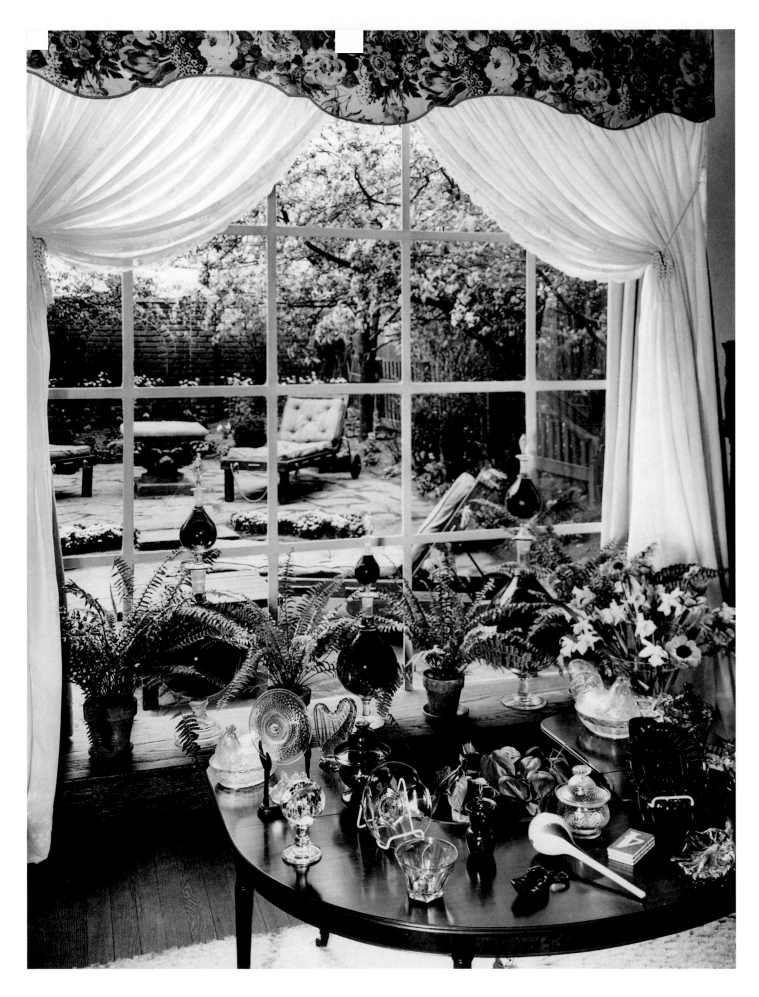

Dining Room of the
Cosmopolitan Club,
122 East Sixty-sixth Street,
1932

The Cosmopolitan Club
between Park and Lexington
Avenues was a meeting place
for women in literature and
the arts. Its interiors were
originally decorated by some
of its members, including
Eleanor Brown McMillen,

Clare Kennard, and Constance
Ripley. In photographing the
club's dining room, Gottscho
focused on its delicately painted
and upholstered chairs, which
here served as surrogates of the
club's sophisticated members.

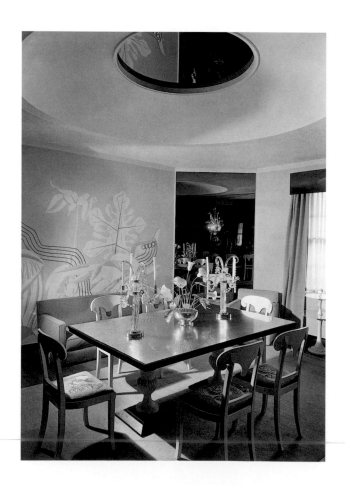

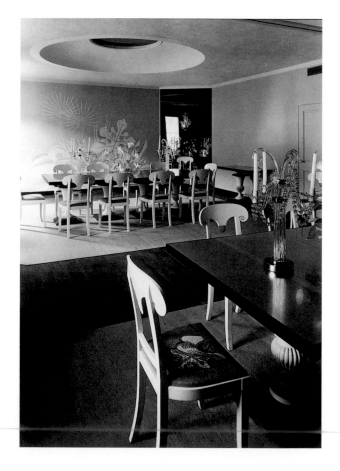

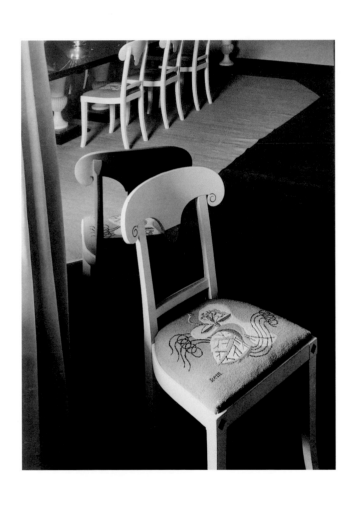

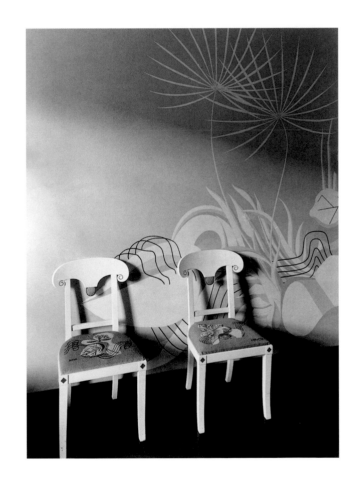

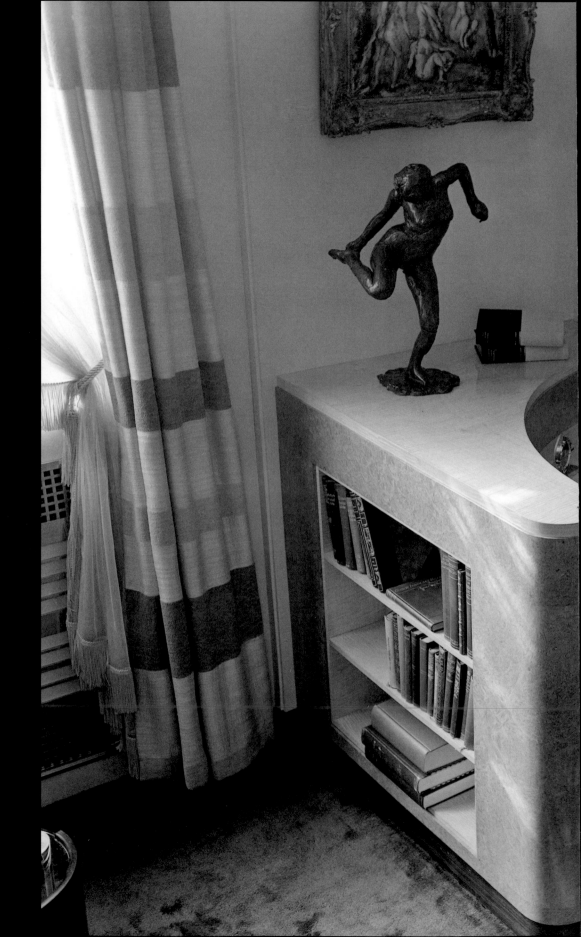

Library in Mrs. Edouard Jones
Residence, 998 Fifth Avenue,
1936

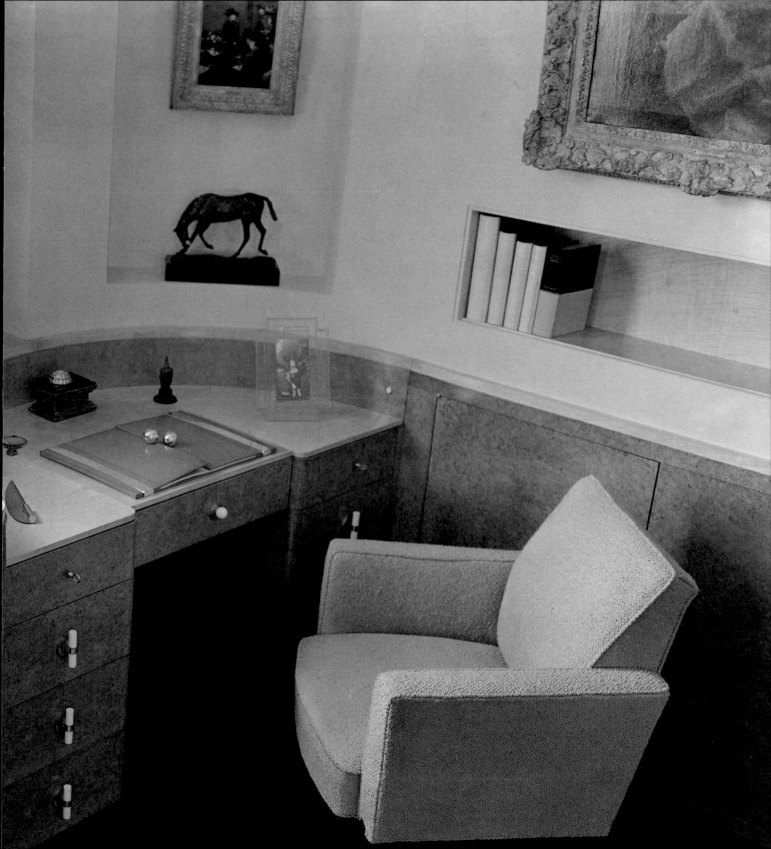

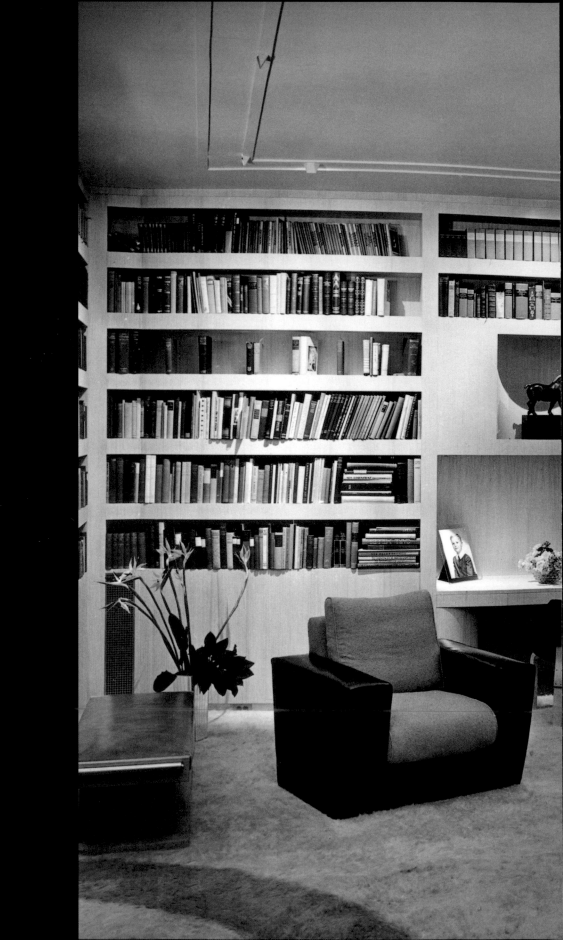

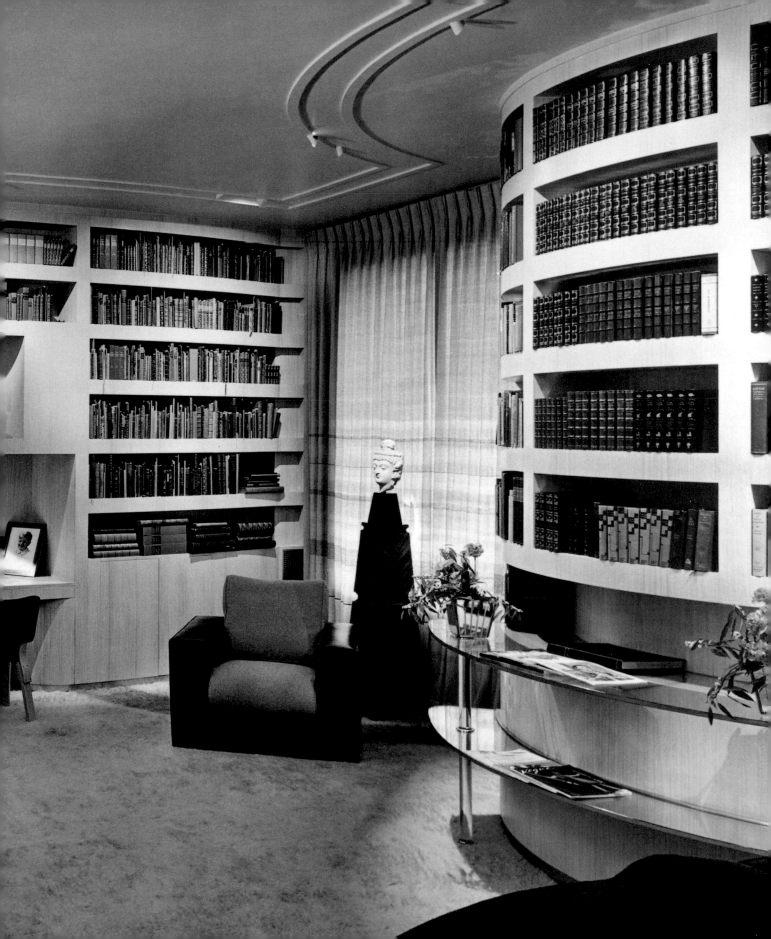

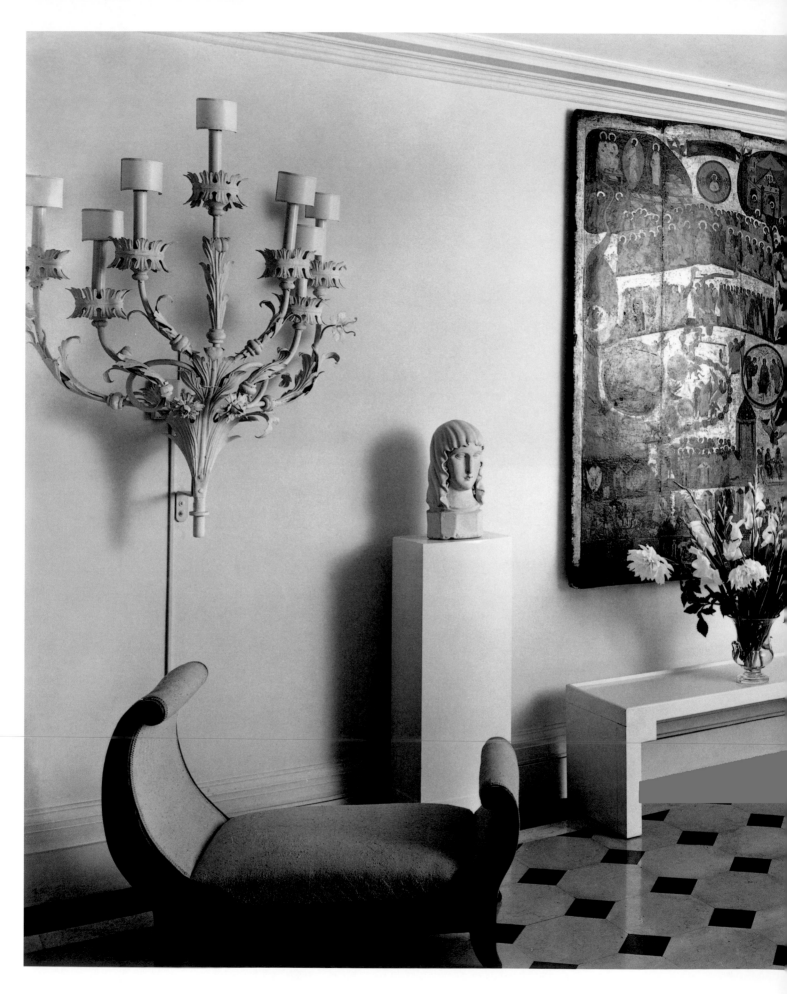

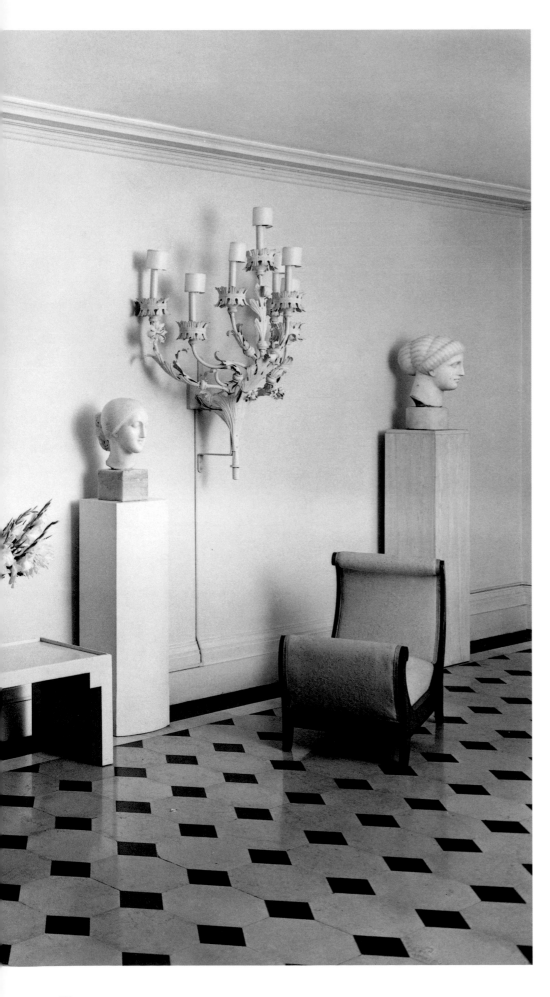

Helena Rubenstein interior,
300 Park Avenue, 1938

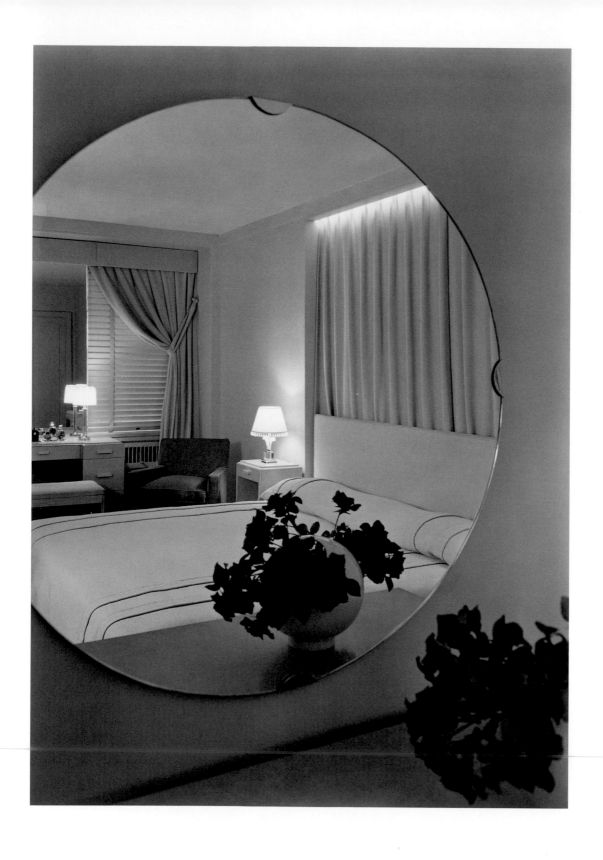

Bedroom in Mrs. I. Schwab
Residence, 1001 Park Avenue,
1936
Jane Smith, Inc.,
Interior Designer

Dining room at
40 East Seventy-first Street,
1931

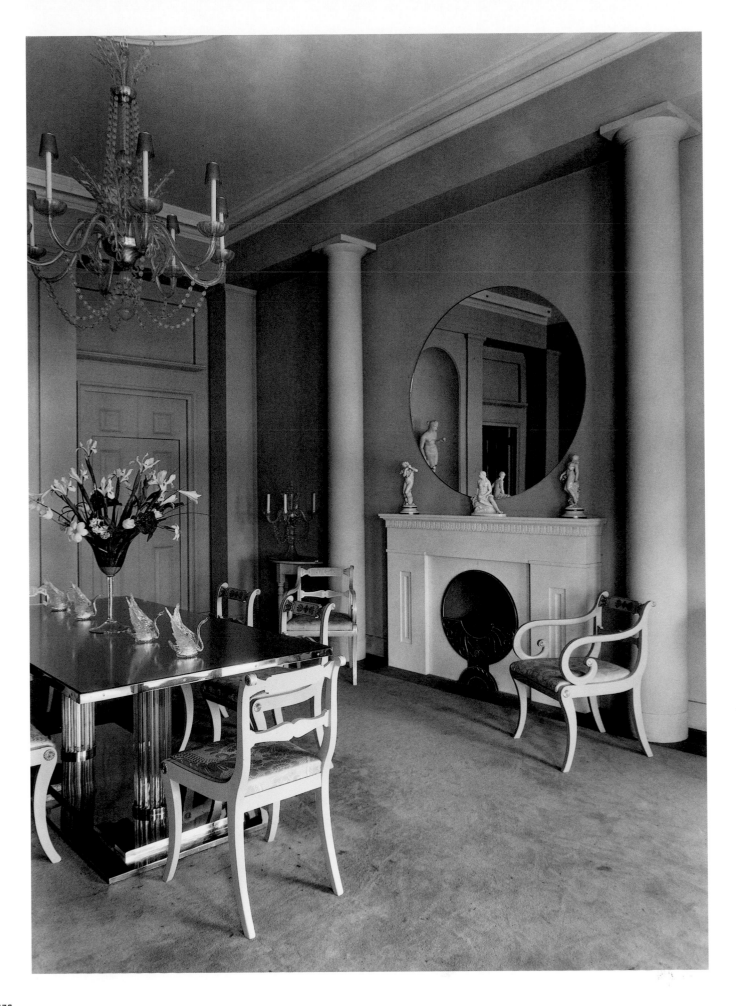

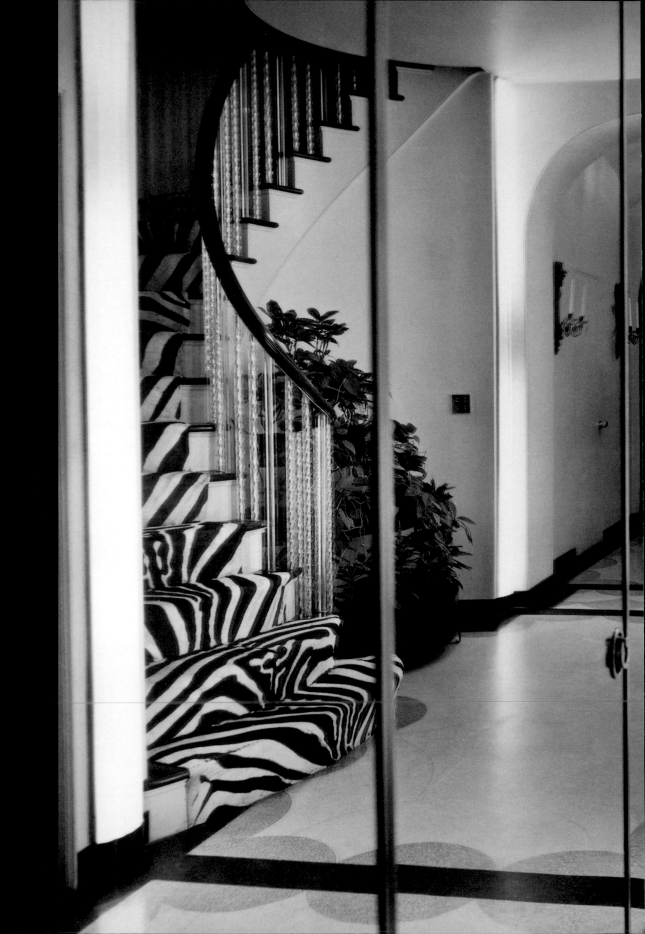

Foyer of William Paley
townhouse,
29 Beekman Place, 1936
Helen Reiners,
Interior Designer

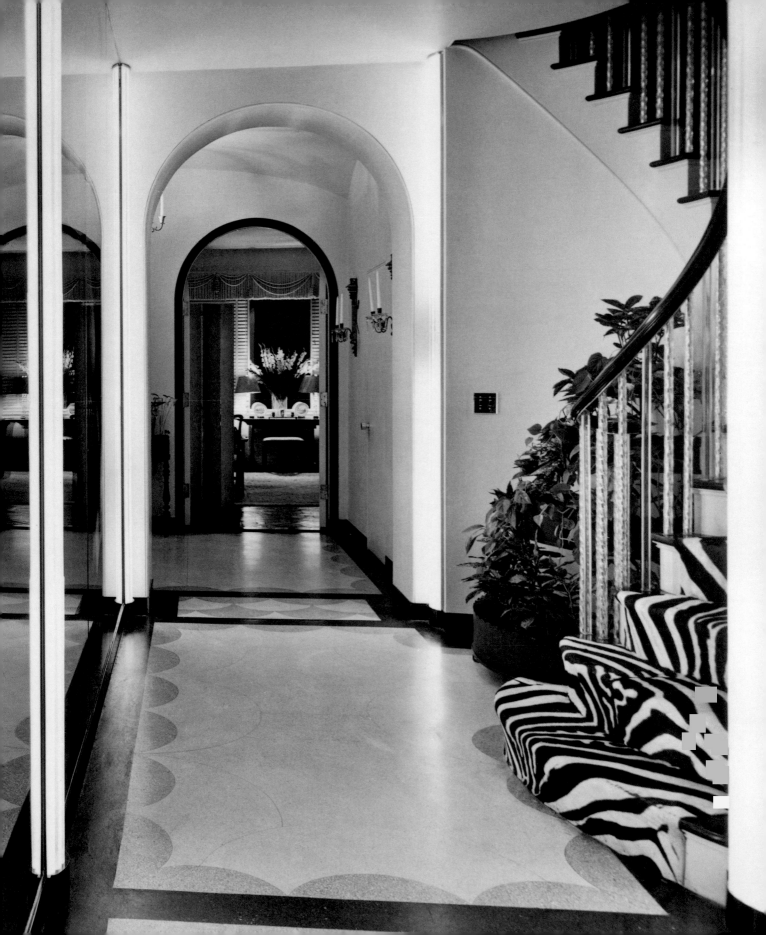

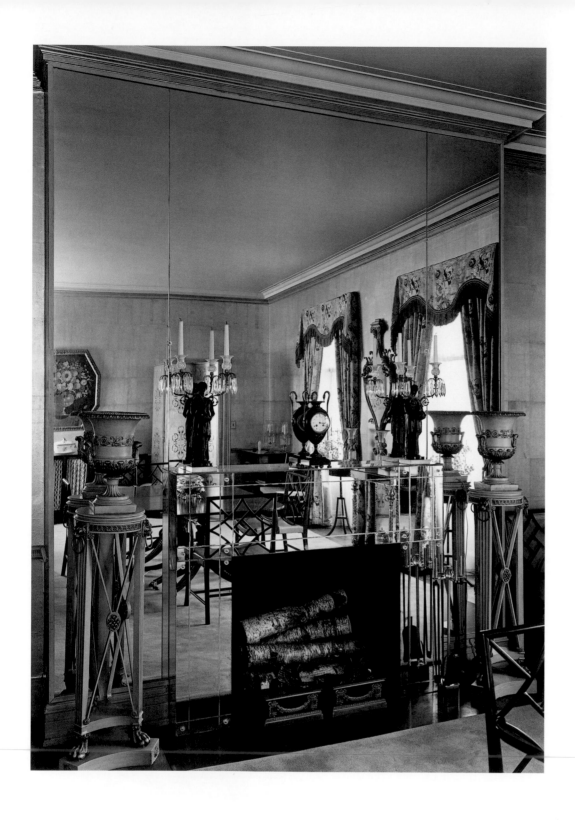

Residence of Mrs. Hugh
Mercer Walker,
730 Park Avenue, 1937

Game room of David
Bernstein Residence,
730 Park Avenue, 1936
Theo. Hofstatter & Company,
Interior Designers

Interior decorators in the
1930s often used frameless
mirrors to create the illusion
of boundless space in
small rooms. Gottscho's
photographs captured, and
even exaggerated, these
architectural devices for eye-
catching theatrical effects.

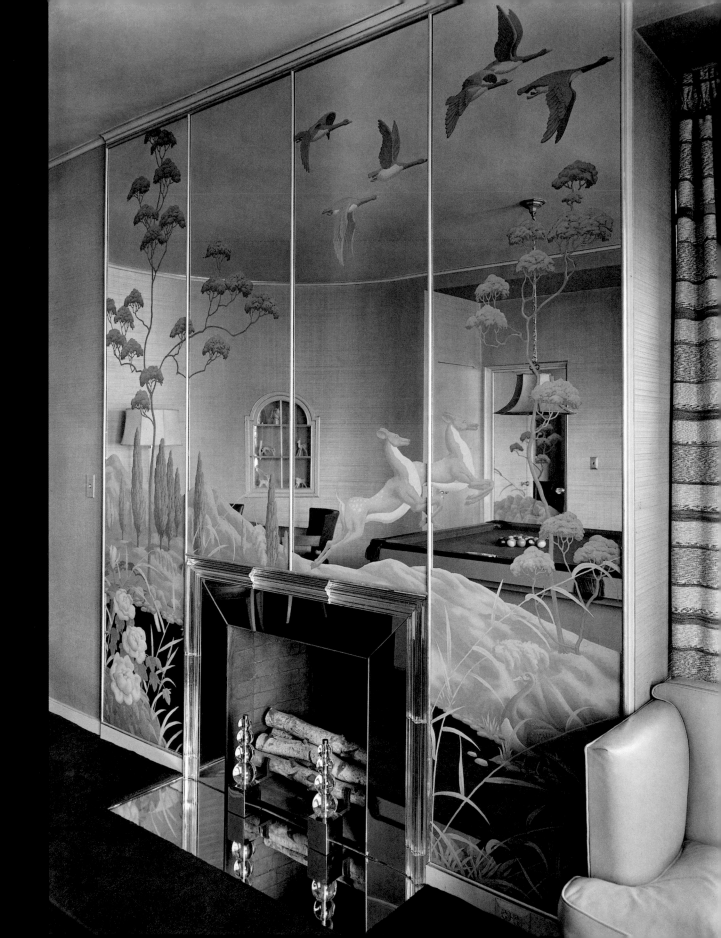

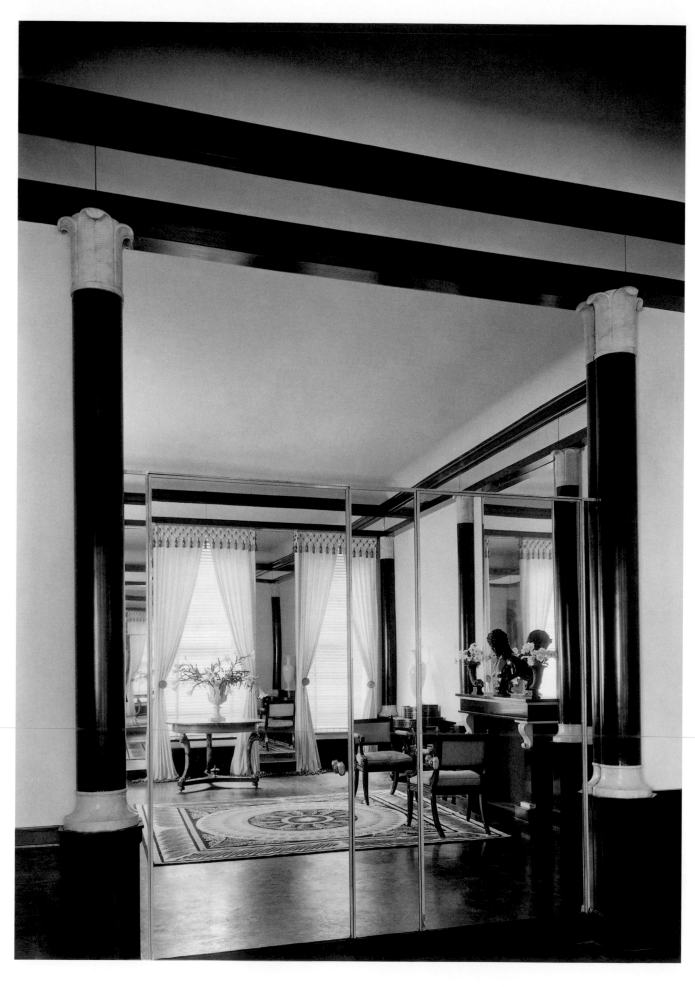

OPPOSITE:
Interior for Simone La Sala,
821 Madison Avenue, 1930
Elsie Cobb Wilson, Inc.,
Interior Designer

BELOW:
Bedroom in the Kuhne
Galleries, 59 East Fifty-
seventh Street, 1934

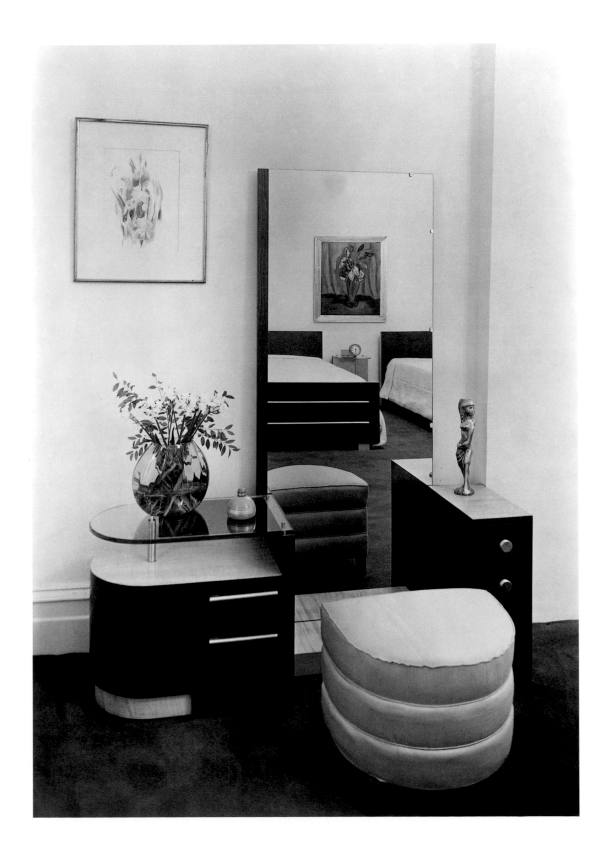

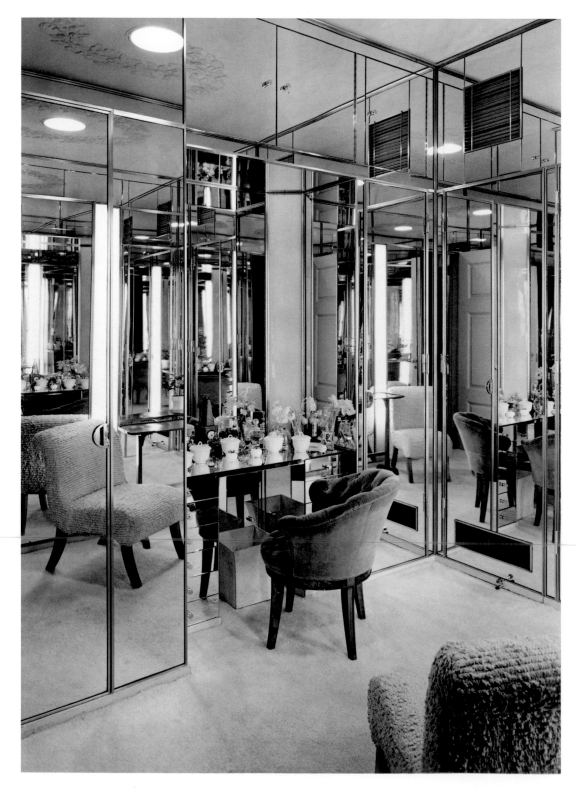

Dressing room of William
Paley townhouse,
29 Beekman Place, 1936

Interior of William Paley
townhouse, 29 Beekman
Place, 1936

Here Gottscho used the slatted
sunlight on the room's floor
to subtly call out the space
occupied by the table and
chairs. To enhance this effect,
he patiently waited for the
exact moment when the light
lined up with the right leg of
the chair on the left.

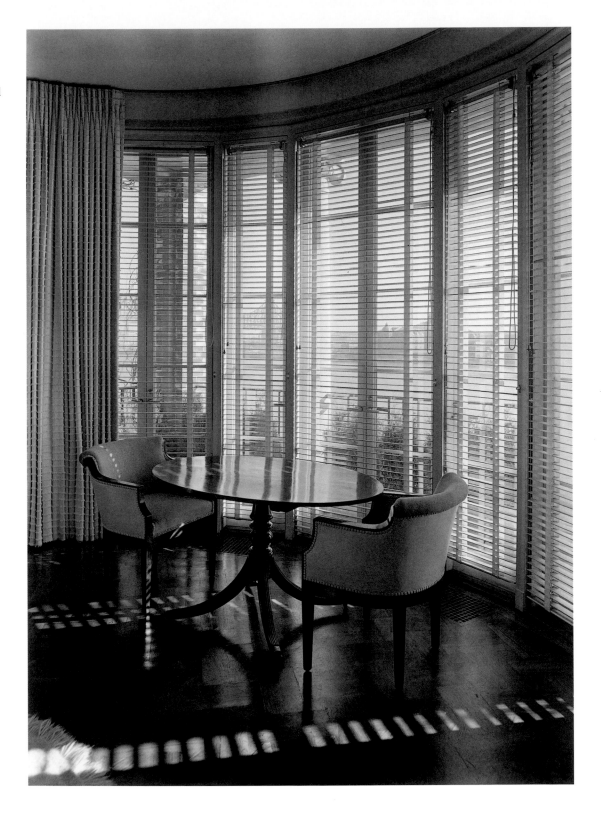

CITY LIVING: HOUSES FOR THE MASSES

Hillside Housing,
Boston Post Road, Bronx,
1935
Clarence S. Stein, Architect

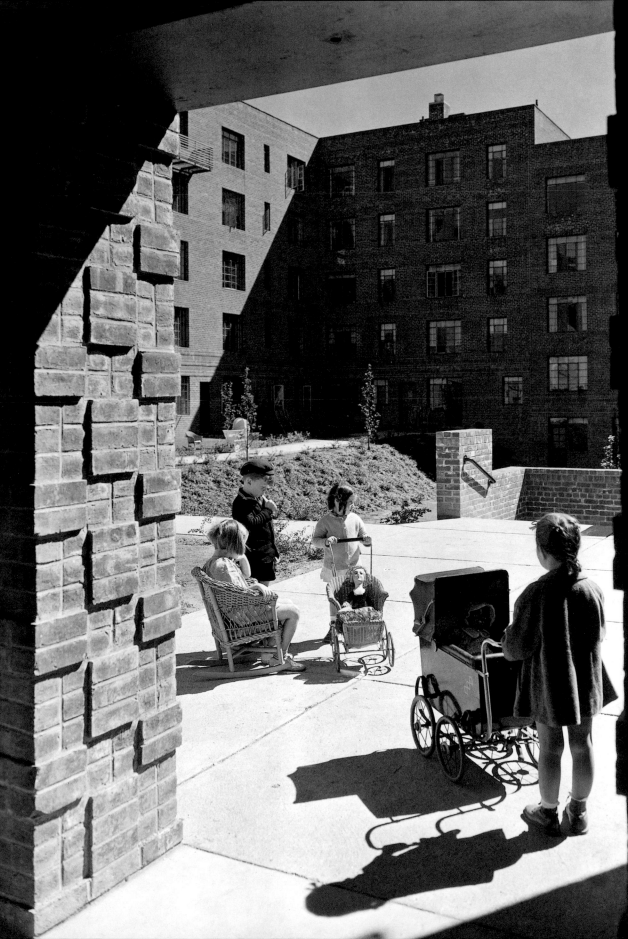

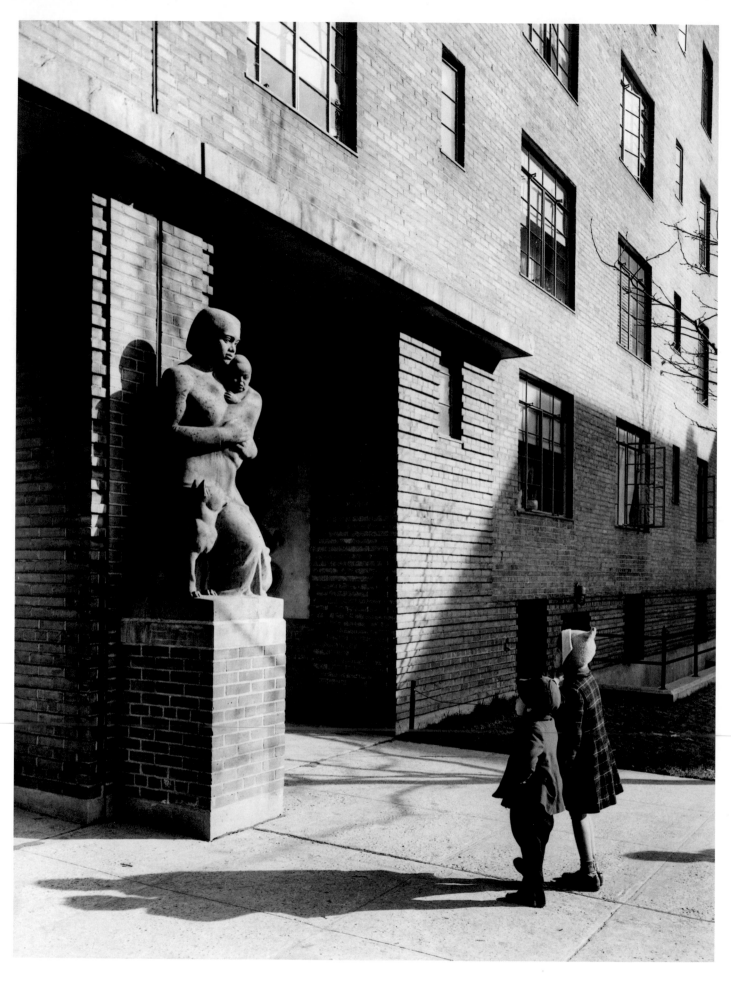

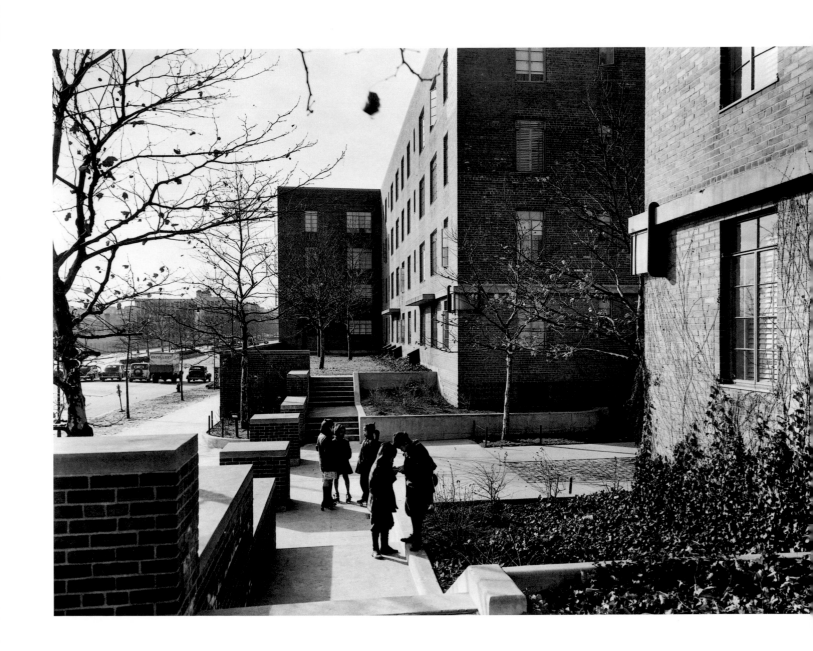

OPPOSITE & ABOVE:
Harlem River Houses,
Harlem River to Macombs
Place between 151st and
153rd Streets, 1936
Archibald Manning Brown
with John Wilson and Horace
Ginsbern, Architects

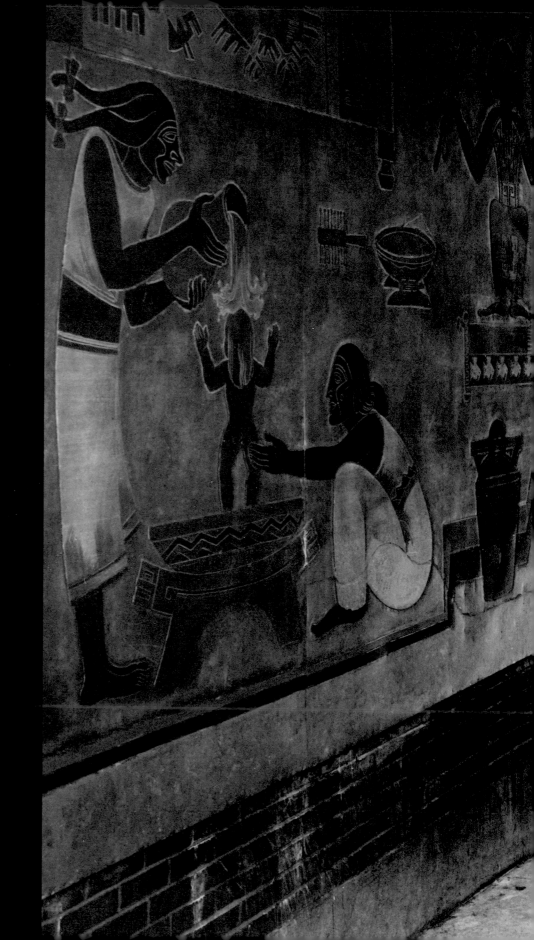

Harlem River Houses, 1936

Amalgamated Houses,
504–520 Grand Street, 1931
Springsteen and Goldhammer,
Architects

THE INSTITUTIONAL CITY

New York State Office
Building, 80 Centre Street,
1931
Sullivan W. Jones and William
E. Haugaard, Architects

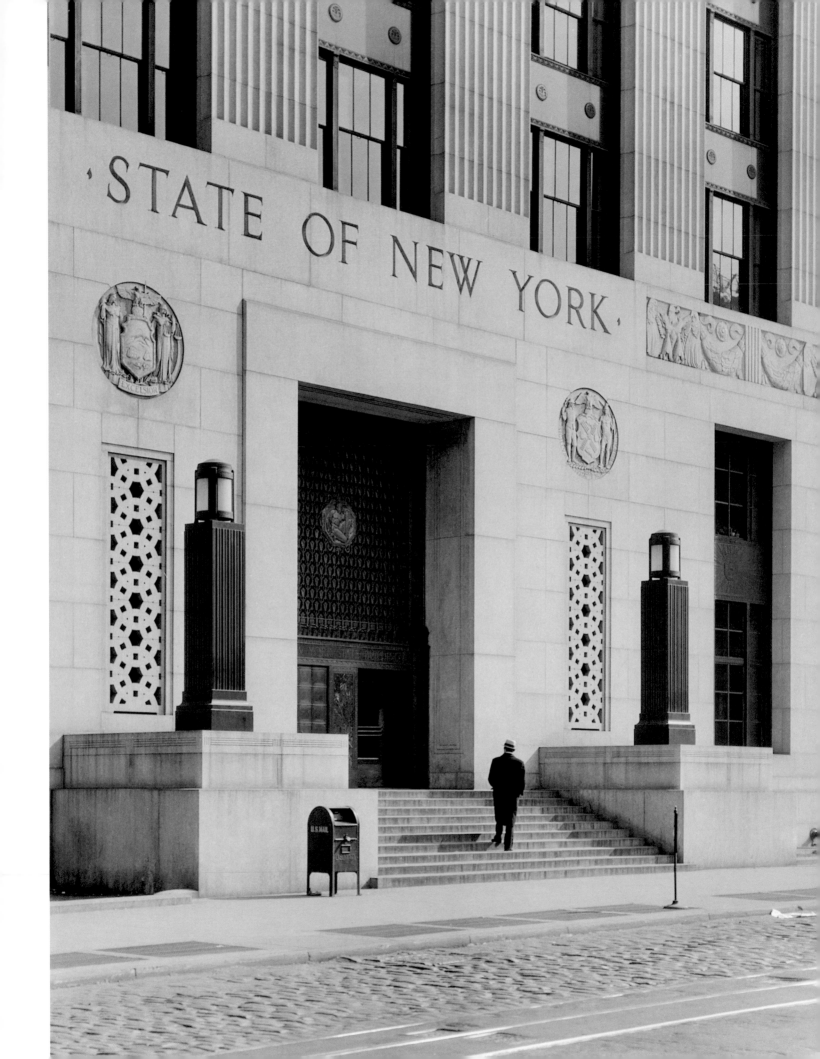

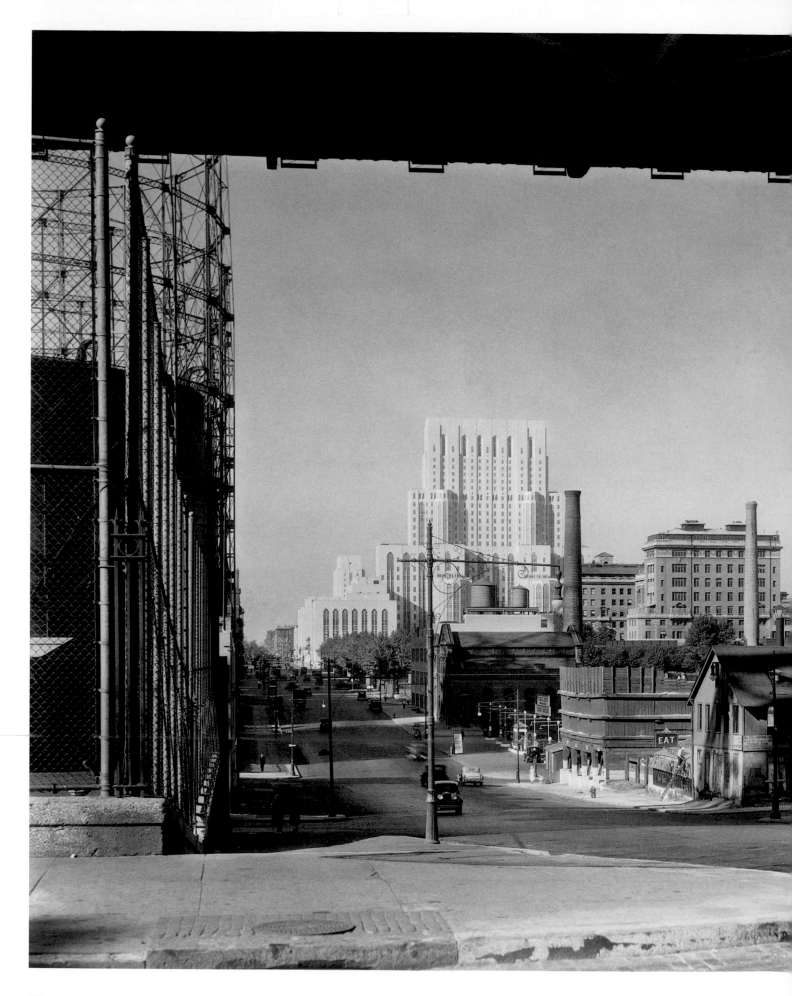

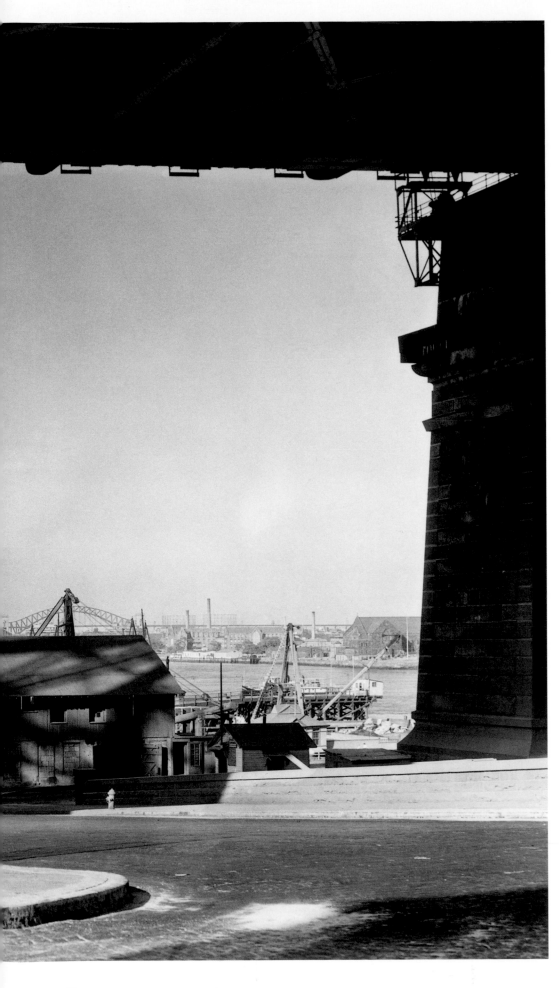

New York Hospital-Cornell
Medical Center framed by the
Queensboro Bridge, 1932
Coolidge, Shepley, Bulfinch &
Abbott, Architects

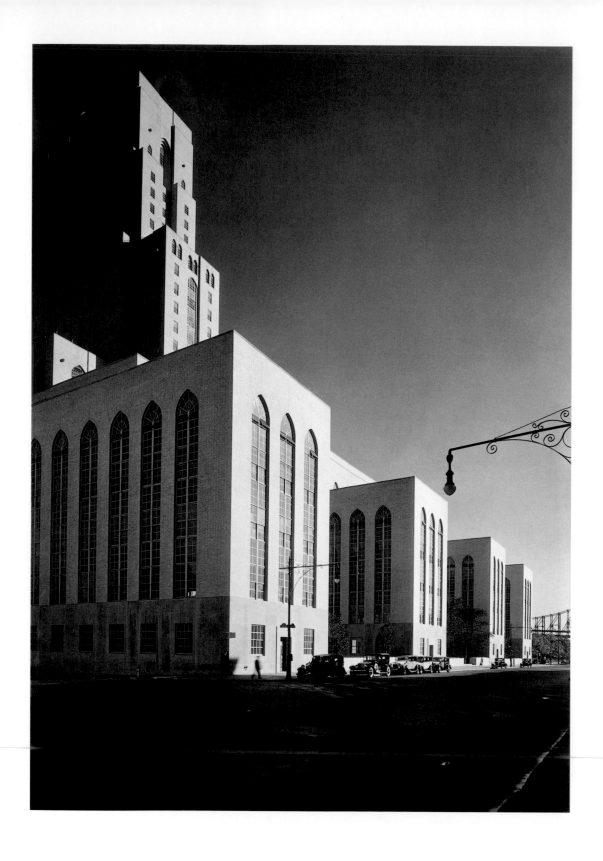

ABOVE & OPPOSITE:
New York Hospital-Cornell
Medical Center, York Avenue
between Sixty-eighth and
Seventieth Streets, 1932

Rather than focus on these
buildings' vaguely Gothic
details, such as the tall, pointed-
arch windows, Gottscho
manipulated sunlight and
shadow to stress the center's
bold, cubic massing.

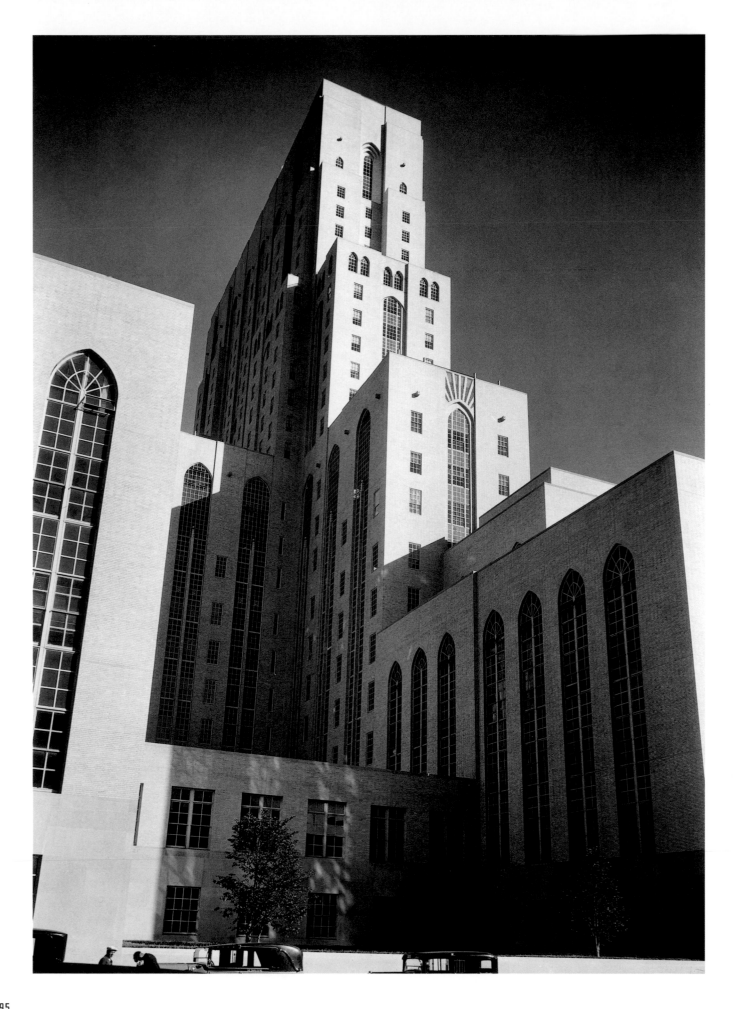

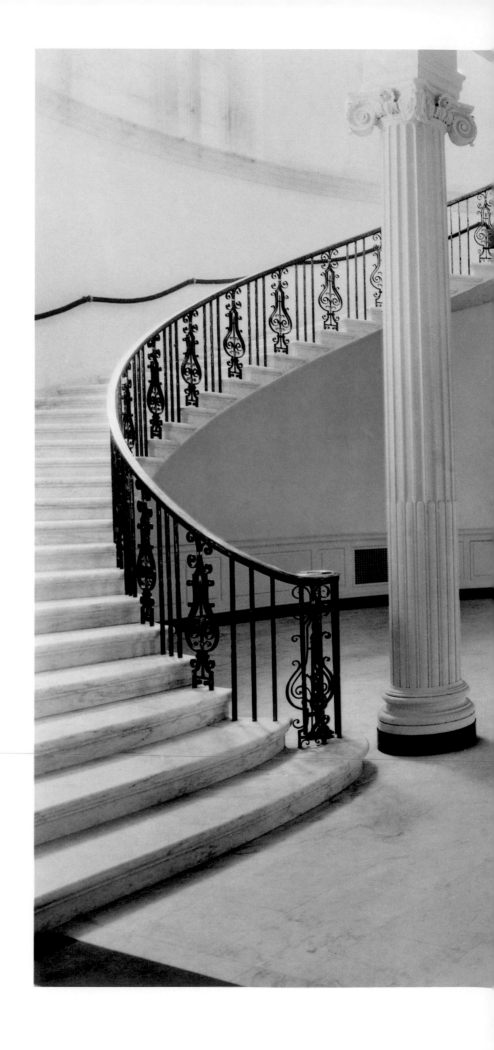

Interior rotunda, Museum
of the City of New York,
1220 Fifth Avenue, ca. 1932
Joseph H. Freedlander,
Architect

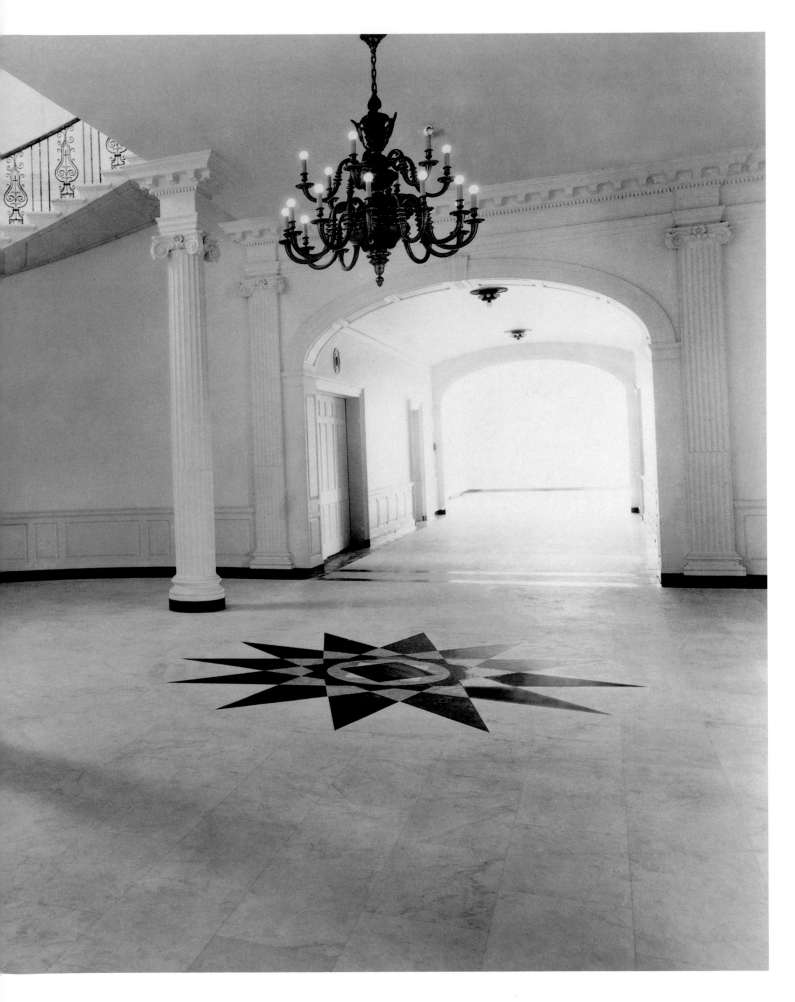

CITY
OF
TOMORROW:
THE
NEW YORK
WORLD'S
FAIR

Trylon and Perisphere, 1939
Harrison and Fouilhoux,
Architects

The World's Fair was built
on a vast open fairground in
Flushing Meadows, Queens,
to celebrate not only the
150th anniversary of George
Washington's inauguration
in 1789, but also America's
industrial leadership in the
world. There were seven
themed zones, including
transportation areas featuring
pavilions built by the major
automakers.

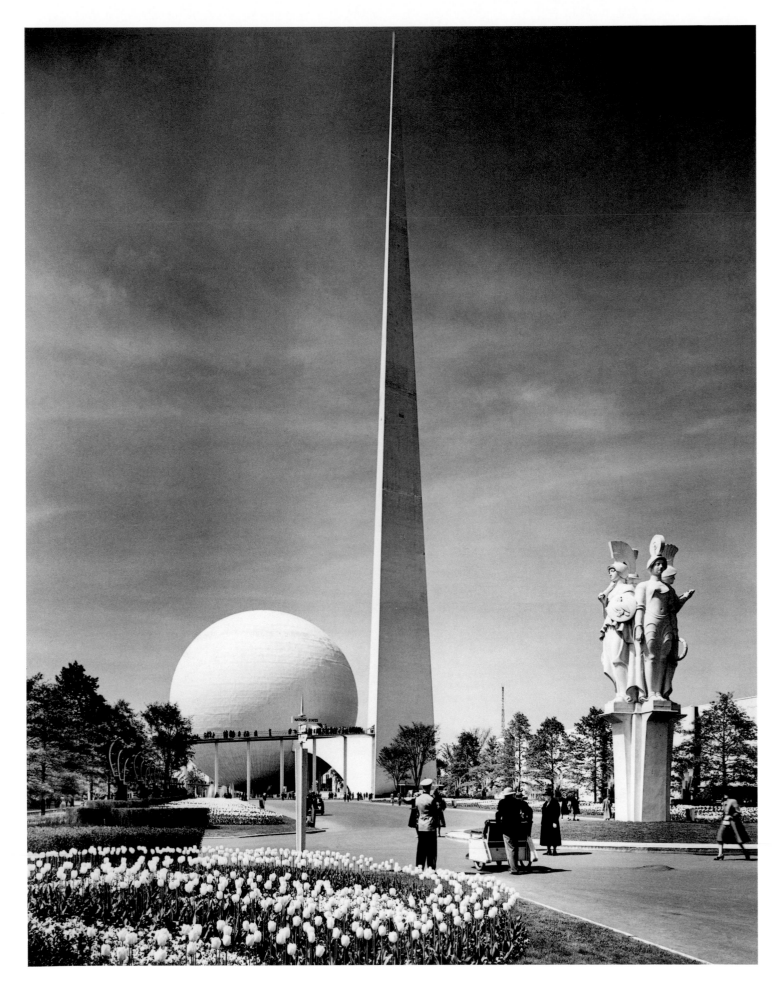

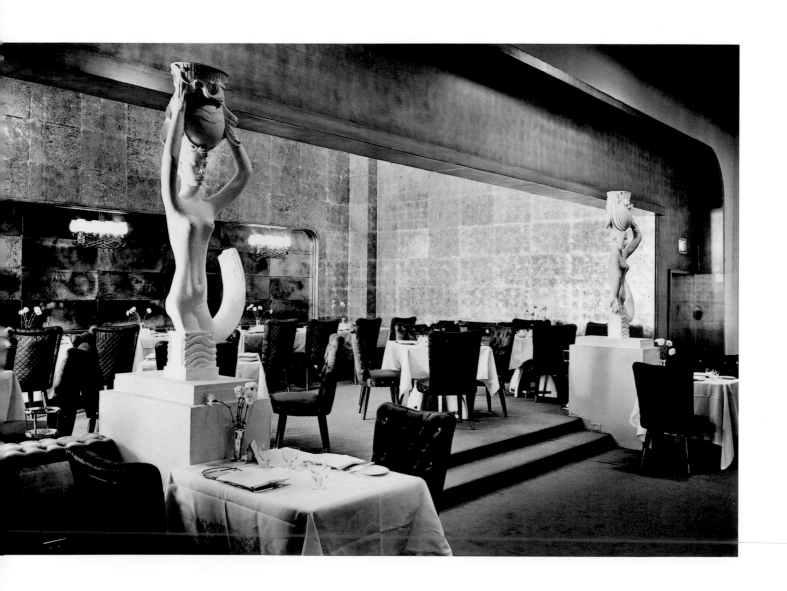

Italian Line restaurant, 1939

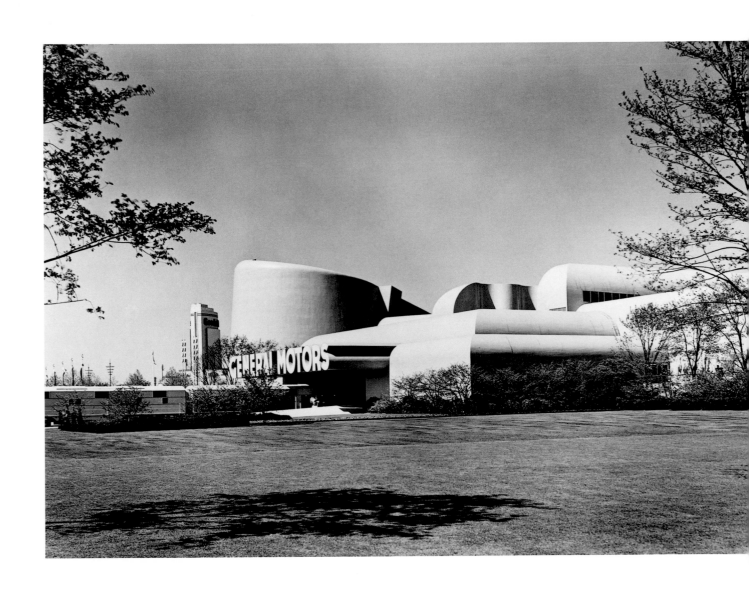

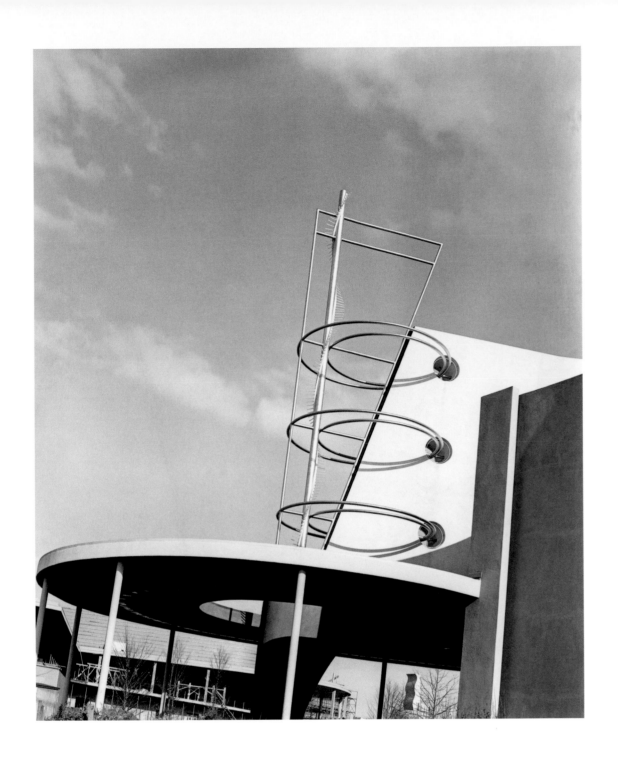

OPPOSITE & ABOVE:
Fair Operations Building,
1939
A. Stewart Walker and Leon
N. Gillette, Architects

Railroads Building, 1939
Eggers and Higgens,
Architects

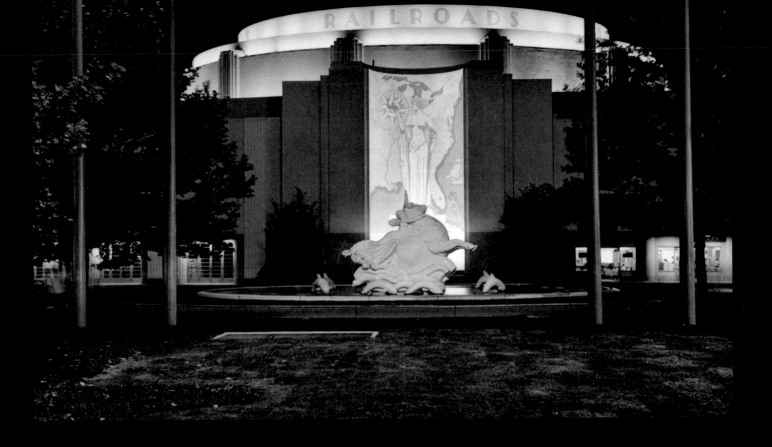

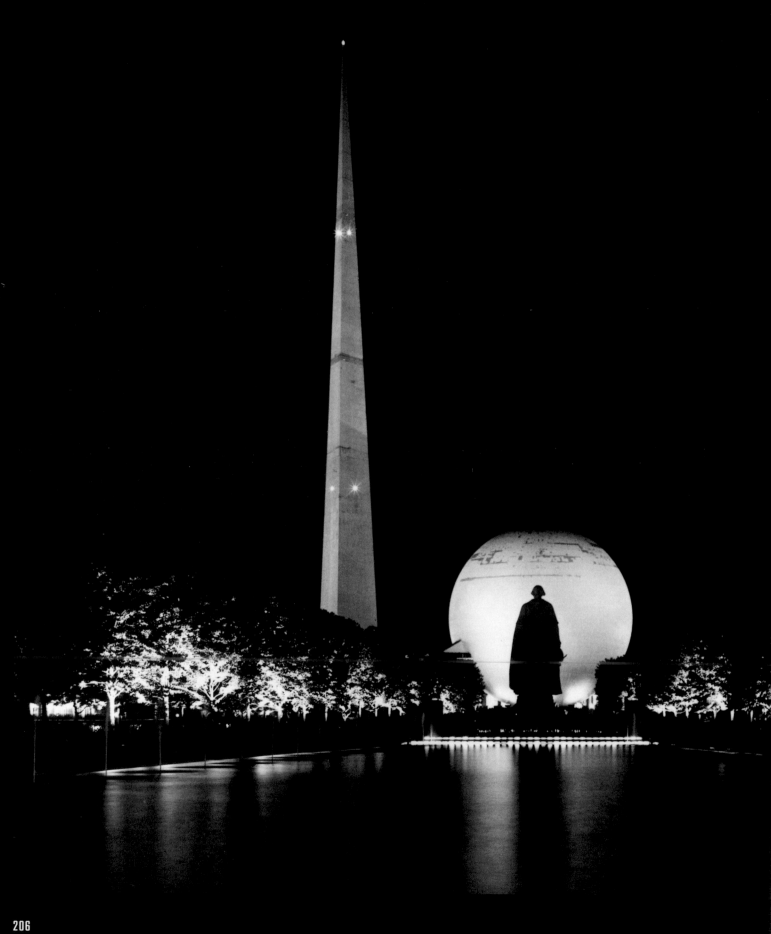

Trylon and Perisphere, 1939
Harrison and Fouilhoux,
Architects

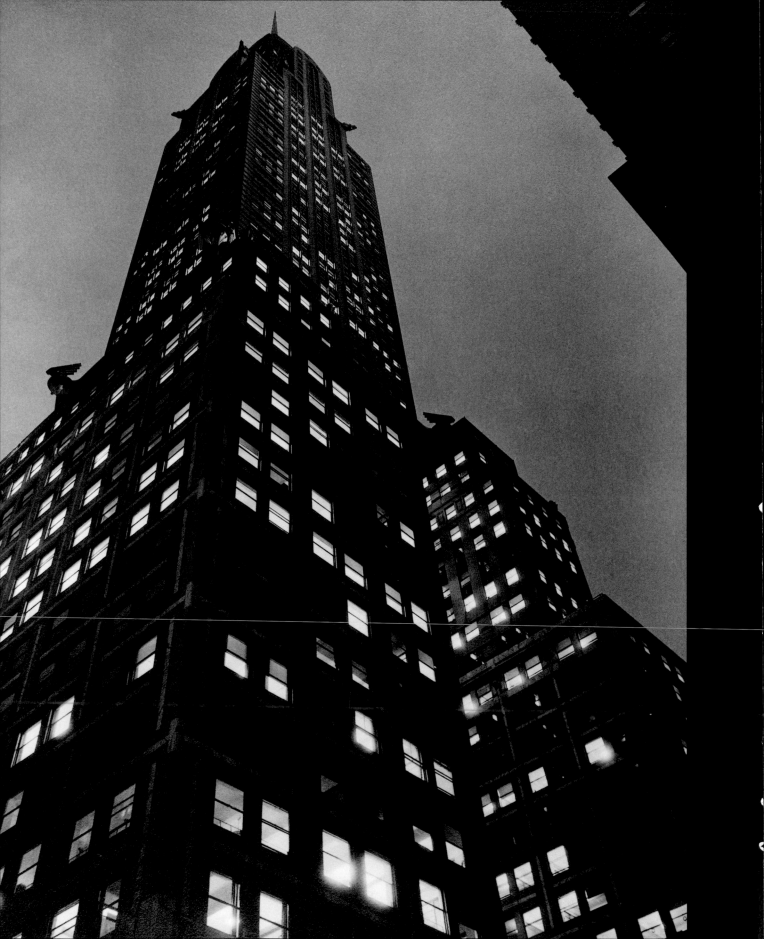

Chrysler Building, 1930
William van Alen, Architect

Looking west down Forty-
second Street from Tudor City
with Chrysler Building at right,
1933

View looking northwest from
the Empire State Building,
1932

Empire State Building (left)
from the Continental Building,
1932

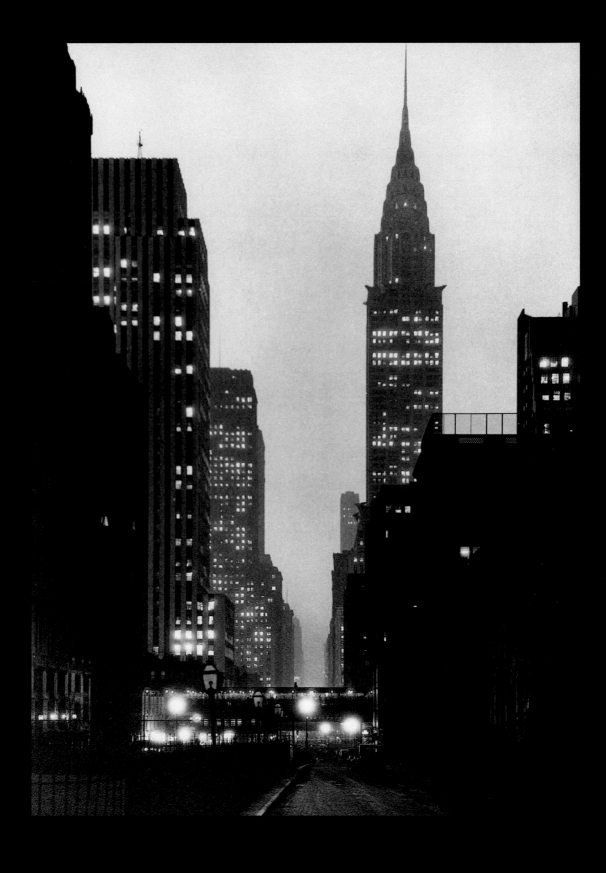

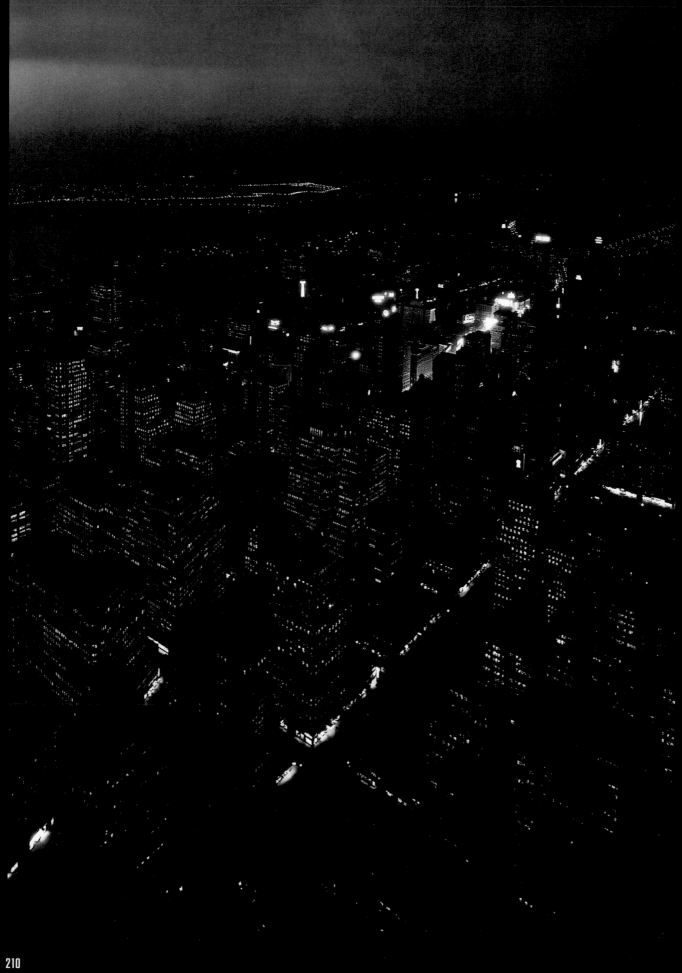

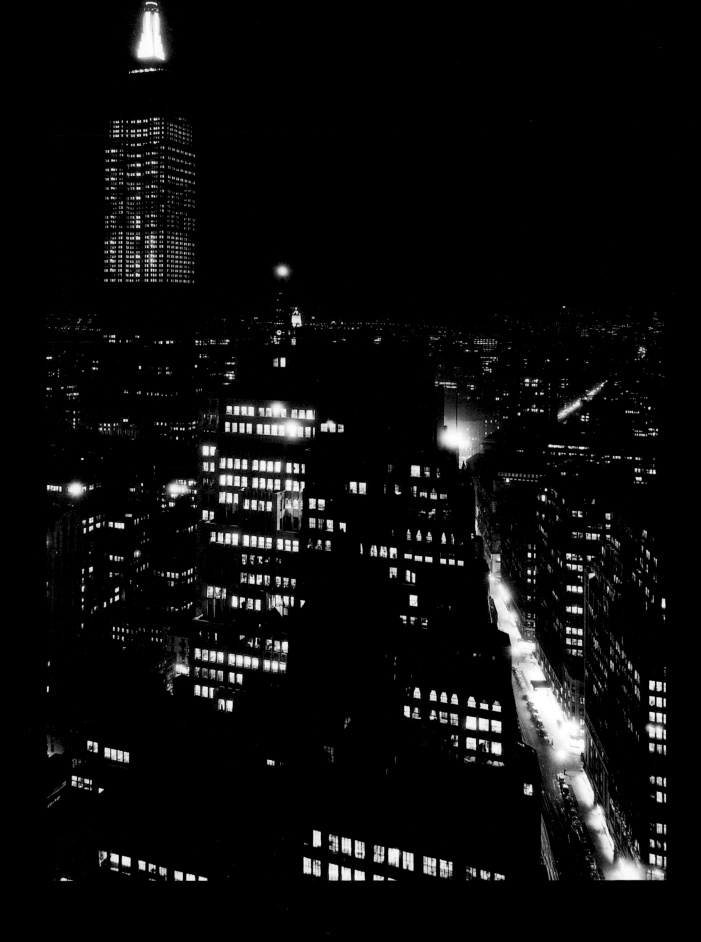

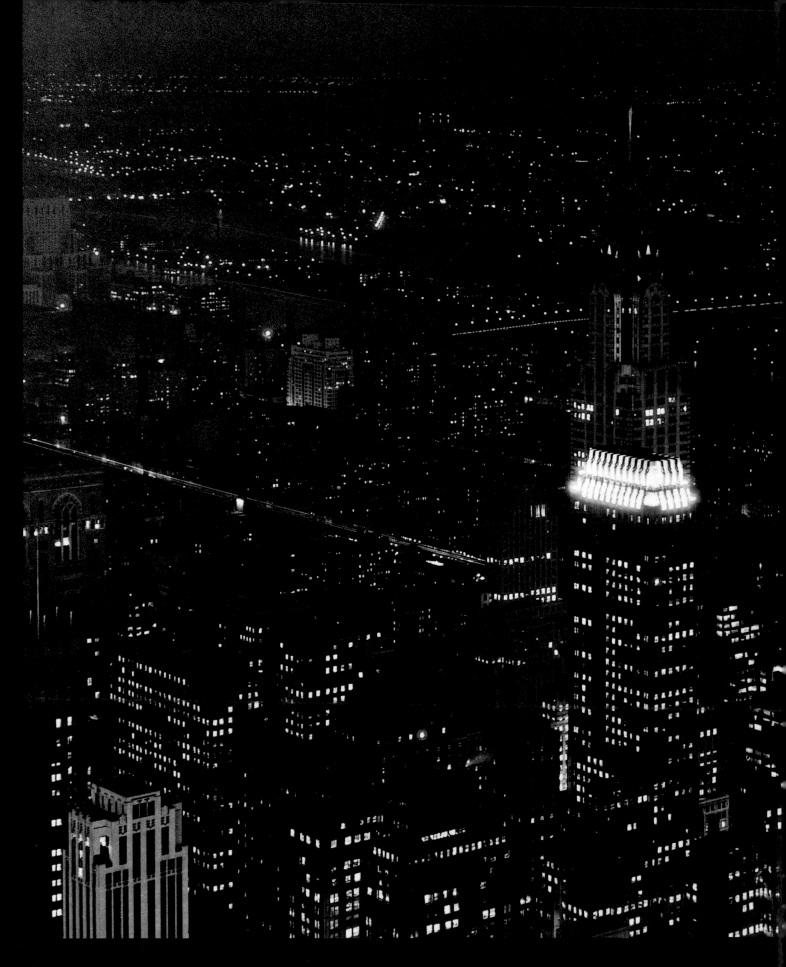

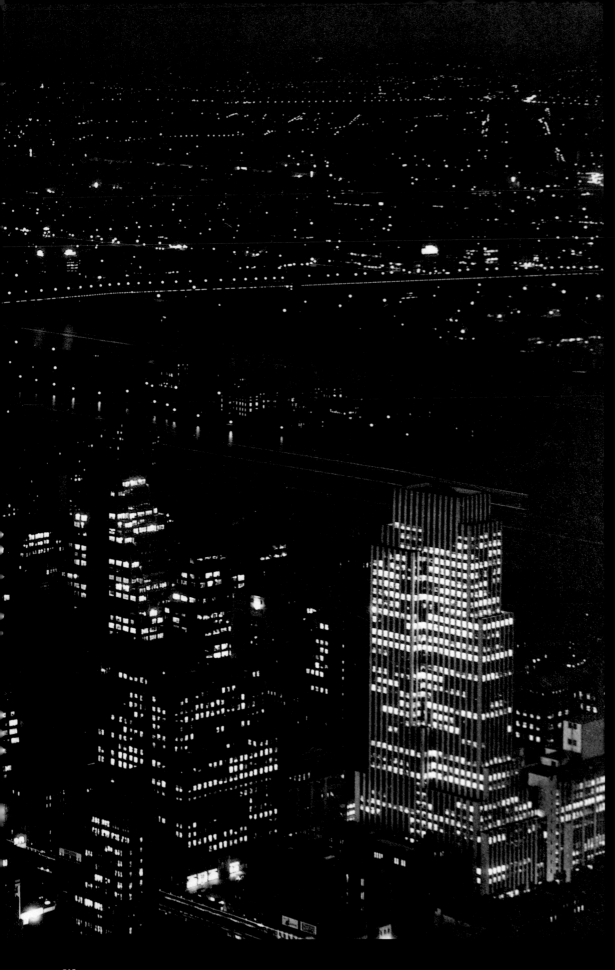

View looking northeast from
the Empire State Building
with Chanin Building (center),
1932

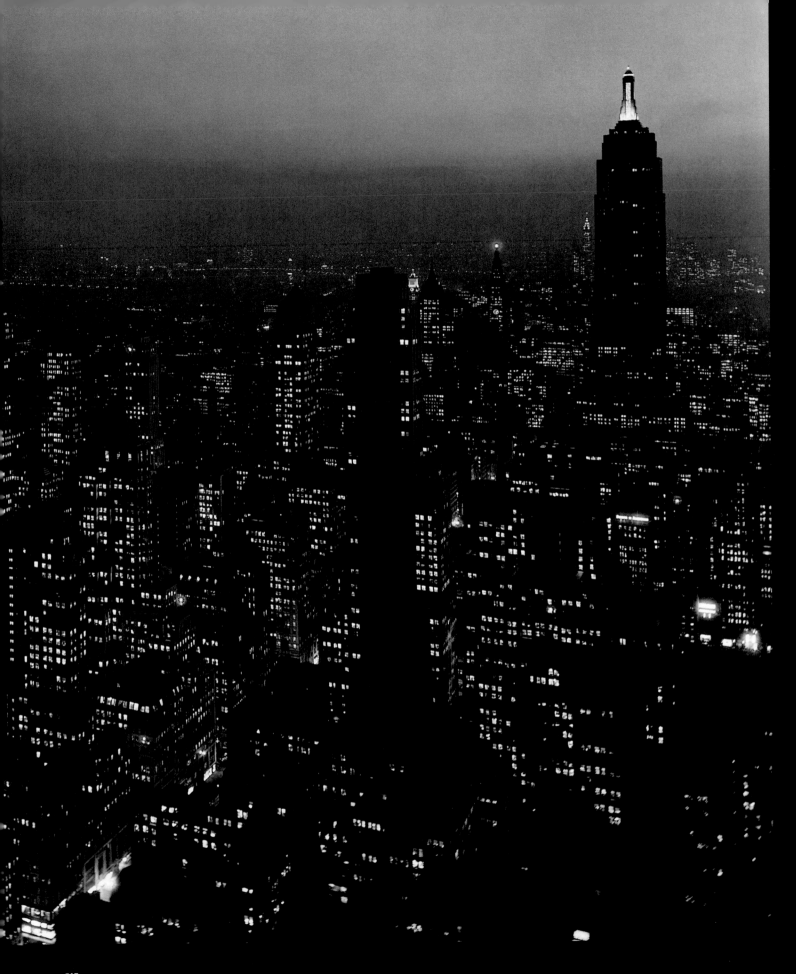

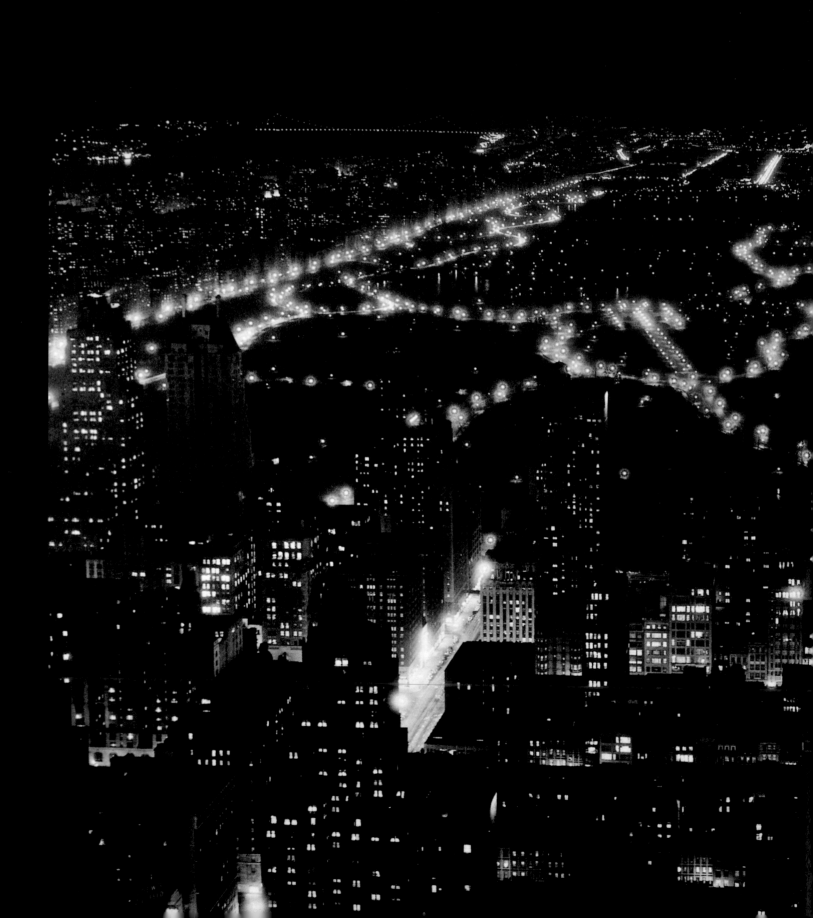

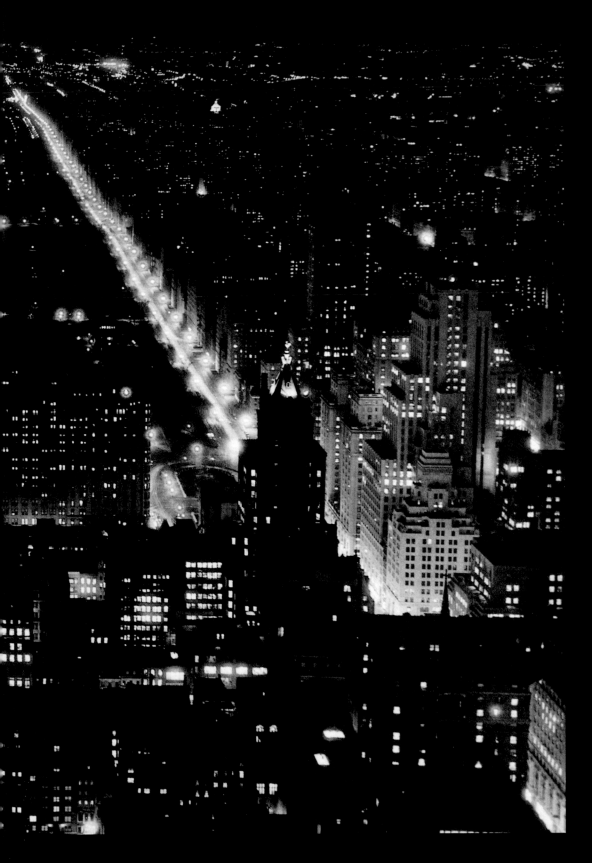

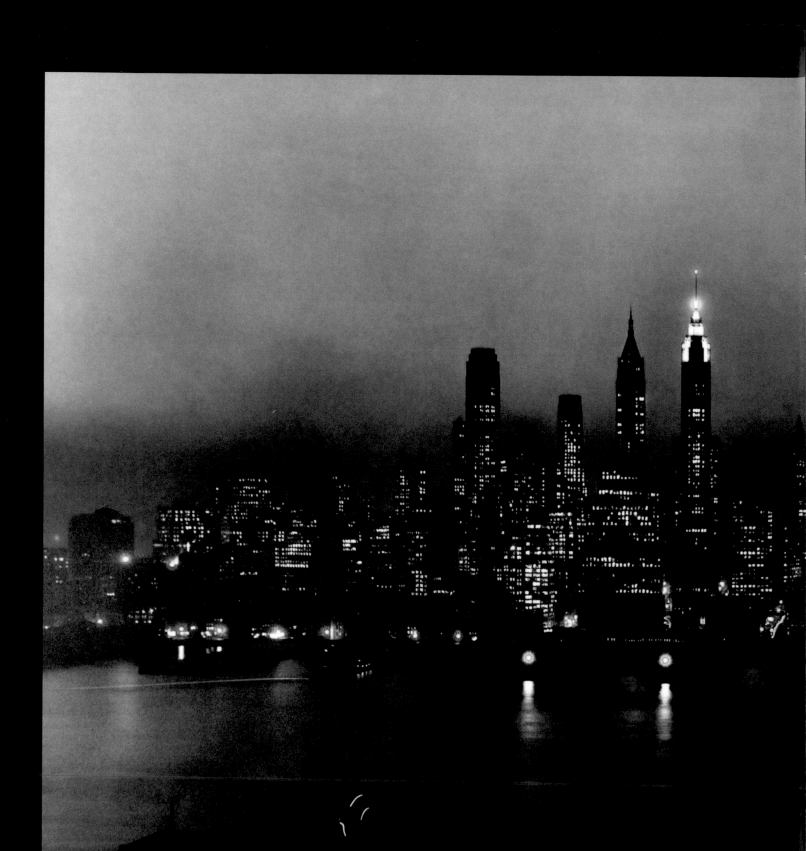

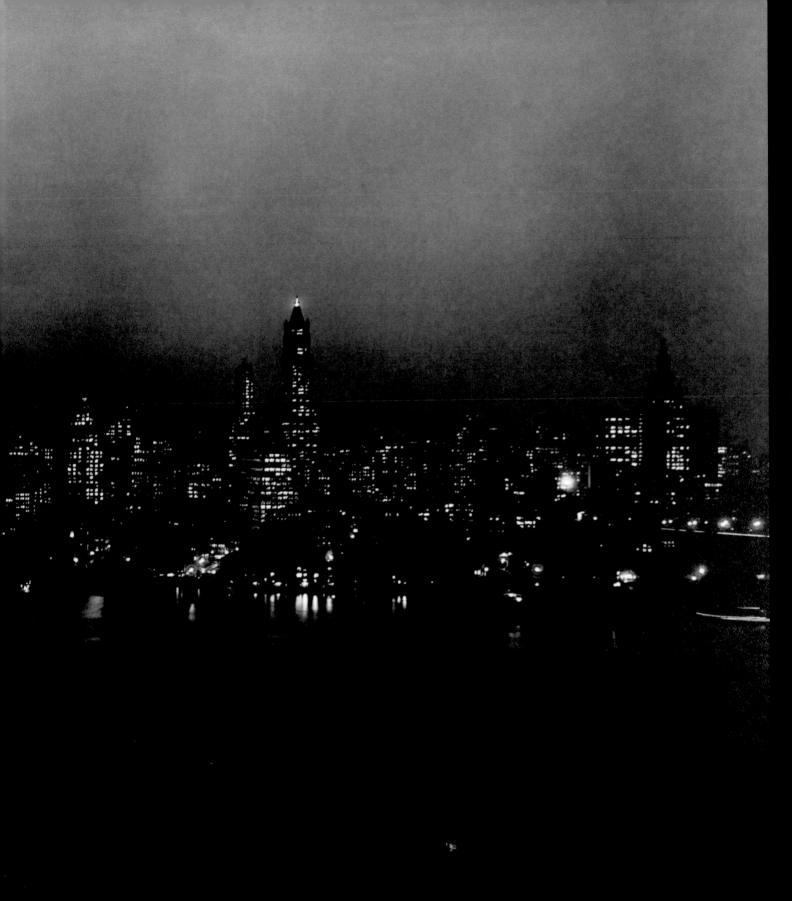

Manhattan from the
St. George Hotel, Brooklyn,
1933

ACKNOWLEDGMENTS

Many people made this book and related exhibition possible. Susan Henshaw Jones, president and director of the Museum of the City of New York, was its first advocate, and she has remained committed throughout its development. This is the most recent project on which we have happily collaborated for more than a decade. The Gottscho project also continued a fruitful working relationship with Mark Lamster, whose enthusiasm for Gottscho's photos attracted the book's excellent publisher, Princeton Architectural Press. Princeton editor Linda Lee provided superb advice on completing the manuscript and also oversaw the book's production. Many people read the manuscript and offered valuable advice: Sarah M. Henry, Norman McGrath, Thomas Mellins, Jeff L. Rosenheim, Bob Shamis, and Bonnie Yochelson, who especially helped me better understand the photography context of Gottscho's time. Natalie Shivers was, as always, an excellent sounding board and content advisor. It was a great pleasure to work with Paul Carlos and Urshula Barbour of Pure+Applied, who designed the book and show in a way that matched the elegant sophistication of Samuel Gottscho's New York. Within the Museum of the City of New York, Tina D'Auria provided invaluable research assistance, and Autumn Nyiri made the project a reality by overseeing myriad details with flair and good humor. In this effort she was greatly assisted by Eileen Morales. Barbara Livenstein handled press relations with energy and aplomb, Robert Blandford organized great programs, and Kassy Wilson directed the exhibition's installation with the help of the Museum's outstanding installation staff. Finally I want to thank Museum of the City of New York trustee James G. Dinan and his wife, Elizabeth R. Miller, whose funding made the project possible.

Donald Albrecht

SELECTED BIBLIOGRAPHY

Deschin, Jacob. "Viewpoint: Samuel Gottscho's Negatives of Architectural Photography Go to the Library of Congress." *Popular Photography* 86 (June 1980): 12, 54, 56, 58.

Gottscho, Samuel H. *My Life in Photography*. Unpublished four-volume manuscript, circa 1956. Prints & Photographs Division, Library of Congress, Washington, DC.

———. *Seventy-one Years, Or My Life with Photography*. Unpublished manuscript, late-1960s. Prints & Photographs Division, Library of Congress, Washington, DC.

———. "Thoreau and Wild Flowers." *Journal of the New York Botanical Garden*, November/December 1951, 63–68.

Kozloff, Max. *New York: Capital of Photography*. New York and New Haven: The Jewish Museum and Yale University Press, 2002.

Neumann, Dietrich, ed. *Architecture of the Night: The Illuminated Building*. Munich, Berlin, London, New York: Prestel, 2002.

Nolan, Leslie. *Shared Perspectives: The Printmaker and Photographer in New York, 1900–1950*. New York: Museum of the City of New York, 1993.

"Nonagenarian: The Talk of the Town." *The New Yorker*, April 4, 1970, 34.

Pare, Richard. *Photography and Architecture, 1839–1939*. Montreal: Centre Canadien d'Architecture/Canadian Centre for Architecture, 1982.

Radcliff, Carter. "Photography: The Persistence of Pictorialism." *Art in America*, September 1980, 51, 53.

Robinson, Cervin, and Joel Herschman. *Architecture Transformed: A History of the Photography of Buildings from 1839 to the Present*. New York and Cambridge: The Architectural League of New York and MIT Press, 1987.

"Samuel Gottscho, Photographer, Dies." *New York Times*, January 29, 1971.

"William H. Schleisner is Dead; Architectural Photographer, 49." *New York Times*, November 8, 1962, 39.

INDEX

PHOTOGRAPH CREDITS